KANTOR WAS HERE

TADEUSZ KANTOR IN GREAT BRITAIN

EDITED BY KATARZYNA MURAWSKA-MUTHESIUS AND NATALIA ZARZECKA

POLSKA! YEAR

Adam Mickiewicz Institute
CULTURE.PL

**black dog
publishing**
london uk

CONTENTS

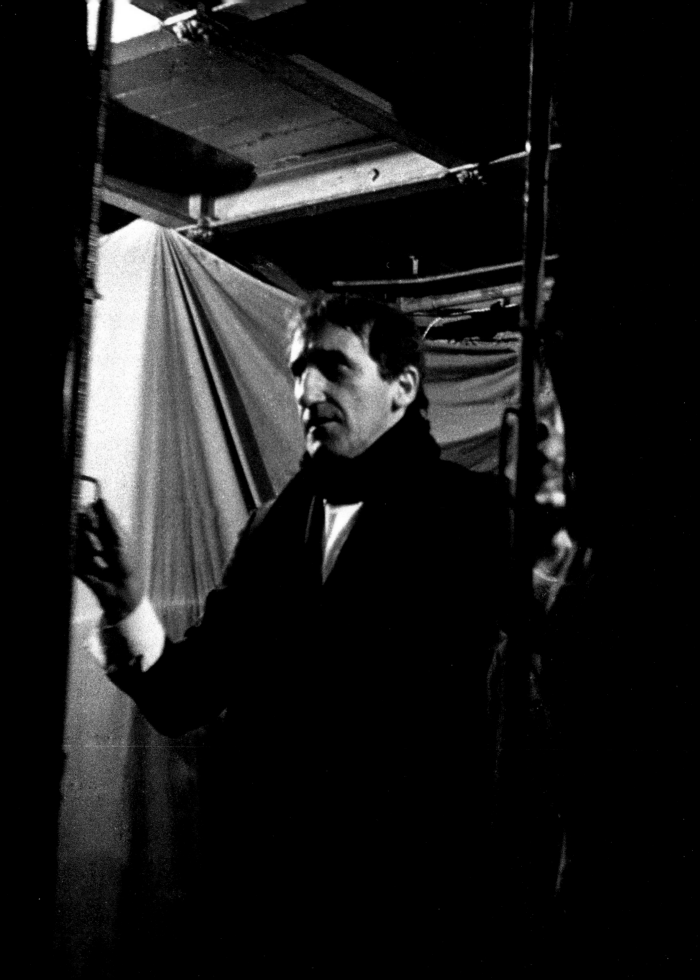

FOREWORD

POLSKA! YEAR TEAM

Tadeusz Kantor is one of the key figures in Polish culture. His impact on art and theatre in Europe is invaluable. The links between the artist and Great Britain are rich and dynamic, even if not all that well known. It made us, therefore, extremely happy to learn that the Sainsbury Centre For Visual Arts in Norwich was interested in organising events which would introduce Tadeusz Kantor's work to the wider British public. Fruitful co-operation between curators and art historians from Norwich, Kraków and Warsaw resulted in the exhibition of the artist entitled *An Impossible Journey: The Art and Theatre of Tadeusz Kantor* and a conference *Kantor Was Here*. Both events were initiated and co-funded by the Adam Mickiewicz Institute in Warsaw as part of POLSKA! YEAR, a major presentation of Polish culture across the UK. We had the great honour to be able to work with incredibly creative people from British and Polish institutions involved in the two projects.

The success of both the exhibition and the conference surpassed all our expectations. It revealed a great interest of the British audience in Polish art. Thus we decided to explore this subject further. Hence this book. There are many people to whom we are extremely grateful for their involvement in this beautiful publication. It was a great pleasure to work with all of you. We owe many heartfelt thanks to Katarzyna Murawska-Muthesius for her enthusiasm and commitment as well as to Natalia Zarzecka and Tomasz Tomaszewski from Cricoteka, the authors of texts and everyone at Black Dog Publishing.

NICHOLA JOHNSON

When the Sainsbury Centre for Visual Arts was approached by Jonathan Holloway and asked to consider the possibility of mounting an exhibition about Kantor, the name meant very little to my younger colleagues. For me, the suggestion revived memories of the extraordinary impact of his brief time in England in the 1970s and the appeal of such a project was enormous. But how might such an exhibition be mounted? Should it, from more than 30 years' distance, be treated purely historically? Should the surviving physical evidence of his work now be presented as visual art? As theatre? As event? As performance? How would a generation of visitors unfamiliar with the anarchic and courageous happenings and performances of the 1960s and 70s react? In the end, what visitors to the Sainsbury Centre encountered was none—or perhaps all-of these things. The 'exhibition' and its accompanying symposium and public events programme was the result of an extraordinary collaboration with Polish enthusiasts and scholars who have kept alive both the memory and the material evidence of Kantor's work and legacy and those who continue to value his impact here in the UK. The fact that the event took place in association with POLSKA! YEAR meant that we were able to benefit from resources that otherwise would have been inaccessible and so could introduce Kantor and his work to a whole new audience. That this publication will capture some of the elements of that collaboration is a wonderful outcome of what was, in every sense, a once-in-a-lifetime happening.

Tadeusz Kantor in the Demarco Gallery presentation of *Lovelies and Dowdies,* Forresthill, Poorhouse, Edinburgh International Festival Fringe, September 1973, photograph Richard Demarco, courtesy Demarco Archive.

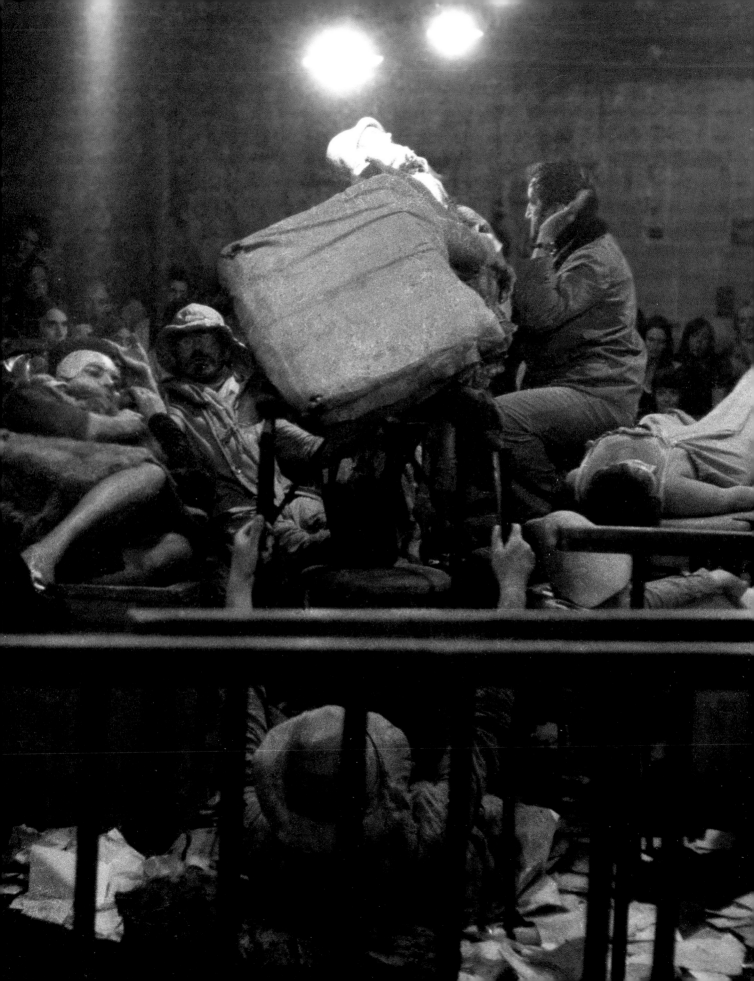

"WHATEVER THIS IS, IT'S EXCELLENT": BRITISH CRITICS ON KANTOR

KATARZYNA MURAWSKA-MUTHESIUS AND NATALIA ZARZECKA

The current boom of Polish art in Britain, buoyant and mainstream, with Mirosław Bałka's Unilever project at Tate Modern and Goshka Macuga's at Whitechapel, is not entirely unprecedented.[1] It had an earlier partisan counterpart in the 1970s, when a small group of British and Polish avant-garde artists and critics, committed to conceptual and performance art and led by Richard Demarco and Wiesław Borowski, broke through the Iron Curtain, exchanging exhibitions and making personal contacts. And, at the very centre of this early British-Polish encounter, unquestionably, stood Tadeusz Kantor, the formidable personality of the Polish post-1945 art world.

Widely considered the major figure of the avant-garde theatre, Kantor was also a painter, a draughtsman, and at the same time a poet and the author of highly original theoretical texts. Born in Galicia, a province of Austria-Hungary in 1915 at the onset of the First World War, Kantor's life spanned the cruelest time in Poland's history, the Nazi occupation as well as Stalinism, coming to an end in December of 1990, just after the downfall of Polish Communist regime. His Cricot 2 Theatre (1955), employing professional actors, as well as artists, critics, art historians and making use of mannequins, was indebted to Dadaist and Surrealist theatrical experiments of Alfred Jarry, Antoine Artaud, Samuel Beckett, and to Edward Gordon Craig's concept of the *Übermarionette*.[2] Both Kantor's theatre as well as his paintings were the arenas of his lifelong struggle against 'illusion', exploding the boundaries between the visual and the theatrical, between static and moving images, figurative and abstract, memory and death, the "reality of the lowest rank" and the sublime. Over the years, Kantor subjected almost any medium to his ceaseless search for expression, travelling as freely between materials and techniques, as he did between all the 'isms', from Constructivism and Cubism, Surrealism and Metaphorical Abstraction to *Informel*, and to Happening and Performance art. Based in Kraków, Kantor was touring with his theatre to all parts of the world. Between 1972 and 1982 Kantor and Cricot 2 visited the UK five times, and the marks of that presence can still be found.

This book is not a comprehensive study of Tadeusz Kantor's exceptionally versatile production in all kinds of media.[3] It takes a different line, studying the reception of his art in one of his major host countries, in 1970s and 1980s Britain, which helped to disseminate Kantor's fame.[4] The volume is a collage of memories, interviews, newly unveiled archival material, as well as new critical approaches to Kantor's art. It assembles texts of the most eminent British curators, critics and scholars: Richard Demarco, Nicholas Serota and Sandy Nairne, who had worked with Kantor early on, and subsequently became the top players of the British art world, and who evaluate his impact as well as assess his legacy today. The stimulus behind the book was a retrospective exhibition at the Sainsbury Centre in Norwich, *An Impossible Journey: The Art and Theatre of Tadeusz Kantor* in the summer of 2009, as well as the accompanying symposium *Kantor was Here*.[5] The research on Kantor's interaction with the British art scene generated by the exhibition, and helped by the contributor to this book Jo Melvin, uncovered drawings by Kantor in British private collections, as well as photographs and documents in the archives of Kantor's British allies and friends, Richard Demarco and David Gothard. This multi-vocal chorus of British curators, critics, scholars, art managers and translators, is supplemented by a voice of the Polish émigré community, provided by Krzysztof Cieszkowski's memory of interviewing Kantor in 1980.

The exhibition *An Impossible Journey* is treated as a separate chapter of the book, in which Sainsbury Centre curators explain its concept, layout, as well as examining its reception and interaction with Kantor by contemporary Norfolk actors and artists. The choice of Norwich for the first retrospective of Kantor since the Whitechapel exhibition in 1976, 'impossible' as it may seem, was not coincidental. Even if neither of Kantor's journeys across Britain had led him there, George Hyde's text on translating Kantor makes a strong claim that "Kantor was

Demarco Gallery presentation of Cricot 2 Theatre in the Forresthill, Poorhouse, Edinburgh International Festival Fringe, 1972, photograph George Oliver, courtesy Demarco Archive.

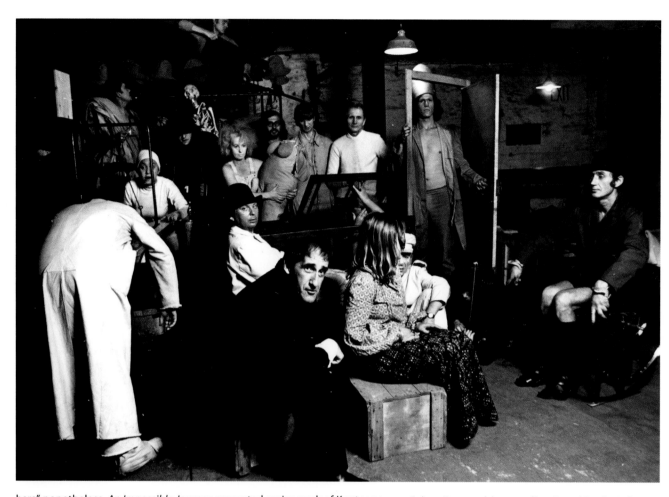

Tadeusz Kantor and the team of *Lovelies and Dowdies* in the Forresthill, Poorhouse, Demarco Gallery production, Edinburgh International Festival Fringe, August/September 1973, photograph Richard Demarco, courtesy Demarco Archive.

here", nonetheless. *An Impossible Journey* presented major work of Kantor as visual artist, including his drawings, geometrical abstraction paintings, *Informel* canvases, later artworks and a generous selection of theatrical objects, thus putting an emphasis on the significance of the static image, sketch or a figure, in Kantor's production. And this book, too, leans towards this aspect of his multi-dimensional oeuvre, often neglected in the Anglophone literature, which mostly celebrates Kantor as the man of theatre. Significantly, many of the contributors to this book are curators, art historians and art critics. Likewise, new critical texts on Kantor's art, presented at the symposium, from further generations of British scholars, led by Sarah Wilson, examine the peculiar geography of multiple borrowings and influences of Kantor's art, as well as the carnivalesque dimension of Kantor's happenings in the text by Klara Kemp-Welch. The closing essay, by Noel Witts, sums up Kantor's British journey, reflecting both on his reception in the past as well as on Kantor's living presence in drama and performance studies today. The book ends with the bibliography of books, articles and reviews of Kantor in Great Britain.

What follows is a brief overview of Kantor's journey through the British Isles, quoting the voices of critics, to tune in with two other accounts of his contacts and his reception in the UK, by Wiesław Borowski and by Noel Witts, and to complete some gaps in the fabric of the memory constructed by this book. Undoubtedly, it was Richard Demarco, an untiring and unfailing supporter of continental and Eastern European modern art, who was the agent of British-Polish *rapprochement* from the 1970s onwards, and who first 'discovered' Kantor. He financed his production and invited him to the Edinburgh Festival, introducing him to British

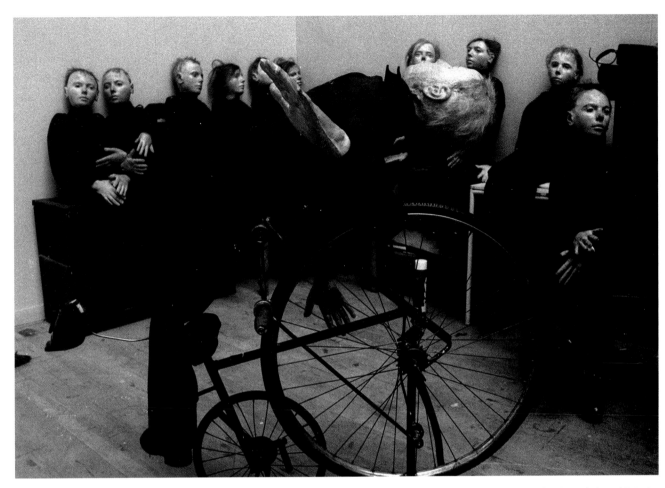

Mannequins from *The Dead Class* at the Edinburgh College of Art, August/September 1976, Demarco Gallery production, Edinburgh International Festival Fringe, photograph Ian Knox, courtesy the author, copyrights by Maria Stangret-Tadeusz Kantor and Dorota Krakowska.

audiences. An inestimable role in preparing the ground for the Polish and British avant-garde interchange, however, was played also by a Warsaw protagonist, Wiesław Borowski, who had introduced Kantor to British readers before the artist's first visit to the UK. As curator of Foksal Gallery in Warsaw, an independent exhibition venue which promoted the international avant-garde, he opened its space in the 1970s to a strong British presentation, with shows of Art & Language, Victor Burgin, John Hilliard, Ian McKeever and Michael Craig-Martin. From 1971, Borowski regularly contributed texts on Kantor and the conceptualist activities of the Foksal Gallery and on other Polish artists, to *Studio International*.[6] The journal, edited by Peter Townsend, was always sympathetic to art from behind the Iron Curtain. Hence, Borowski's text "Kantor and his British Friends" sets off the trail of memories and critical exploration here.

Kantor's visits to Britain begun in Scotland. The Cricot 2 Theatre's first performance, *The Water Hen*, at the abandoned setting of the former Forresthill, Poorhouse at the Edinburgh Festival Fringe, was a huge success. Based on Stanisław Ignacy Witkiewicz's play, the spectacle deliberately blurred the boundaries between play and happening. John Barber dubbed it "the least-publicised, most talked-about event at the Edinburgh Festival", while Richard Eyre declared in *The Scotsman* "If there is a language of modern theatre, then Kantor must surely have invented the syntax."[7] A year later, likewise on Demarco's invitation and in the same setting, Cricot 2 presented another Witkiewicz-based performance, *Lovelies and Dowdies* in 1973, which won the Scotsman Fringe Award. The performance activated the viewers' imagination by relocating the performance into an alternative area of the cloakroom, the space

"of the lowest rank", and by forcefully dragging the audiences into the spectacle. It was on this occasion, when Sandy Nairne, a young Oxford student, who helped with the production of both *The Water Hen* and *Lovelies and Dowdies*, was invited by Kantor to act as Cardinal.

In 1976 Cricot 2 went on a long six week tour around the British Isles with Kantor's most celebrated performance *The Dead Class*, which marked the beginning of his Theatre of Death. This haunting spectacle about the lost memories of a school class in a small Polish-Jewish Galician town, enacted by old people with child mannequins strapped to their backs, was performed to an unwritten 'score' conceived during the long process of rehearsals. It was controlled by Kantor appearing on stage alongside his actors, "cueing the action, the speech, the movement of the crowd, the rise and fall of waves of sound".[8] The tour began again at the Edinburgh Festival, this time in the courtyard of the Edinburgh College of Art, and generated a colossal number of reviews in major British newspapers and journals, "vied with one another in new interpretive nuances".[9] Kantor himself had no English, only French and German, but it was this English-language publicity which helped enormously, spreading his fame from Mexico City and Los Angeles to Shiraz and Tokyo. To cite Richard Calvocoressi "*The Dead Class* held Edinburgh audiences spellbound for a fortnight.... It is a terrifying twentieth century Dance of Death."[10] When the spectacle went on to the Old Fruitmarket Theatre in Glasgow, "Whatever this is, it's excellent", declared *The Glasgow Herald*, adding also "Instead of paint and canvas he uses human beings.... They do use words, in Polish naturally, but they give the impression of being used as pure sound, rather as paint might be, to express mood rather than meaning."[11] In Cardiff, where the show travelled next, the *Echo* asserted: "Cricot Theatre take drama by the scruff of its neck and flings it before the audience".[12]

The final week of *The Dead Class* tour across the British Isles ran at the newly opened Riverside Studios in London, a major avant-garde art forum. It was directed by David Gothard, who had earlier worked with Richard Demarco at the Traverse Theatre, and over the years developed a long-time friendship with Kantor and Cricot 2. Discussions about the haunting effect of the spectacle were now touching the sphere of psychoanalysis: John Elsom in *The Listener* identified the power exerted by Kantor's theatre with the sense of loss, and desire of otherness: "Kantor is evoking a lost world of Europe.... The impact of *The Dead Class*, another unforgettable production, is indeed like communing with a ghostly world, familiar, but farther from us than the moon.... Kantor shows us, with a shudder, what we are missing."[13] In contrast, for John Barber in *The Daily Telegraph*, one of Kantor's faithful reviewers, the appeal of the spectacle lay in its power to communicate with the audiences' own psyche, dragging out "our buried fears and apprehensions into the open and help us to face and understand them. At least, they make us aware we are not alone".[14] The *Morning Star* theatre critic Colin Chambers, not without reservations vis-à-vis Kantor's self-confidence, summed it all up in his way: "He appears to have synthesised a whole tradition of visual and dramatic art which can be traced through the Surrealists and Dadaists, from people like Marcel Duchamp and the English stage designer Gordon Craig to the images of Magritte, Artaud and even Genet."[15]

While *The Dead Class* was performed in Hammersmith in the evenings, Nicholas Serota, then the newly appointed Director of the Whitechapel Gallery, curated the first British retrospective of Kantor's art, *Emballages 1960–1976*. It had already been accepted by the then Director of the Whitechapel Jasia Reichardt, art critic, editor and curator, who was actively engaged in promoting Polish art in the UK.[16] The exhibition included some "theatrical objects", but was mostly devoted to the philosophy of *emballage*, conceptualised by Kantor in the 1960s to take further his search for an art which does not imitate life but reflects on reality (and art itself) through the process of packing it. *Emballage* (French for packing) was for him an entirely

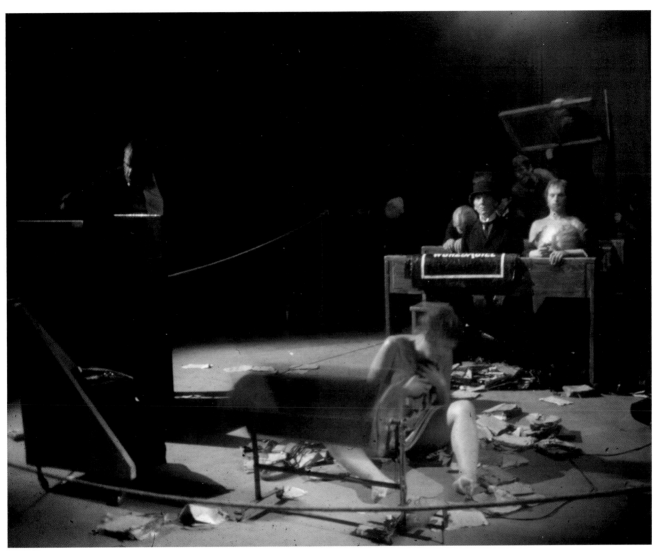

Above *The Dead Class* at Riverside Studios, London, September 1976, photograph Richard Demarco, courtesy Demarco Archive.
Overleaf Jasia Reichardt's article "Kantor's tragic theatre" in *Architectural Design*, November 1976.

new medium, a form of a time-based *collage*, exposing the desire to conceal and preserve, and arguing that art is the process of production rather than the final product, and that representation of reality, life, or another artwork, can be conjured by wrapping them closely using "poor objects", such as bags, bandages, envelopes, parcels, umbrellas or coats. The exhibition included *Multiparts*, conceptual *emballages*, drawings and the photographic documentation of *emballage* happenings, *emballage* interventions into "museum pieces", such as Velázquez's *Infanta* (*Persiflages*), as well as—most eagerly reproduced—*Man with Suitcases*, a human *emballage* alluding to a character of Edgar Wałpor from *The Water Hen*, and a figure of the boy behind the desk. The exhibition, again, was reviewed by major critics, including Caroline Tisdall in *The Guardian*, Marina Vaizey in *The Sunday Times*, Keith Roberts in *The Burlington Magazine*, by Paul Overy, noted for his keen interest in Eastern Europe, as well as by Jasia Reichardt in her column in *Architectural Design*. However, after the wave of enthusiasm for Kantor's ferocious theatre, the exhibition was seen by some critics as "predominantly meditative and forlorn". "Remove the actors and the drill and the churning music and nothing remains but Kantor props", wrote William Feaver in *The Observer*.[17] A critical analysis of the exhibition's reception, bringing in also more sympathetic voices, was written by Nicholas Serota in 2005.[18]

Kantor's tragic theatre

Tadeusz Kantor, one of Poland's most original artists, is preoccupied with worthless discarded objects which have their own desparate sort of existence. JASIA REICHARDT reviews his work, which ranges from drawings and sculpture to happenings and theatre.

Tadeusz Kantor at the age of 62 is one of Poland's most original and inventive artists. His work encompasses so many interconnecting activities that any exhibition, or theatre piece, or manifesto, is only a part of a theme which finds an outlet in several manifestations simultaneously. This is why an exhibition, albeit a comprehensive one covering a span of 30 years, cannot give a real idea of what Kantor is trying to do.

The theme explored in the exhibition at the Whitechapel Art Gallery is that of 'Emballage' — a term adopted by the artist in 1962, but referring to works produced as early as 1956. Literally, Emballage

may seem self-evident, and indeed every item does involve some aspect of wrapping, packing, folding, covering, hiding, disguising. What it really means is that the material of wrapping is not a noble object in its own right, but just the opposite. It can be cheap, vulgar and dispensable, and for Kantor the term signifies his preoccupation with the lowest form of reality: the worthless, discarded, unmentionable objects which have their own desperate sort of existence.

A good example of an Emballage and its fate is a happening of which an enlarged photograph is in the exhibition. This happening which took place in 1967 is called 'A Letter'. It involved the delivery of a 14m long letter weighing 80kg. Eight retired postmen in uniform were charged with this task, and the letter had to be carried lengthwise, i.e. with the carriers one behind the other, as stipulated by the Warsaw police, lest carried frontally it might have looked

like a demonstration banner. letter was white and bulky. Leav the sad post office in the middle Warsaw, the postmen proceeded the Foksal Gallery which was pain black inside and where a number people awaited the letter w increasing suspense. Phone calls w put through to the gallery monitori the letter's progress as the tensi mounted. When the letter arrived postmen had to struggle to get it i the small gallery through the waiti

ARTS

As people were pushed into corners and trampled by the postmen with their whole load so the mood of the slowly changed. They charged letter which by now had an instrument of torture, it and tore it to pieces, finally utely destroying it.

all happenings, this one some previous preparation most of the participants embers of the audience. When concentrated on his theatre very little was left to chance, performance of 'The dead given recently in London at erside Studios, was rehearsed year. The actors included onals and several artists. The s complex although apparently is involved is the reliving of lays by very old people. ing happens in childhood n intensity which is rarely d in later years, and so these in their dotage go through grammar lessons, birth, crucifixion, they go for walks, discover sex, and the classroom char, Death, is seen at the end as a prostitute.

It would be irrelevant to write about the theatre in the context of an artist being shown in a gallery for the first time in England if it were not for the fact that all the works in the exhibition are either studies for, or continuations of, the performances. Thus, pictures with drawings of multiple figures who are attached to objects carrying heavy loads are drawings for the characters in the performances. Even the works which exist in their own right which are combinations of paintings with assemblage attachments relate directly to the happenings, rituals and the theatre. Context is more important here than in most exhibitions. A large photograph of 'The human Emballage' in the exhibition, simply depicts Kantor and a photographer looking at a mummified, bandaged figure standing

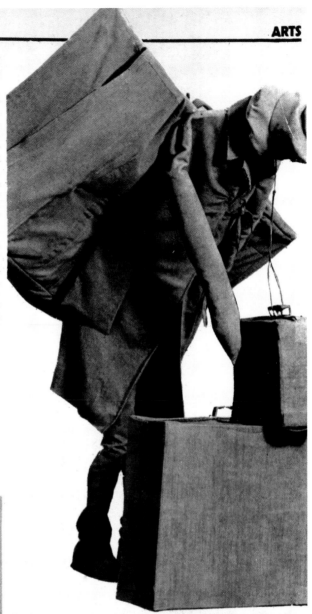

Above. *'Man with suitcases' is an Emballage in which a man and his various burdens have been made out of the same rough canvas material.*

Left. *An Emballage entitled 'Traveller' is a surrealistic fusion of a package with its means of transport.*

Far left. *In the theatre piece 'The dead class', old people relive in their dotage the classroom experiences of their youth.*

on a small pedestal. The related facts demonstrate the importance of context. The place is the site of Nurenburg Nazi rallies. From a jeep which drove Kantor around this vast expanse, the artist wrapped various columns and other protuberances with long rolls of very tough Polish toilet paper. As the jeep drove around the arena in ever decreasing circles, so it eventually approached the figure on a pedestal, that of Kantor's wife, the artist Maria Stangret, who was then also wrapped all the way round. Kantor wrote ' "The human Emballage" is a pure ritual, completely devoid of any symbolic function, it is a pure, ostentatious act.'

Nothing in Kantor's work is without some definite comment about the essential things in life, and that is why the context of his activities cannot be ignored.

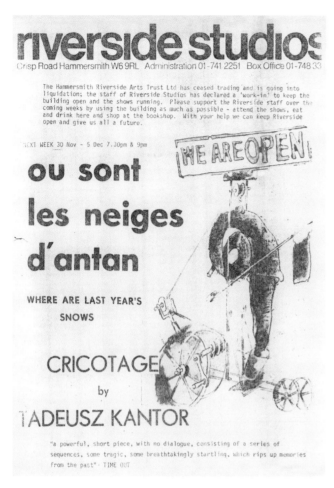

Leaflet for *Où sont les neiges d'antan* with a stamp WE ARE OPEN at Riverside Studios, London, November/December 1982, courtesy David Gothard, copyright Maria Stangret-Kantor and Dorota Krakowska.

In August 1980, during the heydays of the Solidarity revolution in Poland, Cricot 2 again took part in the Edinburgh International Festival, now included for the first time in its official programme and performed in one of its venues at Moray House Gymnasium. The spectacle, first produced in Florence, was Kantor's new autobiographical performance *Wielopole, Wielopole*, inspired by an old photograph from a family album, and located in Kantor's hometown Wielopole Skrzyńskie. Days before its running in London Riverside Studios, the performance was discussed during the *Critics' Forum* programme on Radio 3. Marina Vaizey stressed the power of the visual tableaux created by Kantor, "a camera which turns into a machine gun while shooting the picture, dummies, images… that resolve and dissolve, one into the other, I found it an absolutely gripping experience which was shared by I thought the majority of the audience…." Philip French, in charge of the programme, concurred: "it was an astonishing thing and it does stick in the mind…."[19]

Wielopole, Wielopole in Kantor's British journey opens yet another issue, that of language and the translation of his texts into English. Even if many British critics would have claimed that watching "something in a language which one doesn't understand" could be "thoroughly illuminating", bringing attention to "formal qualities of the whole… facial expression, gesture and tone of voice as vehicles of emotion and meaning", the editor Marion Boyars, after attending the spectacle, approached Kantor with a proposal of the translation of the *Wielopole, Wielopole* text into English.[20] He suggested his colleague, the art critic Mariusz Tchorek, who had lived in the UK since 1978.[21] And from that moment Norwich entered the list of cities, where Kantor's presence was intensely felt, even if Kantor had never visited it in person. Mariusz Tchorek was the co-founder of the Foksal

Tadeusz Kantor and Richard Demarco at the exhibition Witkacy
and Cricot 2 Theatre, Cricoteka, Kraków, 1985, courtesy Richard
Demarco Archive.

Gallery and the author of its theoretical Introduction to the *General Theory of Place*,
1966, which problematised the artifice of gallery space.[22] And, strangely enough,
it was this unresolved conflict with Kantor about the authorship of the concept
of 'Place', which led him to move to Norwich, England, where he lived for a quarter of
a century, working as a writer and as a University of East Anglia (UEA) counsellor,
until his premature death in 2004. He translated the book in cooperation with
George Hyde, who taught English as well as Polish literature at UEA, and who tells
us here of the illuminations, pains and perils of their shared efforts, as well as the
peculiarity of Kantor's theatre from the perspective of the translator.

1982 was the year of the final act of Kantor's British itinerary. Poland was in the
grips of martial law, and this time Cricot 2 visited only London, staying there for over
three weeks, with another round of *The Dead Class*, followed by a cricotage *Où
sont les neiges d'antan* (*Where are the Snows of Yesteryear*). At that time Riverside
Studios was experiencing acute financial problems. A few months before, Kantor
had already joined Roberto Matta, Joan Miro, Samuel Beckett, Peter Brook, Dario Fo
and Richard Rogers in signing the letter of support for the Studios, published
in *The Times*.[23] Taking part in a press conference in the Studios, he declared his
readiness to "perform even in the street"; reputedly, he also paid a visit to the Mayor
of London.[24] In 1991, after Kantor's death, Cricot 2 performed at the Edinburgh
Festival for the last time, with *Today is My Birthday*, the final spectacle created by Kantor,
who died during the rehearsals. One year later the Cricot 2 Theatre dissolved
voluntarily. The majority of the actors continued to perform on their own, many
of them involved in staging seminars and workshops disseminating Kantor's art
across the world.

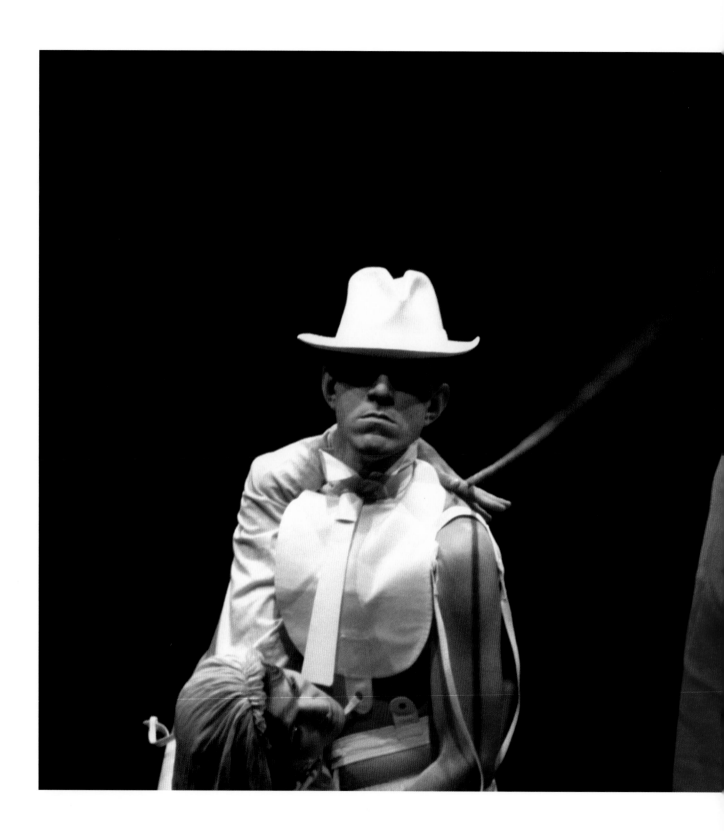

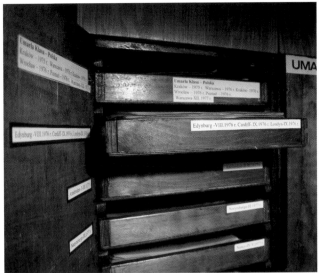

Left *Où sont les neiges d'antan*, Teresa and Andrzej Wełmiński as
The Bride and The Bridegroom and Lesław and Wacław Janicki as
The People of the Street—Cardinals, Riverside Studios, London,
November/December 1982, photograph Caroline Rose.
Top Cricoteka, the "British drawer" with reviews of *The Dead Class*
touring the British Isles in 1976, photograph Paulina Strojnowska,
courtesy Cricoteka.
Bottom Gabriella Cardazzo and Kantor in Cricoteka, during the
production of the film *Kantor*, 1986, courtesy Gabriella Cardazzo.

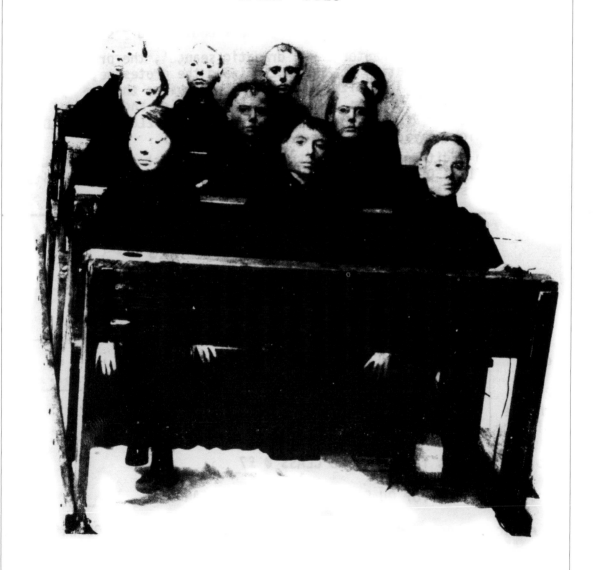

KANTOR IS HERE
17 NOV — 5 DEC

book now
RIVERSIDE STUDIOS
CRISP RD. HAMMERSMITH W6 748 3354

Leaflet for *The Dead Class* and *Où sont les neiges d'antan* at Riverside Studios, London, November/December 1982, photograph used on the leaflet by Andrzej Wełmiński, courtesy Cricoteka.

What helps significantly to keep the Kantor's memory alive is Cricoteka, a unique institution which was set up by the artist himself in 1980 with an initial aim to document the activities of Cricot 2. Its name, typically for Kantor, not only builds up on the French pedigree of the theatre's original name, but is also meaningful, as well as somewhat boastful. It elevates the Cricot 2 Theatre to a new and a distinct art form, implying that Cricot 2 constitutes a world in itself, in fact, an entirely new medium. The complexity of Cricot 2 as the medium, it suggests, composed of instances and pronouncements which are specific to it, makes it perfectly capable of giving rise to a new kind of institution, conceived especially in order to assemble and preserve its unique products, comparable to *pinacotheque, phototheque, filmotheque*.

"My last desire is, said Kantor, to preserve the memory of theatre in order to pass it onto the next generation…. I do not sense the certainty that it would be preserved…. For me, the most important are all those, so called 'props', which I call 'the objects of art'. Paintings will take care of themselves."[25]

The Cricoteka, in which paintings are indeed scarce, were set up in a Medieval house in Kanonicza Street, not far from the Wawel Castle. Its functions and its interior was not only conceptualised, but also designed by Kantor, including made-to-measure cupboards and drawers to store the documents, his notes and texts defining his art in a variety of ways, as well as books, catalogues, photographs, films and tapes, and finally the reviews from Cricot 2 performances, divided geographically into the cities which he visited. Apart from its function as the archives, Cricoteka has also offered the venue for, what Kantor called the "living art events", that is rehearsals, as well as exhibitions and lectures. It was also the place for Kantor's private meetings with other artists, friends and fans. Amongst them were many visitors from Britain, some invited by the frequent guest himself Richard Demarco, such as Gabriella Cardazzo and Duncan Ward, who made a documentary about the artist, having followed Kantor and Cricot 2 with a camera for over two years.[26] After Kantor's death, Cricoteka was renamed as the Center for the Documentation of the Art of Tadeusz Kantor, extending its activities to the entirety of his output, both in the field of theatre and the visual arts. It focused now on the task to preserve and disseminate knowledge about the extraordinary achievements of Poland's most unfathomable and most versatile artist. By publishing books and film records of Kantor's performances on DVD, as well as by arranging seminars, theatrical workshops, exhibitions and conferences on Kantor, Cricoteka has become a veritable nucleus for growing numbers of 'Kantorologists' from all over the world, including Britain.

An Impossible Journey: The Art and Theatre of Tadeusz Kantor at the Sainsbury Centre for Visual Arts in Norwich, was made possible due to Cricoteka which lent many drawings, set-designs, and the 'theatrical objects', including the dramatic installation of child mannequins sitting on school benches from *The Dead Class*. This exhibition and the symposium coincided with a recent surge of interest in Kantor in Britain, as measured by the increasing number of publications, conferences, private theatre companies, as well as graduate and postgraduate dissertation topics in British universities. Likewise, this book, which adapts the title of the Dietrich Mahlow's documentary on Kantor, *Kantor ist da*, 1968, transforming it into past tense: *Kantor Was Here*, is not just the collection of memories of Kantor's past reception in the UK.[27] The book also stakes the claim that Kantor is Here, referring on the one side to the Riverside catchphrase on leaflets promoting Kantor's visit in 1982, and, on the other side, recording the contemporary twists of the developing British branch of 'Kantorology', with its variety of foci: the rarely discussed geography of his multiple borrowings and creative adaptations, the significance of Kantor's *Informel* paintings and *emballages* for performance art, the medium of happening and installation, as well as the relationship between the specificity of Kantor's confined space and Polish language. The book's ultimate aim is to widen approaches to studying Kantor's oeuvre, which could benefit even more from as yet hardly attempted adaptation of perspectives offered by psychoanalysis, gender studies, as well as postcolonial discourse analysis.[28] The latter appears especially valid in the context of Kantor's emphasis on the values

of multi-ethnic and multi-confessional Central Europe, as well as his obsessive attention to the marginal, the degraded, the excluded, the impure and undecidable.

The publication of this book would not have been possible without a very generous support from the Adam Mickiewicz Institute in Warsaw, the organiser of Polska! Year, which promoted Polish culture in the UK, 2009/2010. The IAM not only offered grants for the exhibition, the symposium, and the book, but it also supported and encouraged us all the way through. Our special thanks go to the Coordinator of Polska! Year Aneta Prasał-Wiśniewska and to Anna Mroczkowska.

We would like to thank the following individuals and institutions for making the book possible. Above all, our thanks go to Nichola Johnson, the then director of the Sainsbury Centre for Visual Arts at the University of East Anglia, Norwich, and to the Head of Collections and Exhibitions Amanda Geitner, for their initiative to take on the task to stage the Kantor exhibition. We want to extend our thanks also to Veronica Sekules, Sarah Bartholomew and Jo Geitner, who designed the layout of the exhibition, as well as to Jonathan Holloway of Norfolk & Norwich Festival, Lynda Morris, Eva Oddo, Natalia Svolkien, Jarosław Suchan, Director of Muzeum Sztuki w Łodzi, and to all those who have been involved in Kantor events which eventually led to the book.

For their help given to our research in the archives in London and Edinburgh, we would like to thank the Director of the Polish Cultural Institute in London Roland Chojnacki, to Jo Melvin, Gary Haines at Whitechapel Gallery, and to Janis Adams, Ann Simpson and Kirstie Meehan at the Scottish National Gallery of Modern Art and the Dean Gallery. Our special thanks go to Terry Ann Newman, Deputy Director of the Demarco European Art Foundation, Arthur Watson and Euan MacArthur at the University of Dundee Archive and Chris Pearson at the Giclée UK Limited for their invaluable advice and assistance in searching the Richard Demarco Archives, as well as to Katarzyna Krysiak and Lech Stangret at the Foksal Gallery, Piotr Kłoczowski and Słowo/obraz terytoria publishing house, and to Uta Schorlemmer, whose book on Kantor's reception in Germany and Switzerland, formed a model for this volume. The list of people who helped us on various stages of the production of the book is long, but we would like to extend our thanks to Tomasz Tomaszewski as well as to the staff of Cricoteka: Anna Halczak and Józef Chrobak, Bogdan Renczyński, Jan Raczkowski. Finally, we would like to thank all the contributors of the book and, last but not least, the dedicated staff of Black Dog Publishing Limited, led by Duncan McCorquodale.

Finally, we want to thank all those who gave us permission to reproduce images in this volume: above all to Maria Stangret and Dorota Krakowska, and to those who lent their objects to the exhibition, namely to The National Museum in Kraków, The Historical Museum of the City of Kraków, Muzeum Sztuki w Łodzi, The National Museum in Poznań, Neues Museum in Nürnberg, Whitechapel Gallery in London, Whitechapel Gallery Archive, Gallery Starmach, Kraków, Richard Demarco and The Demarco European Art Foundation, The Tchorek-Bentall Foundation, Maria Stangret, Dorota Krakowska, Anna Halczak, Erica Bolton, Krzysztof Bieńkowski, Stefan Derędowski, David Gothard, Ian Knox, Sandy Nairne, Rebecca O'Brien, Hanna Ptaszkowska, Jasia Reichardt Archive, Dr Karl Gerhard Schmidt.

NOTES

1 The Unilever Series: Miroslaw Bałka *How It Is*, London: Tate Modern, October 2009–April 2010; Bloomberg Commission: Goshka Macuga: *The Nature of the Beast*, London: Whitechapel Gallery, April 2009–April 2010. British artists are regularly shown by the Centre for Contemporary Art Ujazdowski Castle, including Tony Craig, 1997, Sam Taylor-Wood, 2000, Darren Almond, 2007; *No such thing as society,* British photography, 2008.

2 The term Cricot 2, refers to the first theatre company named Cricot, set up by painters and actors in Kraków in 1931, and, reportedly, is an anagram of Polish *to cyrk* (it's a circus), rendered however in francophone module, by replacing 'y' and 'k' with 'i' and 'c', subsequently.

3 Borowski, Wiesław, *Tadeusz Kantor*, Warsaw: Wydawnictwa Artystyczne i Filmowe, 1982; Kobialka, Michal, ed., Kantor, Tadeusz, *A Journey Through Other Spaces*, Berkeley/Los Angeles/London: University of California Press, 1993; Pleśniarowicz, Krzysztof, *The Dead Memory Machine: Tadeusz Kantor's Theatre of Death*, Aberystwyth: Black Mountain Press, 2000; Suchan, Jarosław, ed., *Tadeusz Kantor: Niemożliwe/Impossible*, Kraków: Bunkier Sztuki Galeria Sztuki

Wspólczesnej, 2000; Miklaszewski, Krzysztof, *Encounters with Tadeusz Kantor*, George Hyde, ed. and trans., London and New York: Routledge, 2002; Suchan, Jarosław and Marek Świca, eds, *Tadeusz Kantor. Interior of Imagination*, Warsaw: Zachęta/Kraków: Cricoteka, 2005; Kobialka, Michal, Further On, *Nothing: Tadeusz Kantor's Theatre*, Minneapolis: University of Minnesota Press, 2009; Witts, Noel, *Tadeusz Kantor*, London and New York: Routledge, 2010.

4 A similar idea has guided the pioneering volume edited by Uta Schorlemmer, *Kunst is ein Verbrechen. Tadeusz Kantor, Deutschland und die Schweiz. Errinerungen—Dokumente—Essays—Filme auf DVD,* Nuremberg, Kraków: Verlag für moderne Kunst, Cricoteka, 2007. Its Polish edition: Schorlemmer, Uta, ed.,"*Sztuka jest przestępstwem." Tadeusz Kantor a Niemcy i Szwajcaria. Wspomnienia—dokumenty—eseje—filmy na DVD,* Nuremberg: Verlag für moderne Kunst/Kraków: Cricoteka, 2007.

5 Murawska-Muthesius, Katarzyna, *An Impossible Journey: The Art and Theatre of Tadeusz Kantor*, exhibition leaflet, Norwich: Sainsbury Centre for Visual Arts, University of East Anglia, 2009.

6 Borowski, Wiesław, "Tadeusz Kantor and his 'Cricot 2' Theatre", *Studio International*, vol. 187, January 1974, pp. 22–23; Borowski, Wiesław, "To Paint Anew: Thought from Warsaw", *Studio International*, vol. 196, January/February 1983; Borowski, Wiesław, "The Paintings from Chłopy of Andrzej Szewczyk" [Review: Warsaw], *Studio International*, vol. 196, April/May 1983; Borowski, Wiesław, "Tadeusz Kantor's 'Où sont les neiges d'antan'", Warsaw/London February 1981 [Riverside Studios London: performance], *Studio International,* vol. 196, April/May 1983, p. 51.

7 Eyre, Richard, "Inside the Human Corral", *The Scotsman*, 21 August 1972.

8 Caplan, Leslie, "Ambiguity in the grotesque", *The Times Higher Education Supplement*, 24 September 1976.

9 Miklaszewski, p. 51. For excerpts of some other British reviews, as well as French, Iranian and American, see the chapter "Around the World with *The Dead Class*", pp. 47–67.

10 Calvocoressi, Richard, "Edinburgh Festival: Tadeusz Kantor: Cricot 2 Theatre", *Studio International*, vol. 193, January 1977, pp. 45–46.

11 AW, "A painting comes alive", *Glasgow Herald*, 23 August 1976.

12 Elwell, Julia, "Puppets on the string of life", *Echo*, 9 September 1976.

13 Elsom, John, "Décor by Babel", *The Listener*, 2 September 1976.

14 Barber, John, "Digging up Our Buried Years", *The Daily Telegraph*, 6 September 1976.

15 Chambers, Colin, "Experiments in the Polish experience", *Morning Star,* 20 September 1976.

16 Jasia Reichardt, of Polish origin, was Assistant Director of the ICA in London, 1963–1971, Director of the Whitechapel Gallery, 1972–1974, has taught at the Architectural Association, and published widely on the links between art and other disciplines, especially science and technology. Her exhibitions as well as her column *Art* in *Architectural Design* in the 1970s did much to promote Polish art in the UK. Unfortunately, she could not be contacted by the editors.

17 Feaver, William, "Painting prose", *The Observer Review*, 17 October 1976.

18 Serota, Nicholas, "Tadeusz Kantor at Whitechapel", in Suchan and Świca, pp. 122–125.

19 Transcript of *Critics' Forum* broadcast on Saturday, 30th August, 1980, BBC; manuscript in the collections of Cricoteka.

20 Calvocoressi, p. 46; A.G., "Polish Play beats Language Barrier", *The Glasgow Herald*, 7 September 1973.

21 In fact, Kantor was planning to publish his texts and manifestoes in English, corresponding about this idea with Mariusz Tchorek since the late 1970s, and authorising him, in 1980, to be the sole translator of his texts into English, and in particular of *Wielopole, Wielopole*. A detailed correspondence is preserved in the hardly explored archives of The Tchorek-Bentall Foundation in Warsaw.

22 For the English translation of Mariusz Tchorek's text, see Borowski, Wiesław, Hanna Ptaszkowska, Mariusz Tchorek and Andrzej Turowski, "Foksal Gallery Documents", *October*, vol. 38, Autumn 1986, pp. 52–62. See also Chmielewska, Ella, Agnieszka Chmielewska, Mariusz Tchorek, Paul Carter, "A Warsaw Address: a dossier on 36, Smolna Street", *The Journal of Architecture*, vol. 15, issue 1, February 2010, pp. 7–38; Polit, Paweł, "Warsaw's Foksal Gallery 1966–1972: Between PLACE and Archive", *Artmargins*, January 2009, http://www.artmargins.com/index.php/featured-articles/179-foksal-gallery-1966-72-between-place-and-archive, accessed 20 July 2010.

23 "Riverside Studios", *The Times*, 9 June 1982.

24 Miklaszewski, Krzysztof, "Przykazanie X: Może ja jestem kopnięty, ale wy wszyscy—też!", *Tadeusz Kantor: Między śmietnikiem a wiecznością*, Krzysztof Miklaszewski, ed., Warsaw: Państwowy Instytut Wydawniczy, 2007, pp. 265–269; Janiccy, Wacław and Lesław, *Dziennik podróży z Kantorem*, Kraków: Wydawnictwo Znak, 2000, pp. 125–128.

25 Halczak, Anna, *Cricoteka,*Warsaw: Biblioteka Narodowa/ Cricoteka, 2005, p. 32.

26 Ward, Duncan and Gabriella Cardazzo (directors), *Kantor*, London: Filmmakers, 1987, 35 min..

27 Mahlow, Dietrich (director), *Kantor ist da: Der Künstler und seine Welt*, Saarländischer Rundfunk, 1968, 46 min..

28 See Zarzecka, Natalia and Michal Kobialka, *Tadeusz Kantor: Twenty Years Later, a special issue of Polish Theatre Perspectives*, vol. 2, no. 1, Spring/Summer 2011 (forthcoming).

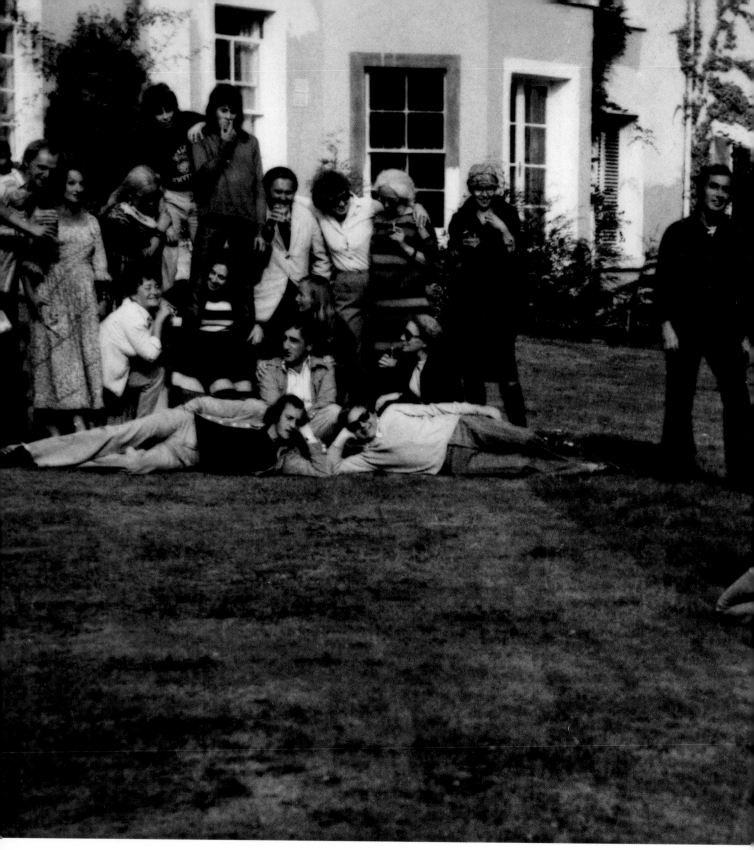

Cricot 2 and Tadeusz Kantor in the garden of Kerfield, Peebles, August/September 1976.
Matilda O'Brien hosted Tadeusz Kantor and the Cricot 2 team in her house near Edinburgh, photograph taken by Matilda's son Peter O'Brien, courtesy Peter O'Brien (caption Jo Melvin, hereafter JM).

TADEUSZ KANTOR AND HIS FRIENDS IN THE UK

WIESŁAW BOROWSKI

When the well-known art critic and curator Teresa Gleadowe, on one of her frequent visits to Poland, was asked by a journalist from Warsaw as to when she had become aware of the existence of a Polish contemporary art, she answered with just one word: "Kantor".

In my essay I am not going to focus just on Kantor, but I am going to write about those people I met in Great Britain, to whom both Kantor and the Cricot 2 Theatre owe a very great deal. Here then, is a handful of my memories.

Richard Demarco arrived in Warsaw, in the Foksal Gallery, for the first time in the Autumn of 1971. Pointing to the "poor degraded" objects in the Gallery, such as a metal barrel, hermetically sealed and hanging on a thick chain, bearing an inscription "To be opened in 1984", he exclaimed "All these should enter the collections of the National Museum! Instead of those propagandistic paintings." All of us were both totally overwhelmed by this statement and a little bit perturbed at the same time, as Richard Demarco was in the company of a 'guard' from the Ministry of Art and Culture. The metal barrel was made by Tadeusz Kantor and it was a left-over of an earlier action in the Gallery. It was not likely that the inscription "the year 1984" on its surface would be associated by anybody with George Orwell who at that time was hardly known in Poland. But Richard's enthusiasm won over all our anxieties. Without delay we went to Kraków, where Richard met Kantor and his Theatre Cricot 2, attending the spectacle of *The Water Hen* after Witkacy. He announced right away "This has to be shown at the Edinburgh Festival." And it was. What followed is widely known. The Cricot 2 Theatre, totally unknown in Britain, performed in Edinburgh in 1972, achieving its first success abroad. The theatre critic John Barber wrote in *The Daily Telegraph:* "Apart from Kantor, the official programme of the Festival turned out to be miserably orthodox." Richard Demarco was the first and the most crucial figure to introduce Kantor and his theatre to the British art world.

In August 1973, again invited by Demarco, Tadeusz Kantor and the Cricot 2 Theatre, arrived in Edinburgh with a new spectacle *Lovelies and Dowdies*. All performances were held in the Poorhouse, an amazing venue and a veritable *objet trouvé*, which was adapted especially for Kantor's theatre.

During the heated preparations for the first night we received a lot of help from many people. Amongst them, there was a nice, tall young man—Sandy Nairne. He was fascinated by Kantor, who, in turn, as it soon turned out, made a very good use of this. I then played the role of the millionaire in *Lovelies and Dowdies*. Even if Kantor kept praising me, claiming that, it was my very helplessness on stage which was precisely what he needed, I have never been comfortable in my role as an actor. Neither did I want, nor did I know how to be an actor. After a week, for personal reasons, I had to leave Edinburgh and Kantor gave my role to Sandy Nairne, for whom it was also his first appearance on stage. He was the only British actor who performed in the Cricot 2 Theatre. Sandy, who went on to become the Director of the Institute of Contemporary Arts (ICA), and, among others things, had a high position in Tate, and then became the Director of The National Portrait Gallery, has kept his fascination with Kantor until today. He also visited Kantor in Kraków, manifesting on many occasions, his friendship and support for Kantor's art—and for all of us.

Joseph Beuys, and with him, Caroline Tisdall, came to Edinburgh while we were there. The first meeting between Kantor and Beuys took place thanks to Caroline. Rehearsals at the Poorhouse were very tense. Kantor, agitated, was interfering loudly, when Beuys appeared with Demarco and asked: "Has anything happened, could I help?" After a short while, both of them, smiling, threw themselves in each other's arms, as old friends. During the spectacle, I was sitting next to Beuys who said when the performance ended: "This is a great work, but 15 minutes too long." Beuys visited us in the home of Demarco's friends where we stayed, together with two actors of the Cricot 2 Theatre, Romand Siwulak and Andrzej Wełmiński. They were also visual artists. The conversation was long, but it focused on Kantor only at the beginning. "Kantor is a great artist and he will be all right", said Beuys and turned his attention to those two young actors. He asked them in detail about their activities, gave them a long speech about art, treating them as colleagues. I think they still remember

this meeting today. Beuys stayed at the time in Edinburgh for a while, having been invited, of course, by Richard Demarco. In one of the art schools, he was giving his famous lecture without an end, during which he was drawing and writing on black boards, frequently changed for him. Later, in 1981, Beuys annexed the poor door which led directly from the street to the Poorhouse, and, at that time, still had the remnants of Kantor's theatre posters stuck on it. The door became a part of his work entitled *Poorhouse Door—A new beginning is in the offing*.

Kantor was also involved in a private dialogue with Beuys. Caroline Tisdall, an art critic at *The Guardian*, wrote a number of texts on Kantor's theatre and art. She made friends with many of Kantor's actors and had always shown us her hospitality. Apart from art, she was also interested in politics and social issues. She visited Warsaw accompanied by her husband in 1985, shortly after the end of martial law. This was an anxious time in the city, the crowds were visiting the tomb of the Reverend Popiełuszko in the Żolibórz district of Warsaw, who had been murdered in cold blood by the state security. Caroline was very keen on going there too and this is what we did. Joseph Beuys had already visited Poland in 1981, during the Solidarity period. He brought then a set of his works entitled *Transport to Poland (Polen-Transport)* as his gift for the Muzeum Sztuki w Łodzi. A result of our meeting in Edinburgh was his exhibition at the Foksal Gallery.

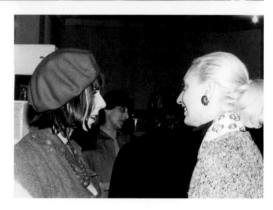

Top left Wiesław Borowski at the Demarco Gallery, Edinburgh Arts 1973, photograph Richard Demarco, courtesy Richard Demarco Archive.
Top right Tadeusz Kantor and Richard Demarco at Riverside Studios, London, 1976, photograph Chris Harris, courtesy David Gothard.
Bottom Rebecca O'Brien left and Erica Bolton in conversation at Riverside Studios in 1976, photograph Chris Harris, courtesy David Gothard (JM).

The Cricot 2 Theatre's next visit to Britain, in the summer of 1976, began, traditionally, from Edinburgh. Kantor's new spectacle *The Dead Class*, was met with wide interest by the British media, and was to be remembered for a long time by critics and audiences. This time, the whole team was put up in the nearby village Peebles, to which we were transported from Edinburgh by coach. Kantor and several actors stayed in a beautiful house belonging to Matilda O'Brien. What a house it was! Open and hospitable, it was located in the beautiful countryside around Peebles, on the river Tweed. Kindness and sincere friendship, shown to us by Matilda and her two daughters, who came up from London, created an unforgettable, almost family atmosphere.

Old friends of the Cricot 2 Theatre, as well as critics, including Neal Ascherson, and collectors, such as Panza di Biumo, kept coming to Edinburgh, sometimes even to Peebles. All of them wanted to "see Kantor" and to visit Kantor. Conversations about Kantor never ended. Amongst them, the most important people for the future reception of Cricot 2 in Britain were Erica Bolton and David Gothard. It is they who arranged spectacles in London, which had already been announced. From the start, their relationship with Kantor and his team were not only professional, but also deeply personal. David—a spontaneous character and a mildly ironising intellectual at the same time—had already been cooperating with Kantor when he

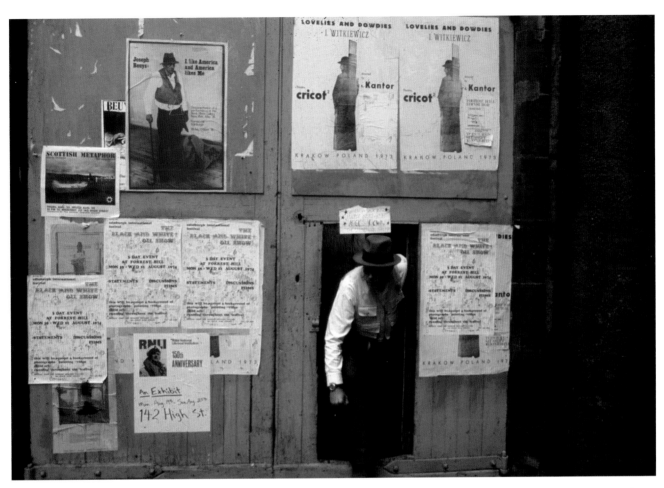

Joseph Beuys emerging from the Forresthill, Poorhouse, at the time of Edinburgh Arts 1974. Posters on the doors advertise performances by Joseph Beuys and *Lovelies and Dowdies* of Cricot 2, photograph Richard Demarco, courtesy Demarco Archive.

worked in the Richard Demarco Gallery. He was always around, but would often disappear from sight. Erica, a beautiful lady with blond hair, worked as Manager of Riverside Studios, a new art venue which was being set up in London. She was in charge of the negotiations with Kantor, combining her impeccable manners with an extraordinary simplicity and naturalness. She was always loaded with folders full of papers—plans of the stage and auditorium, prospectus', contracts and photographs—and she conducted all the conversations and recorded all the details with a rare precision and sensitivity. Since then, David and Erica, as well as the Cricot 2 Theatre, were going to be associated with *Riverside Studios* in Hammersmith.

During the performances of *The Dead Class* in London, Nicholas Serota, then the Director of Whitechapel Art Gallery, organised a large exhibition of the art of Tadeusz Kantor, showing his series of *Emballages*, in September 1976. Nick, by then, already a legendary personality of the British art world (soon its 'number one') presented to the British public another aspect of Kantor's creativity, alongside his theatre. For many days, both masters, each in his own field, were working together on this perhaps most significant exhibition of Kantor's paintings abroad, methodically and patiently, even if not without small controversies.

The Cricot 2 Theatre kept returning to the Riverside Studios with new performances, and with *The Dead Class*, in 1982. Almost every night amongst the spectators was the remarkable Italian composer Luigi Nono, who then lived in England. We remembered him from his first concerts in Poland in the 1950s, given during the International Festival of Contemporary Music, 'Warsaw Autumn'. I asked him why he comes every night to *The Dead Class*. "Because of Kantor's music", he answered.

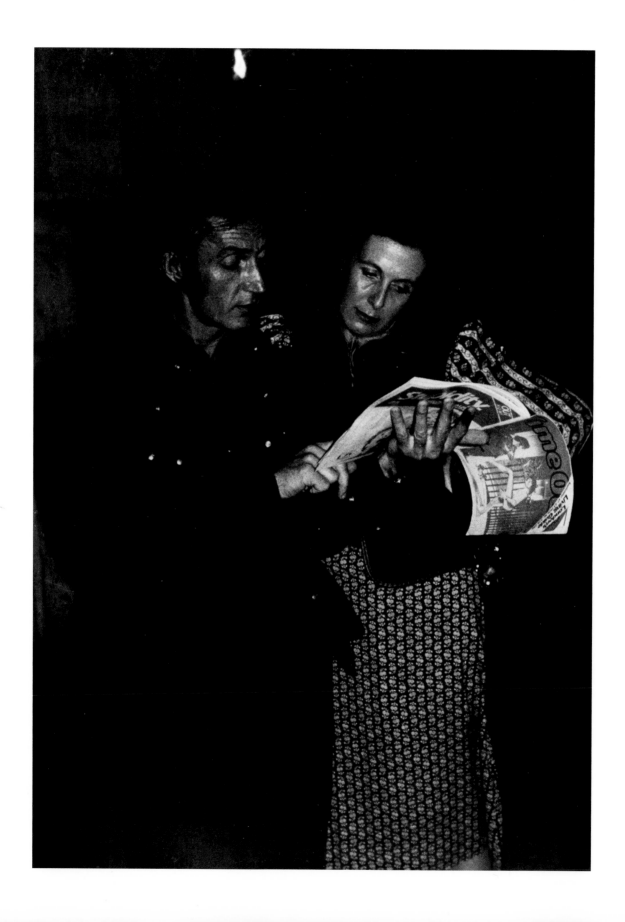

Opposite Wiesław Borowski and Matilda O'Brien were at Riverside Studios during Cricot 2's first appearance in London with performances of *The Dead Class*. They are reading a review of *The Dead Class* in *Time Out*, photograph Chris Harris, courtesy David Gothard (JM).
Above David Gothard seated in Studio 1 at Riverside. The performances of *The Dead Class* took place in Studio 2 looming into Studio 1 through the open double doors, photograph Ian Knox, courtesy Ian Knox (JM).

Two years earlier, when the Riverside Studios hosted *Wielopole, Wielopole*, the editor Marion Boyars approached Kantor with a proposition to publish the script of this spectacle with his commentaries in English. The translation was entrusted to George Hyde, Professor of Literature at the University of East Anglia and to Mariusz Tchorek. The process of translation and editing took a long time and this beautiful book was eventually published in 1990, when Kantor was still with us.

I still have this book, with Mariusz's dedication. Mariusz was my great friend. He was the major author of the first manifesto of the Foksal Gallery in Warsaw, which we set up together with Anka Ptaszkowska in 1966. After his departure from Poland in 1970, I saw him again, only ten years later, at the performance of *Wielopole, Wielopole* in London. He had already settled in Norwich and he invited me to stay with him. I visited Mariusz in Norwich twice, and stayed in his house for many days, which I will not forget. We talked about everything, about his passions and interests in art, life and psychotherapy, and about what had led him to come to Norwich. His intellect was probing and original in everything he was doing. He wrote extraordinary brilliant texts, amongst others about Witkacy, Gombrowicz, Strzemiński and Stażewski. Kantor remained for Mariusz an enigma and a problem throughout all his life.

Translated by Katarzyna Murawska-Muthesius

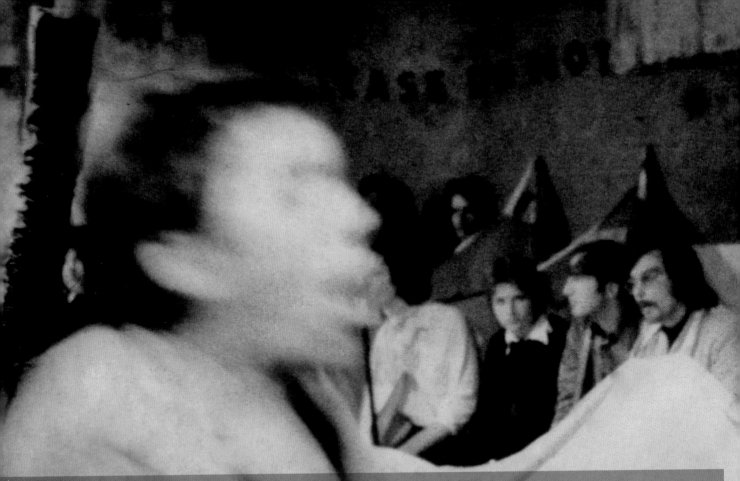

20.08–27.08.1972

Edinburgh International Festival, The Fringe
Forresthill, Poorhouse
Performances of *The Water Hen* after
Stanisław Ignacy Witkiewicz
Additional performance filmed by Scottish
Television at Gateway Television Studios

20.08–9.09.1972

The Richard Demarco Gallery *Atelier 72*
Exhibition of 43 contemporary Polish
artists including Tadeusz Kantor,
with Muzeum Sztuki w Łodzi

19.08–8.09.1973

Edinburgh International Festival, The Fringe
Forresthill, Poorhouse
Performances of *Lovelies and Dowdies*
after Stanisław Ignacy Witkiewicz
Awarded with Fringe First

12.09–14.09.1973

Glasgow, Fruit Market
Performances of *Lovelies and Dowdies*
after Stanisław Ignacy Witkiewicz

18.08–04.09.1976

Edinburgh International Festival,
The Fringe
Edinburgh College of Art
Performances of *The Dead Class*
Awarded with Fringe First

08–09.1979

Edinburgh, Gladstone Court
*Ten Polish Contemporary Artists from the
Collection of Muzeum Sztuki w Łodzi*
Group exhibition including Tadeusz
Kantor's works set up by Richard
Demarco Gallery

26.08–30.08.1980

Official Edinburgh International Festival
Moray House Gymnasium
Performances of *Wielopole, Wielopole*

23.08–27.08.1991

Official Edinburgh International Festival
Empire Theatre
Performances of *Today Is My Birthday*
Cricot 2's last production premièred in
January 1991, after Tadeusz Kantor's death
on 8 December 1990

EDINBURGH AND GLASGOW

Demarco Gallery presentation of *Lovelies and Dowdies*, Edinburgh,
Forresthill, Poorhouse, Edinburgh International Festival Fringe, August/
September 1973, from the right: Kantor, Tina Brown and Sean Connery,
photograph Richard Demarco, courtesy Demarco Archive.

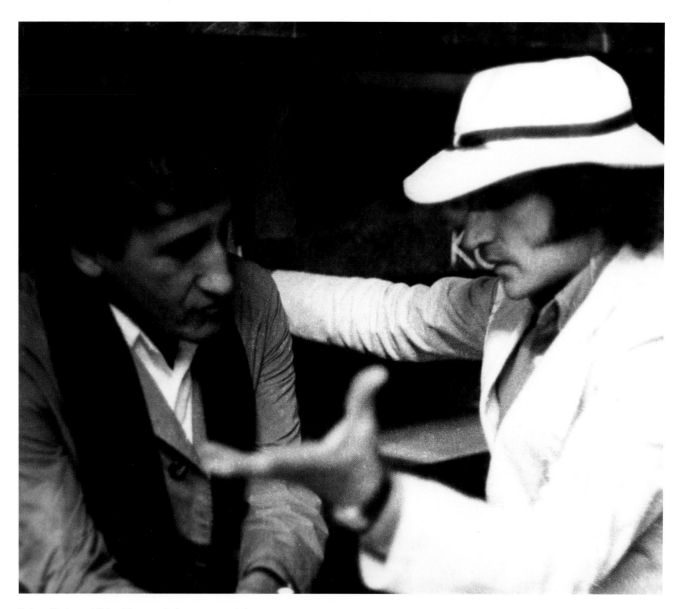

Tadeusz Kantor and Richard Demarco in the greenroom during
the Demarco Gallery production of *The Water Hen* at the Forresthill
Poorhouse , Edinburgh International Festival Fringe, August 1972,
photograph Richard Demarco, courtesy Demarco Archive.

TADEUSZ KANTOR'S CRICOT 2 THEATRE AT THE EDINBURGH FESTIVAL

RICHARD DEMARCO

First of all, I must say how pleased I am to be contributing alongside my friends who played leading roles in establishing the reputation of Tadeusz Kantor and the Cricot 2 Theatre in the English-speaking world under the aegis of the Edinburgh Festival.

Of course, I am referring to Wiesław Borowski and Sandy Nairne. They both performed as actors under the direction of Tadeusz Kantor in the Cricot 2 Theatre production of Witkiewicz's play *Lovelies and Dowdies*, and to David Gothard who brought the 1976 Cricot 2 production of *The Dead Class* to the Riverside Studios in London.

Tadeusz Kantor and Joseph Beuys had much in common; against the odds, they both survived the agony of the Second World War. They were both inspirational teachers, and it would be wise to ignore the rumours that they are dead and gone. Both are very much alive as twenty-first century artists—as heroic defenders of truths ignored by the massed battalions proclaiming the falsehoods inherent in postmodernism. They have both escaped the narrow confines of art history to become worthy personifications of the cultural heritage of post-war Europe. Perhaps the most important aspects of their work which they have in common are related to the fact that they both defied easy and neat categorisations. They tested themselves and those around them to the breaking point.

In 1972, I presented an exhibition for the Official Edinburgh Festival. It was entitled *Atelier 72*. It was dedicated to the post-Second World War Polish avant-garde. It was the third part of an exhibition programme designed over a period of the four years, 1970, 1971, 1972 and 1973, to focus attention on the impact of the Cold War on the artists imprisoned behind the Iron Curtain. All the members of the Cricot 2 Theatre company were listed as *Atelier 72* visual artists involved in making manifest Tadeusz Kantor's interpretation of Stanislaw Ignacy Witkiewicz's play *The Water Hen*.

I wanted the Edinburgh Festival to provide a four-stage programme under its international spotlight which would establish a cultural dialogue between Western Europe and its counterpart on the wrong side of the Berlin Wall.

The first stage of the programme was an exhibition devoted to the art world of Düsseldorf as a city in 1970 then challenging the supremacy of New York as the world capital of the visual arts. Among the 32 artists represented was Joseph Beuys. In collaboration with Henning Christansen, the Danish artist-composer, Beuys created what he called "an action" entitled *Celtic Kinloch Rannoch: The Scottish Symphony*. This was inspired by the Christian world of St Columba on Iona and the Ossianic mythology associated with Fingal's Cave on Staffa and Mendelssohn's *Hebrides Overture*. The Beuysian concept of a 'symphony' was essentially a 'requiem' for all the artists Beuys regarded highly from the Italian Renaissance to the Russian Revolution—from Da Vinci to Malevich.

The second stage in 1971 was defined by an exhibition showing the spirit of the Romanian avant-garde focused on Bucharest. This brought artists of the calibre of Paul Neagu, Horia Bernea, Ovidiu Maitec, Pavel Ilie and Ion Bitzan to Edinburgh: five artists well prepared to produce art with a spiritual quality embedded in Romanian folk culture in the tradition established by Brancusi.

As the third stage, *Atelier 72* encapsulated a spirit of avant-gardism that withstood the tragic history of Poland between the two World Wars. It was inspired by the extraordinary collection of avant-garde art to be found in the Muzeum Sztuki in Łódź, a collection which benefited from the support by artists of the calibre of Pablo Picasso, Hans Arp, Kasimir Malevich, Katarzyna Kobro and Władysław Strzemiński. Ryszard Stanisławski was the director of the Muzeum Sztuki. It must be said that without

Tadeusz Kantor, *À Richard—Tadeusz*, drawing, 29 August 1972, courtesy Richard Demarco, copyright Maria Stangret-Kantor and Dorota Krakowska.

his inspirational role as the acknowledged expert on the modernist movement in the international art world, the exhibition would not have materialised. For *Atelier 72*, Tadeusz Kantor was represented by his Cricot 2 Theatre and by an installation entitled *A Demarcation Line*. He expressed it simply as a drawing of a line with a list of words on either side defining human types populating the art world of Poland. He chose to entitle it "a demarcation line" which in his words "must be made quickly and firmly as it will function anyway whatsoever we choose to do—automatically and relentlessly leaving us on this side or the other". This *Demarcation Line* is identified as an art work explaining the ethos of the Gallery Foksal.[1] It summed up this gallery's history and its *raison d'etre*. It was used by Kantor as a space of experimentation so that, through the genius of Kantor, it was recognised as a work of art in itself. As I speak, I am conscious of the fact that I am in the presence of the

Foksal Gallery director Wiesław Borowski and that we must acknowledge the important role played by Mariusz Tchorek who chose to live a significant part of his life in Norwich. It was he, together with Wiesław Borowski and Anka Ptaszkowska, who brought the Foksal Gallery almost miraculously into being, coinciding with the Demarco Gallery's first year of existence in the early 1960s.

On the left-hand side of the Demarcation Line were "the backward—the presumptuous, the settled, the judges, the opinion-makers—the continuators cultivating their line and their individualities—*ciquettes* propagating thoughtlessly and alarmingly pseudo avant-garde-mass producing with consent, and unanimously, battering on myths and all kinds of sanctities."

On the right hand side, Kantor listed the following words: "the few, the unofficial, the neglected, refusing prestige, not afraid to be ridiculous, the risk-taking, impossible."[2]

By drawing his line on a blank plastered surface of a stone wall and across a stone floor, Kantor made it perfectly clear that the twentieth century art world, whether located in the East or West of the Iron Curtain, was really more seriously divided by a line which separates the true from the false avant-garde. He was thinking of those artists who had inspired him—Stanisław Ignacy Witkiewicz, Stanisław Wyspiański, Witold Gombrowicz and Bruno Schulz. They lived and worked through troubled and testing times and were far removed from a world now dominated by gallery and theatre directors who believe that the role of the artist is that of a celebrity hell-bent on a career of fame and fortune.

A Demarcation Line was an affirmation which I accepted as a statement of Kantor's preparedness to work under the aegis of the Demarco Gallery defending the values and aims of the Foksal Gallery. A few years later, he was awarded the Rembrandt Prize for his outstanding gifts as a painter at a time in which he found himself regarded as an extraordinary man of theatre working with his friends and the gifted artists who comprised what he chose to call Cricot 2 Theatre.[3] Kantor thus made clear the role of the artist as sculptor or painter preferring to work outside the walls of a gallery or studio. He gave the Cricot 2 members the right to be identified closely with the Polish theatre world as personified by Witkiewicz.

In 1973, I presented an Edinburgh Festival experimental Summer School programme inspired by the Bauhaus and Black Mountain College. Tadeusz Kantor, Joseph Beuys, Marina Abramović, Hans Hollein, Paul Neagu, Roland Penrose, Norbert Lynton, Peter Selz, George Melly, and Hugh MacDiarmid were among those I chose as teachers. I gathered the students together from art schools in North America and Europe. They, together with Beuys and Kantor, collaborated in the Cricot Theatre production of the Witkiewicz play *Lovelies and Dowdies*.

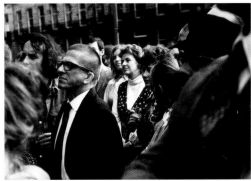

Opposite *Atelier 72* exhibition poster, The Demarco Gallery, Official Edinburgh Festival, August/September 1972, courtesy Demarco Archive.

Top Joseph Beuys during his performance of *Celtic Kinloch Rannoch: The Scottish Symphony*, presented for the Official Edinburgh Festival by the Richard Demarco Gallery. The work is entitled *Where are the Souls of the Departed?* by Johannes Stuttgen, *Strategy: Get Arts* exhibition, August 1970, photograph Richard Demarco, courtesy Demarco Archive.

Bottom Ryszard Stanisławski at the opening of the *Atelier 72* exhibition at the Richard Demarco Gallery, Official Edinburgh Festival, August 1972, photograph Richard Demarco, courtesy Demarco Archive.

KANTOR

Tadeusz Kantor

A DEMARCATION LINE

A DEMARCATION LINE

A DEMARCATION LINE
must be made everywhere and always
quickly and firmly,
as it will function anyway
whatever we choose to do,
automatically
and relentlessly,
leaving us
at this side or the other.

if we make it
we shall have an impression
of a free choice
or an awareness of necessity,
even if we are the losers.

a demarcation line
emerges always and everywhere
it performs all possible roles
it assumes all possible forms
it is eternal
and immoral.

Backward
Presumptuous
settled
taking their seats
judges
jurors
opinion-makers
decision-makers
continuators
cultivating
their line
and their
individualities

ciquettes
pseudo-avant garde
propagating
thoughtlessly
and alarmingly
pseudo-avant garde
mass-producing
with consent
and unanimously

pseudo-avant garde
tamed
and legitimate
with testimonials
and credentials
battening on
myths
and all kinds of
sanctities
sinister
shamans
missionaries
prosperous
quack

the few

the unofficial

the neglected

refusing prestige

not afraid to
be ridiculous

the risk-taking

disinterested
but completely
without a chance
to be applied
or adjusted

without a chance
to give account
and justify

helpless

impossible

The exhibition
is no longer an indifferent means
of presenting and recording
 it becomes
an active environment

Involving the audience in adventures and traps,
refusing them and not satisfying
their reason of being
spectators
beholders
and visitors.

 The exhibition
does have a 'ready' reality, though;
it is my own creation and my own past
foreign and made objective
by getting mixed
with the matter of life.

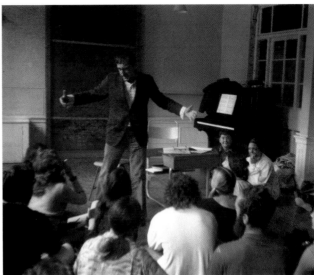

Opposite Tadeusz Kantor, *A Demarcation Line*, from the *Atelier 72* exhibition catalogue, courtesy Demarco Archive, copyright Maria Stangret-Kantor and Dorota Krakowska.
Left Wiesław Borowski with Richard Demarco at the Foksal Gallery in Warsaw, 1976, photograph Richard Demarco, courtesy Demarco Archive.
Right Tadeusz Kantor giving his lecture to the Demarco Gallery's faculty and students of Edinburgh Arts at Melville College, 1973, photograph Richard Demarco, courtesy Demarco Archive.

This experimental school was entitled "Edinburgh Arts". It came into being as a direct response to Kantor's *A Demarcation Line* and gave me the opportunity of introducing Tadeusz Kantor to Joseph Beuys in the living room of my own house. This provided me with a moment of hope for a better future for the arts helping to heal the wounds inflicted upon Poland and Germany involved in an horrific scenario of senseless warfare. Sadly, Beuys and Kantor both died within four years of each other leaving me with a distinct sense of loss, ill-protected from an art world increasingly controlled by bureaucrats who were politically obliged to associate culture with tourism, leisure and sport, with little or no regard to the fact that all manifestations of art are at their most effective when they ascend to the condition of prayer.

As a further mark of respect for Kantor's achievements, I presented a 12-day Official Edinburgh Festival conference entitled *Demarcation 84*. Through this, I endeavoured to place Kantor alongside Beuys, in the spirit of modernism expressed through the visual arts. In doing so, I was emphasising my view that Kantor was not only a great figure in the history of theatre but also in the history of sculpture and painting.

Kantor died in 1990 and was spared the triumph of postmodernism and the false avant-garde under the control of all those who could be defined by the word *ciquette*, a French word he invented and used with relish when dealing with those who misunderstood the nature of his life-long battle to defend the truth embedded in the heart of a European cultural heritage with a distinct spiritual dimension handed down to him from his Jewish and Christian forebears.

NOTES

1 *A Demarcation Line* was a version of *The Dividing Line* happening, performed in Kraków on 18 December 1965 which, in turn, had been a modified version of Kantor's first happening *Cricotage*, that had taken place at the Foksal Gallery on 10 December 1965.

2 Kantor's text quoted after *Atelier 72: Edinburgh Festival: August–September,* Edinburgh: Richard Demarco Gallery, 1972.

3 For the text of Kantor's *Little Manifest*, written on the occasion of the reception of the Rembrandt Prize, see the article by Krzysztof Cieszkowski "Kantor: Theatre as Theatre" in this volume.

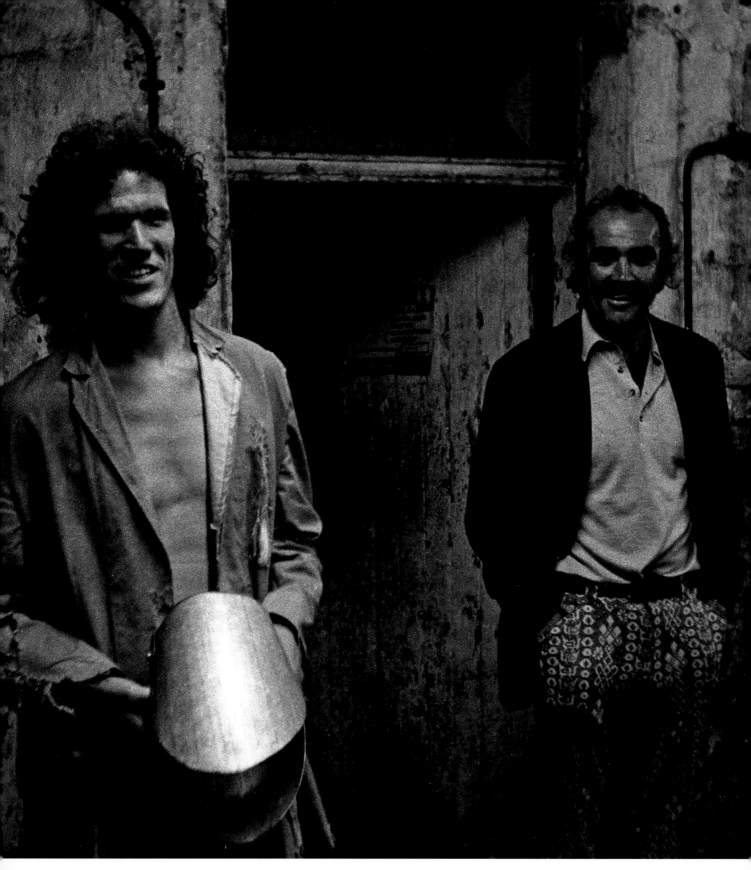

Sandy Nairne in Cardinal's dress, with Sean Connery and Sally
Holman, *Lovelies and Dowdies*, Edinburgh, Forresthill, Poorhouse,
Edinburgh International Festival Fringe, August/September 1973,
photograph Richard Demarco, courtesy Demarco Archive.

LEARNING FROM LIFE

SANDY NAIRNE

A symposium can be an occasion of thoughtful celebration. Together with the *Impossible Journey* exhibition at the Sainsbury Centre for Visual Arts, the discussion on Tadeusz Kantor's work in June 2009 in Norwich, offered exciting new thinking about his work and ideas. My own involvement with Kantor and the Cricot 2 Theatre needs a little explanation, and I want to sketch the cultural situation in Edinburgh in 1972 and 1973, and to describe something of the impact of Kantor and the Cricot 2 Theatre.

I was invited by Richard Demarco to be part of his team of student helpers at the Gallery in 1972. I assisted with the first Summer School presented that year in Edinburgh, with *Atelier 72*, the Polish contemporary art exhibition for the Festival, part of a sequence which includes *Strategy: Get Arts*, 1970, and also with the production of Kantor's *The Water Hen*. I returned in 1973, and worked on the production of *Lovelies and Dowdies*. To my surprise I ended up being asked to stand-in on stage as The Cardinal. As a student helper it was an opportunity that I had not expected—briefly to become an actor as well as production manager, though that may sound like too grand a term for what I was doing.

Part of my work related to an extraordinary place, the Poorhouse. It was not actually a Poorhouse. It was on the site, perhaps, of a Poorhouse; up against the old Medieval wall of the Greyfriars Cemetery. It was a disused plumbers' workshop building, which had been abandoned for at least 20 years and was not in good shape. And although health and safety issues were considered, we were in a creative city that stretched the rules. I don't think such a space would now be allowed to be used for theatrical productions. Although the name, the Poorhouse, was evocative of something abject, the space itself spoke of different kinds of work. And this resonated with the energetic intensity of Tadeusz Kantor's productions, which revolved around carefully controlled and repetitive activities.

A critical part of my endeavour was very clear, working with Sally Holman from the Gallery—to try and make it possible, physically, to put on each production. However, the cast, including the Director of the Foksal Gallery, Warsaw, Wiesław Borowski, still had to put up with very basic facilities which would not match even the lowest of current standards, employing for instance old subterranean store-rooms as changing rooms.

The context of the Edinburgh Festival was not one of creative harmony. It was a place of considerable dissonance, in the sense that Ricky had created the Demarco Gallery, growing out of the Traverse Theatre, as a very strong and independent initiative but perceived to be in opposition to the mainstream. Edinburgh was dominantly a conventional theatre and music festival, established in a relatively old-fashioned city, and with little attention paid to the visual arts. At this date neither Festival organisers nor the critics were calling for more avant-garde theatre or experimental artists. There were some new ideas here and there, but there were not that many new initiatives and the fringe had not yet grown to its present extraordinary scale. Ricky was responsible for some of the very best innovation in the arts in Scotland.

Another factor was the legacy of *Strategy: Get Arts*, when Ricky had invited Joseph Beuys and other artists from Düsseldorf to create an exhibition which turned out to have a lasting impact on Scotland and ultimately the British art scene. It included work of great force and intelligence, although largely ignored by the critics. Yet it broke the presumption in post-war art history that an artistic axis ran simply from France to America, with the rise of Abstract Expressionism and post-painterly abstraction in the United States following an earlier time of predominance of Parisian painting. *Strategy: Get Arts* demonstrated an arena of installation and sculptural work (inspired by conceptual developments and the Fluxus movement) that Britain was not fully part of. I do not underestimate the importance of what British artists were achieving—just two years later *The New Art* at the Hayward Gallery, 1972, showed that a very energetic conceptual generation of Gilbert and George, Richard Long and other artists coming out of St Martin's, were making considerable waves. What was happening in England was important but it was relatively contained, and it was polite compared to what was happening in Düsseldorf, or indeed in the work of Tadeusz Kantor in Poland. His work was not polite; polite was not the point.

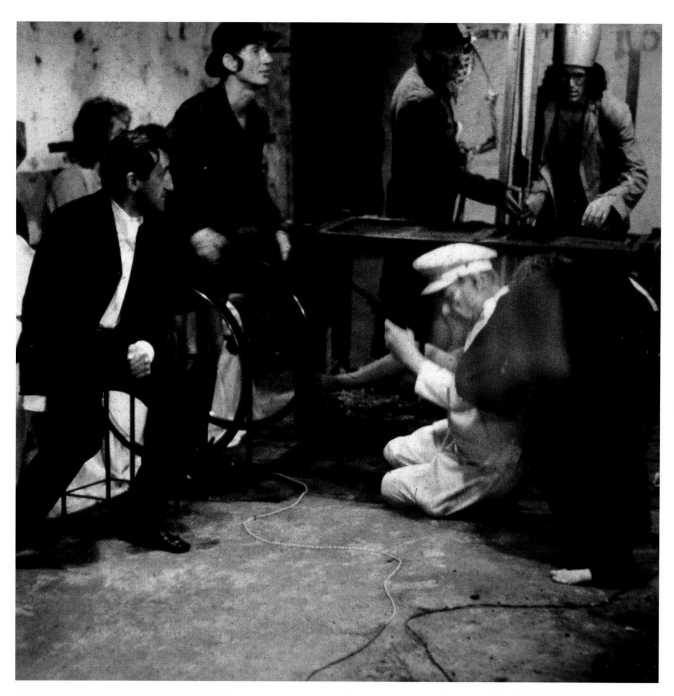

Lovelies and Dowdies performers: Tadeusz Kantor, Wiesław
Borowski, Sandy Nairne, Edinburgh, Forresthill, Poorhouse,
Edinburgh International Festival Fringe, August/September 1973,
photograph Richard Demarco, courtesy Demarco Archive.

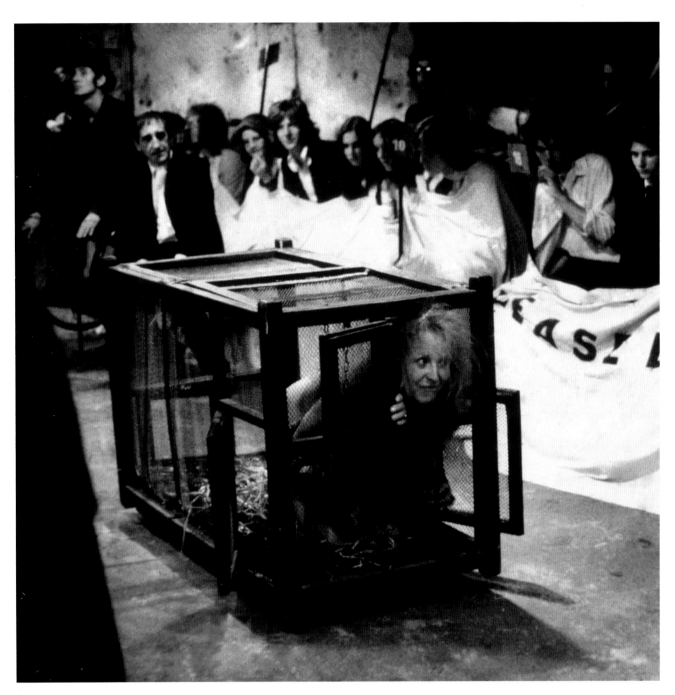

Zofia Kalińska in *Lovelies and Dowdies,* Edinburgh, Forresthill,
Poorhouse, Edinburgh International Festival Fringe, August/
September 1973, photograph Richard Demarco, courtesy
Demarco Archive.

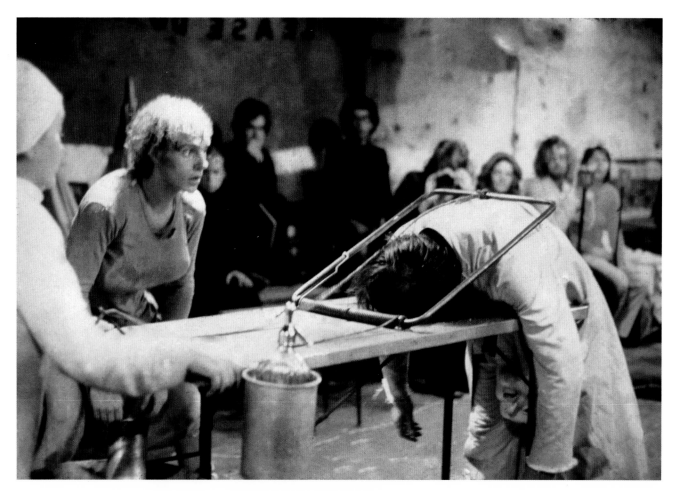

If being polite was not the purpose of Kantor's work—and here was an evident assertion of a new kind of energy—it still related to a humanistic tradition within Europe, linked in his use of Stanisław Ignacy Witkiewicz's texts, and drawing on more universal themes in both *The Water Hen* and *Lovelies and Dowdies*. You sensed that categories were merged—you could not define whether this was performance or installation, or whether it might be questioning the very idea of theatre. Although there were tickets for performances and it started at an advertised time, theatre was probably the least, and last, thing that it was.

Looking back, there is an indelible image of Kantor acting each night like a conductor. Was he actually conducting every performance? Or directing or dictating? I had a sense (Wiesław Borowski and others know much more about this) that there was a contest—a certain to and fro—between Kantor and the company, including moments when the actors would answer back. However much you could feel Kantor's powerful presence as the creator of the work and as a visible figure on the edge of the stage, the collaborative element and the strength of the relationships in the ensemble appeared critically important. Yet there was also an element of confrontation within it. Kantor created his works, like many great artists, through becoming certain of what he wanted and being very determined to realise his concepts. The drawings are revealing because you see how his ideas are enacted. However broad his imagination, Kantor draws something with the graphic power to conjure up a particular object or to imagine a scenario or a character. These would be realised absolutely as he had imagined them.

I learned an important lesson about confrontation. In *Lovelies and Dowdies* the very beautiful stone-flagged floor of the Poorhouse was not usable because a

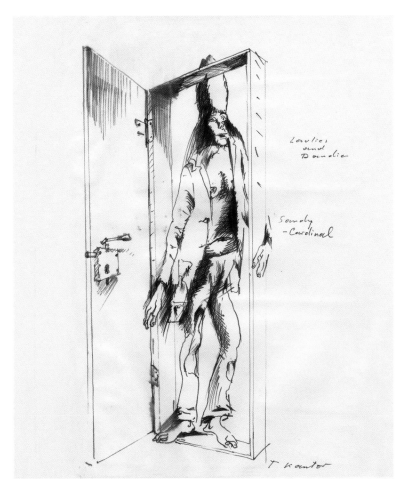

large, human-scale mousetrap had to trundle back and forth across it. There was no choice but to alter this floor, and luckily there were no Scottish Heritage inspectors watching us as concrete had to be laid. But having covered the central performance area, and despite putting a sealant over it, as the mousetrap was pushed back and forth concrete dust was catching in the actors' throats. Kantor shouted at me— accusing me of ruining the production. I was incensed and had the temerity (after nights perhaps with little sleep) to take a light bulb in my hand and smash it on to the ground just in front of his feet. The confrontation forced a re-think and a solution with paint was agreed to. Kantor got what he required, but I felt I had made my own point about my responsibility.

I was completely fascinated by the circumstances in which the Cricot 2 had emerged, and I was lucky enough to travel to Warsaw and Kraków to explore a little more of the intellectual life surrounding the Cricot. I learned that Kraków in the early 70s had many more working theatres and companies than a similar-sized regional university town like Oxford—by a very long way. In addition it had the independent impetus of Kantor and various associated artists. My connection with Kantor was an extraordinary experience for me as an Oxford student, and it shifted my view about contemporary culture. More importantly, Kantor's work was influential on all those that encountered it—paving the way for new ideas in performance, and encouraging visual spectacle to be given greater emphasis in contemporary theatrical work.

KANTOR IN EDINBURGH IN THE PHOTOGRAPHS OF IAN KNOX

JO MELVIN

In 1976, the filmmaker Ian Knox, then a student at Edinburgh College of Art took a set of photographs, recording not only the performances of *The Dead Class*, but also behind-the-scenes of its production, including the filming of a TV documentary on the spectacle. Knox was involved in many other ways during the Festival, making handbills in the spirit of cheaply produced flyers advertising Kantor's former appearances in Edinburgh. Ian Knox's most recent film is *Martino Unstrung*, 2008, which explores the jazz musician Pat Martino's astonishing neurological crises.

Opposite The Cricot 2 troupe in a causal mood in the greenroom at the Edinburgh College of Art, 1976, photograph Ian Knox, courtesy Ian Knox.
Above and right The Cricot 2 actress Mira Rychlicka in an improvised greenroom, getting ready for a performance of *The Dead Class* at the Edinburgh College of Art 1976, photograph Ian Knox, courtesy Ian Knox.

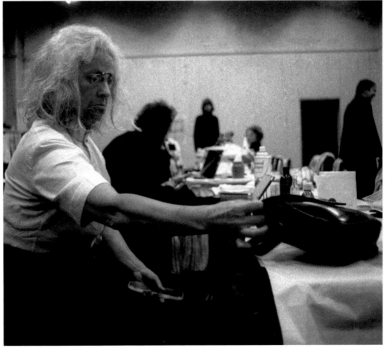

Left Rebecca O'Brien and Julian Bannerman during preparations for *The Dead Class* at Edinburgh College of Art, 1976, photography by Ian Knox, courtesy Ian Knox.

Julian Bannerman, a landscape designer, was then the Manager of the Richard Demarco Gallery. Rebecca O'Brien, today an independent film producer, was then working in a cafe and supplied Cricot 2 with free refreshments. Her mother, Matilda O'Brien was a friend of Richard Demarco. She met David Gothard as a young director in residence. She helped David Gothard in finding accommodation for the artists groups with families during the Festival. Kantor and Cricot 2 were billeted in Peebles, the small borders town near Edinburgh and nearby Matilda O'Brien's home, Kerfield. Matilda O'Brien provided not only financial support and hospitality, but also, reportedly, significant emotional support for Tadeusz Kantor.

Opposite The sculpture court at the Edinburgh College of Art, 1976, photograph Ian Knox, courtesy Ian Knox.
The court, empty of audience and cast, except for the seated mannequin of the caretaker from *The Dead Class*, shows the proximity of the audience's seats to the school benches of *The Dead Class*. In the foreground are the reel-to-reel recorders for the music.

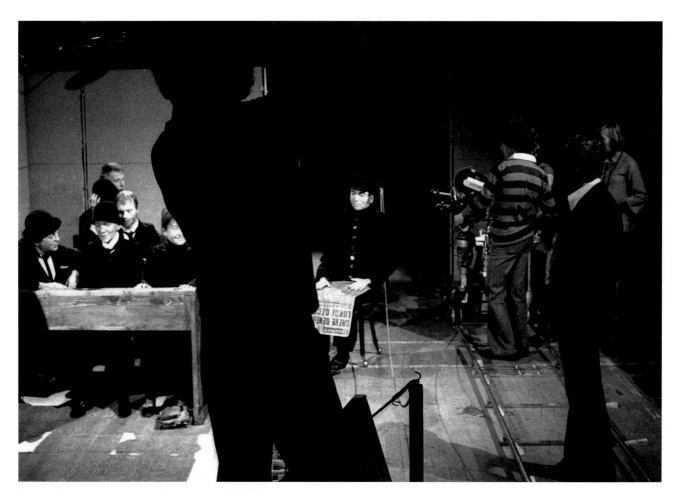

Above and Opposite The filming of *The Dead Class* by BBC Scotland, 1976, photographs Ian Knox, courtesy the author.

BBC Scotland made a documentary about the Edinburgh Festival of 1976. The film was produced by Rosemary Wilton, Alan Benson, Tom Cotter and Keith Alexander. A ten minute sequence of *The Dead Class* was included in the film. It was interspersed with an interview with David Gothard, who spoke about the extraordinary emotional experience of watching *The Dead Class*. He identified its effect as emotions emerging from within the viewer, turning him or her from just a passive witness into a silent collaborator.

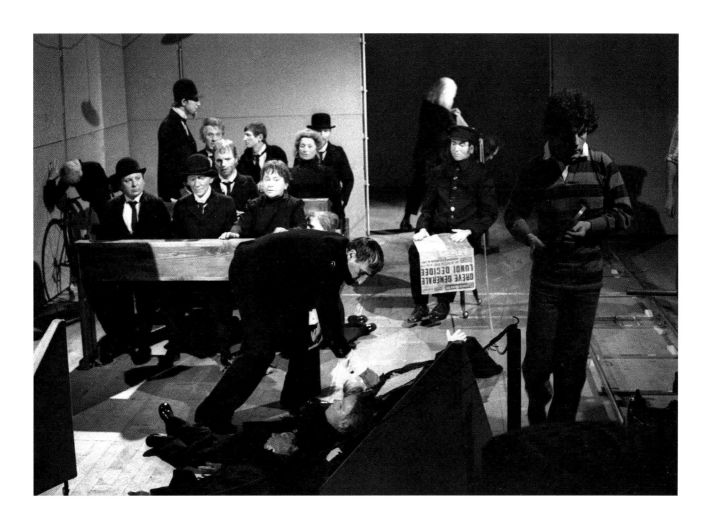

THEATR COLEG Y BRIFYSGOL CAER...

⊚ SHERMAN

THEATRE OF UNIVERSITY COLLEGE

IN THE ARENA

Sep 8 & 9
8pm
From Poland- the astonishing
CRICOT THEATRE 70p

Sept 10 & 11
7pm
LLANOVER HALL YOUTH THEATRE
MACBETH 70p

Sept 14-18
8pm
LLANDAFF MUSICAL SOCIETY
HERE'S A HOW-DE-DO
The inside story of Gilbert & Sullivan 70p

Sept 28-Oct 2
8pm
PAINE'S PLOUGH
present a musical with a difference
MUSIC TO MURDER BY 70p

Oct 6-9
8pm
THE PIP SIMMONS THEATRE GROUP
**THE DREAM OF A
RIDICULOUS MAN**
Based on a short story by Dostoevsky 70p

Oct 13-16
8pm
SHARED EXPERIENCE with three very different
**ARABIAN NIGHTS'
ENTERTAINMENTS** 70p

MAIN STAGE E...

Sept 11
7pm
POST OFFICE NATION...

Oct 1 & 2
7.30pm
**UNDER
JAZZ SUITE
the STAN TRAC...**

Oct 12-16
7.30pm
(& 2.30 matinees
Oct 13-15)
The resident company
MOLD ARTS CENTRE...
JULIUS

Oct 19-23
& 26-30
7.30pm
WELSH DRAMA...
THE WIL...
£1.50, £1.00, 70p

FILM

Aug 30-Sept 4
2.30pm
**THE TAL
BEATRIX**
Frederick Ashton and...

BRITISH FILM
Aug 30-Sept 4
IN CELEB...
(David Storey) with A...

Sept 7-10
& 20-23
A DELIC...
(Edward Albee) with...

Sept 13-18
BUTLEY

all at 7.30pm 70p

8.09 – 9.09.1976

Sherman Theatre of University College
The Arena
Performances of *The Dead Class*

YDD

HOW
TO
GET
THERE

SHERMAN ENTRANCE
Senghennydd Road or
via Students Union
steps in Park Place

Three minutes walk to
B. Rail Queen Street
Station

Services
3 & 39 to
Salisbury
Road (B)

B. Rail Central and
Bus Station.
Services 50 & 52
to Park Place (A)

ARDIFF

LUNCHTIME SHOWS every Wednesday

LATE NIGHT FILMS Fridays 10.45pm
Leaflets available at the Box Office

CARDIFF

The SHERMAN VOUCHER SCHEME entitles pensioners and students to generous concessions
The Theatre works with the support of the Welsh Arts Council and the South East Wales Arts Association

TS

RAMA FESTIVAL - Welsh Round

ILK WOOD
ONALD HOUSTON with
QUARTET £1.00

the new
ATR CLWYD)

AESAR Shakespeare

OMPANY
DUCK Henrik Ibsen

S OF
OTTER 'U'
oyal Ballet 70p (children 40p)

RE SEASON
RATION 'A'
ates

TE BALANCE 'AA'
erine Hepburn and Paul Scofield

(Simon Gray) with Alan Bates

YN GYMRAEG (in Welsh)

Medi 24 & 25 CWMNI THEATR CYMRU
7.30pm **Y LEFIATHAN**
Drama olaf Huw Lloyd Edwards 70c

Medi 28-30 THEATR YR YMYLON (WELSH ACTORS COMPANY)
7.30pm **CARIAD CREULON** Bryn Williams 70c
(& Iau 2pm)

Hydref 11 & 12 CWMNI THEATR CYMRU
8pm **YNYS Y GEIFR**
Ugo Betti (cyfieithiad Islwyn Ffowc Elis) 70c

EXHIBITIONS

Sept 13-Oct 9 **DEREK BARRETT**
Drawings & small paintings

Oct 11-30 **CHINESE PAPERCUTS**

Sherman Theatre's September/October 1976 programme,
including the production of *The Dead Class*, Cardiff,
September 1976, courtesy Richard Gough.

THE DEAD CLASS IN CARDIFF

RICHARD GOUGH

Opposite Front of the Sherman Theatre in Cardiff, courtesy Sherman Theatre.

Above Fragment of the Sherman Theatre's September/October 1976 programme, including the production of *The Dead Class*, Cardiff, September 1976, courtesy Richard Gough.

ACT ONE

Kantor came to Cardiff in September 1976 and he was never to return. For the small number of people who saw the two presentations of *The Dead Class* (probably no more than 120) a return of another sort was difficult—a return to 'normality' in theatre, a return to the everyday: a return to the neat conception of what a theatre director does and how s/he does it; a return to the order and stability of memories and the distance of the past; a return to a sweet nostalgia of childhood.

And instead a *turn* to how an ensemble materialises their work and embodies an aesthetic; a turn to the power of objects and the poetics of their patina; a turn to animation and the haunting presence of mannequins; a turn to exhausted and decrepit bodies struggling to people the stage; a turn to a theatre of death.

A return to life, although no longer the same.

A 'terrible beauty' was witnessed on those two nights and the memory of it and the seemingly demonic, possessed and enraged presence of Kantor, as conductor, was burnt on the backs of our minds and the folds of memory. As I write now 34 years later (almost to the day), I cannot name a single production that has had such a profound effect upon me.[1] The fact that Kantor came to Cardiff with this awe-inspiring production can be credited to one person—Geoffrey Axworthy—the Director of the then recently established Sherman Theatre, which was then part of the University of Cardiff. Following the success of two previous presentations of Kantor/Cricot at the Edinburgh Festival (*The Water Hen* in 1972 and *Lovelies and Dowdies* in 1973), hosted and curated by the pioneering Richard Demarco, *The Dead Class* was presented (again) by Demarco during the last week of the 1976 Edinburgh Festival and destined for an eight-night run at the Riverside Studios in London. Geoffrey Axworthy seized the opportunity to bring Kantor and the Cricot ensemble to Cardiff having had a baptism of fire in the *Lovelies and Dowdies* in Shiraz (Iran) two years previously. He knew this was important work, he knew the audience would be small (students would not have returned to university), but he also knew that there was emerging in Cardiff a distinctive group of experimental theatre/dance companies who were open to and actively engaged with international work, he hoped Kantor might inspire and influence, he hoped a local audience would be thrilled and challenged and what is more he admired Kantor and wanted to host him and his company.

In the Sherman Theatre 'brochure' (a bimonthly broadsheet) for September/October 1976, the visit of Cricot Theatre is announced thus:

> We are delighted to welcome one of the world's exciting experimental theatre companies—from Poland and via this year's Edinburgh Festival. The strong visual quality of these artist-performers enables them to communicate in a unique manner with a non-Polish-speaking audience. (While the group performs at the ICA this summer, paintings by Kantor, their director, will be on exhibition at the Whitechapel Gallery).

This short understated text—the adjective-laden, supersaturated and hyperbolic marketing spin of theatre brochures were yet to come (a product of Thatcher's eighties)—was penned by Geoffrey Axworthy, as were most of the short descriptions of the film and theatre programme. (Was the Theatre Marketing Officer itself a product of Thatcher's 80s?). The broadsheet is exceedingly plain: a single A4 sheet folded twice printed in blue and orange containing no images (except for a film still on the front cover), with texts in 8-point typeface (the above, one of the longest descriptions) together with a calendar for the two months.

However, in these brief lines the 'difficulty' of marketing such an event in the mid-1970s, and the extra-ordinary opportunity (for the general audience and the theatre profession) this visit presented for Cardiff are conveyed. Geoffrey Axworthy clearly signals that this production was coming from the Edinburgh Festival and

moving on to London (even though it was the Riverside Studios and not the ICA), he clarifies and assures that the piece will communicate to a non-Polish-speaking audience and consists of strong visual material. Also he allows one superlative claim in his opening line—"one of the world's most exciting experimental companies"— although the inclusion of 'experimental' was a calculated risk.

Coming from Edinburgh, en route to London carried kudos in a capital city (Cardiff) still struggling to assert itself in the mid-70s (and still does today), the need to assure an audience that a production would be comprehensible even without an understanding of Polish is very much a sign of the times; 34 years later Welsh audiences are accustomed to enjoy a rich diet of international theatre through the enterprise and endeavour of Chapter Arts Centre and the Centre for Performance Research and the numerous tours and festivals they have curated and produced. But back in 1976 presentation of theatre work in languages outside English or Welsh was rare in Wales and indeed in the rest of the UK; outside the weeks of the Edinburgh Festival, Britain remained relatively isolated from international and European productions—even in London at this point, Peter Daubeny's World Theatre Season was no longer happening, the London International Festival of Theatre (LIFT) was still two years away from being born and the BITE season at the Barbican (London) not yet even a twinkle in the Barbican's eye.

There is another curious detail about this publicity copy. Nowhere is the title of the production mentioned—*The Dead Class*—only the name of the company (in English) is mentioned on the calendar, and the above text is simply headlined "Cricot Theatre". The title of the piece was known by Geoffrey Axworthy and long established and Polish posters existed, but I cannot recall knowing what the production was titled in advance of actually seeing it, and I can't recall any display of posters or images in the Sherman Theatre itself. Was Geoffrey Axworthy cautious or anxious about staging a piece called *The Dead Class*? In addition to the other concerns mentioned above was Kantor's obsession with a Theatre of Death and a piece entitled *The Dead Class* likely to be too much for the good citizens of Cardiff? Is to include death, the dead, funeral or any such morbid evocation in the title of a production a known 'killer' for audience attendance; Arthur Miller and his *Salesman*, an exception perhaps? We will never know why Geoffrey Axworthy chose to suppress the title from any publicity but not knowing the piece was entitled *The Dead Class* had an uncanny effect on my first experience of witnessing it.

However, before proceeding with a description of the production presented in the Arena stage at the Sherman Theatre, Cardiff, on Wednesday 8 September and Thursday 9 September 1976, I should like to dwell further on Geoffrey Axworthy's short text. I recall at the time being struck by the mention of the Director, Kantor, having an exhibition of paintings at the Whitechapel Gallery. I was intrigued by this, still poised to go to University to study Drama/Theatre (and having deferred a place for three years) and yet now already wondering if Art School was beckoning and possibly a more appropriate place to study—the idea of an artist, painter, sculptor (I was yet to learn of Kantor's installations, happenings and assemblages) combined with being a theatre-maker, a theatre director was fascinating, both a revelation and a challenge. At that time (I was just 20 years old) I was only really aware of Robert Wilson and Meredith Monk as contemporary practitioners who crossed boundaries and borders. There seemed to be either historical European precedents (such as Sergei Eisenstein, Jean Cocteau and Antoine Artaud) or contemporary North American artists; but in 'reality' and in the relative isolation of mid-70s Wales I was surrounded by hard-line physical theatre fundamentalists and all our talk and references seemed to be towards a poor and pure theatre of ritual and 'truth', the 'sur-expressive' and the universal, action and gestures, signals through flames… the influence of Grotowski, Brook and Barba figured large. Even if I had the paint brushes, I would have had to hide them! From that last parenthesised sentence in Geoffrey Axworthy's copy, Kantor appeared as some dark angel—the theatre director who also paints; the artist operating in both gallery and theatre. So, it was

possible. Little was I to know how that provocation was to inspire and influence; little was I to know what a composite and multi-talented artist Kantor was, a poly-math, generating art works in numerous media, in space and time as event and action. But (a few weeks later) I did go on an expedition (a pilgrimage?) to East London and ventured out to the Whitechapel Gallery and the revelation began.

Finally, with regard to the publicity copy, although I did not register it at the time I now see the hyphenation of artist and performer, as in "[t]he strong visual quality of these artist-performers enables them to communicate in a unique manner", as a prescient remark/definition from Geoffrey Axworthy, accurately evoking the hybrid nature of these figures in action, neither actors nor puppets, not only visual artists but also painters in time and rhythm, living sculptures/sculptors, installation-makers, dancers and personas in still life (dead nature). Again, I repeat, this is 1976, Performance Art, Performance, Live Art and all the numerous categories and definitions for describing, analysing and funding hybrid art-forms that linger on the borders between theatre, fine art, sculpture, music and dance and emanate through their events and eventfulness have yet to be captured and defined; they were indeed still emerging and are still evolving. Geoffrey Axworthy's use of the hyphen is especially apposite with regard to Kantor's 'actors' (the term "performer" was itself just emerging) operating within this hyphenated state of artist-performer, betwixt and between, harnessed to neither one nor the other, the actions and images were embodied and came into being differently.

Thankfully I did not have only the Sherman publicity copy to entice me to see the production—I received 'word of mouth'; enthusiastic recommendation and curious descriptions of previous Cricot productions from the Sherman Theatre's Director. Geoffrey Axworthy had been a great supporter of Mike Pearson and the Cardiff Laboratory Theatre (with whom I was collaborating) since its inception three years earlier (the Sherman Theatre was itself built and opened in 1973 funded by the University of Wales, College Cardiff), and the Sherman was where the early productions of Cardiff Laboratory Theatre were rehearsed and presented even though Chapter (Wales' Contemporary Arts Centre) was rapidly emerging in a disused school, on the other side of town, as the 'natural' home for experimental theatre and dance (Geoff Moore's Moving Being—multi-media performance company—was a founding resident company).

Geoffrey had seen some of my early performance and installation work within the 'umbrella' of Cardiff Laboratory Theatre and followed them with interest and concern; I very much valued his comments and criticism and particularly admired how he could place the experimental and often uncompromising work, which Mike Pearson and I and a host of others were naively exploring, within a greater context of theatre forms and world theatre traditions. He had travelled extensively and worked in Baghdad and Ibadan (Nigeria) before taking up the position within Cardiff University (then known as University of Wales, College Cardiff) to establish the Sherman Theatre (programming events several years preceding the opening) and to launch a taught MA course in Theatre Studies. He would often talk about productions seen through his travels and his regular attendance at the Edinburgh Festival. I recall a particularly animated account of a production of Macbeth (in a clearing in the jungle near a remote village in Nigeria) when the entire audience fled into the (real) jungle as Burnham Woods approached. But it was his accounts of Tadeusz Kantor's work that intrigued me most. Geoffrey had attended the 1974 Shiraz Festival in Iran (this annual arts festival (1967–1977), discontinued after the revolution, was where the Shah of Iran hosted one of the most celebrated festivals of avant-garde and traditional arts—commissioning Peter Brook's *Orghast* and Stockhausen's *Hymnem at Persepolis* and Robert Wilson's *Ka Mountain* among many other outstanding productions). Geoffrey described how he had seen Kantor's production of Witkiewicz's *Lovelies and Dowdies* (I thought I knew Witkiewicz through Grotowski but nothing prepared me for this account). In my own memory now, perhaps recreating a quintessential Kantorian moment, the descriptions

come in waves and seemingly across several encounters, mixing in shards, broken scraps and excerpts from *The Water Hen* (also Witkiewicz) that Geoffrey had seen in 1972 in Edinburgh, but most of all I remember his account of being selected from the audience, on being taken away, and being dressed up as a Mandelbaum or was it a Libertine (or was that another group) and then he and a gang (of other audience members) having to demand to participate in an orgy. At another moment I see a line of Mandelbaums sitting quietly and the other section of the audience having to pass slowly as if on inspection. This description of casting the audience into roles, splitting them in groups, repositioning them (in both scenographic and choreographic sense) and allowing one section to encounter another was to have a profound influence on me—and all this through an elderly, experienced man of theatre (Geoffrey was in his 60s in 1976) reminiscing to a novice.

Geoffrey's excitement in hosting Kantor and the Cricot ensemble in his theatre was palpable. This was only the third year of full Sherman Theatre programming (both main stage and studio—the Arena), and although neither the Cardiff public nor the profession knew of the significance of this visit (nor the reputation and previous work of Kantor), Geoffrey knew it was a coup and felt that Kantor (although already famous in France and Italy) was about to become a world renowned artist and that the production of *The Dead Class* was destined to become a seminal twentieth century work; the reception in Edinburgh had been remarkable and a world tour was clearly shaping up, within weeks the run at the Riverside Studios, London (not the ICA as announced in the Sherman brochure), and the impact made (on public, press and profession) would confirm Kantor and Cricot as a major force within world theatre, to be sustained for the next 15 years and then beyond. Although acclaimed in Edinburgh the month before and much cherished and hosted by Richard Demarco (and promoted through the Demarco Gallery in Edinburgh as artist and performance-maker) for several years previously, these two Cardiff dates and the days surrounding represented something of a respite for Kantor and the members of Cricot 2. They weren't to know it but (perhaps they did), after London, their touring and ever demanding schedule of rehearsal and assembly would increase exponentially. Cardiff was something of a rest for Kantor and the ensemble, a pause and (with hindsight) a moment of shift and change; the Cardiff dates a pivot, a hinge and by all accounts they enjoyed it! Geoffrey had hired an entire Victorian house near to the theatre and Caroline Axworthy recounts tales of endless cooking (*borscht* and *pierogi*), the ensemble running around the house savouring the expanse and the freedom, playing games and enjoying being together. While their theatre might be replete of death and darkness, this lodging house was full of life and light, one gets a sense of a company relaxing (Kantor was to reminisce favourably about these days and invited Geoffrey and Caroline to Paris the following year). I can almost see these two mature men (who bore a certain resemblance) playing in the living room, swopping stories of theatre, travel and travail, gossiping in French, enjoying a glass or two and letting their hair down.

It is interesting to note that there was a two-week gap between the end of the Edinburgh Festival run of *The Dead Class* (4 September) and the start of the London run at the Riverside Studios (11 September), not the easiest time to programme international experimental theatre work in the UK (the end of summer holidays but before university terms have begun) but surprising to discover that no other theatre in the UK attempted to do so. It is testament to Geoffrey Axworthy's commitment to world-class theatre and to the Sherman Theatre's local audiences that he brought this extraordinary production to Cardiff and had the vision and will to do so.

INTERMISSION

Kantor's production of *The Dead Class* was not my first experience of Polish theatre, there had been two previous encounters; equally disorienting and revelatory.

The first had been at the National Student Drama Festival (NSDF) held in Cardiff in 1974 and the second at the NSDF in London the following year. At the Cardiff edition of the National Student Drama Festival, hosted by the Sherman Theatre as a part of its inaugural programme, three productions impressed me greatly, scarred and marked me, and altered my conception of what theatre could be—how narratives could be constructed and how emotions could be communicated physically, viscerally and directly. As an impressionable 18 year old, suddenly Peter Brook's evocation of Holy and Ritual theatres, as described in his book *The Empty Space* (which I happened to have tucked into my satchel; not yet a student but earnestly studious), made sense in heart and mind, became real and live, 'felt' experiences, shocking and troubling to 'old', received and tired notions of how theatre operated. The three productions were Time of the Season by the experimental youth theatre group of Llanover Hall (Cardiff) directed by Mike Pearson, a production of the Ritual Theatre directed by Barry Edwards and a student group from Kraków called *Pleonazmus* with the curiously titled production *One Fire Brigade Wouldn't Be Enough*. Many years later I was to discover that founding members of the Warsaw based Akademia Ruchu (a company with which I was to collaborate and produce many times in the 1980s and 1990s) had been part of this short-lived student theatre company Pleonazmus. And the brutal tableaux, concrete sounds and agonised silent screams of early Akademia Ruchu work were replete in this stark production of Pleonazmus, impressive for both its athleticism and control. In retrospect I can see that all three of these extraordinary productions were influenced by the work of Jerzy Grotowski, but at that point he was just a name lost in the empty space between Peter Brook's book and my experience of theatre.

The following year I was to accompany Mike Pearson (now an acquaintance and with whom I was desperately seeking an apprenticeship) to the NSDF in London. My memories are vague but I recall learning to walk out of productions, learning to reminisce about theatre and the 'old days' (even though the events had only happened a few years earlier), learning about Poland and Grotowski (Mike had seen *Apocalypsis Cum Figuris*), learning a great deal about Pete Sykes and Rat Theatre (and being fascinated), learning about the politics, geography and 'landscape' of British alternative theatre in the mid-1970s (and being amazed by both flora and fauna), seeing a production of *The Phantom Captain* (early live art/performance artist Neil Hornick), seeing numerous productions that we HAD to get angry about AND then, in a basement of the Student Union in Gower Street, we saw a production of Teatr STU—for me it was astounding, shocking and deeply moving, my abiding memory is of performers being wrapped tightly in shrouds, living bodies mummified, a violent act of submission and coercion but also care and comfort. I was also struck by the intimacy and complicity of the audience; we were all seated as if children at a grand dining table, the action and events served for our consumption and nourishment. Mike was to say it was influenced by Grotowski's production of Marlowe's *Faustus,* but I was not to know, and to experience theatre served as dinner was enough to set me on a quest. If this was Polish theatre, then I needed to know more.

ACT TWO

The moment I walked in to the Arena Studio of the Sherman Theatre at 7.55pm on Wednesday 8 September 1974 to see *The Dead Class,* I was transfixed by the 'elderly' man pacing up and down on the forestage of this cramped space. He seemed to inspect each of us with piercing, shifting, darting eyes; clasping his hands, ringing them obsessively. Was he about to speak? Was he nervously summoning up an announcement? Had something disastrous occurred and an apology was now required?

As a teenager growing up in Cardiff I had regularly visited Bristol Zoo. I recalled the great white polar bear captured in its concrete cell, pacing up and down seemingly deranged both disdainful and frightened of the onlookers; I felt now I was seeing the negative image, a frailer frame all in black except for crisp white shirt (no tie), more fox than bear but similarly captured, ready to pounce and prey. It was unnerving, who was he and why was he there?

Having never seen a Kantor production before the physical reality of his presence on stage—the director, the auteur, the conductor, the puppet master, the MC—was mesmerising and deeply troubling; 30 years on this may not seem novel or innovative but back then and with no foreknowledge of Kantor's aesthetic, style or signature this was a startling beginning and something, that for me, has never ended.

In the crypt of Hereford Cathedral I had once heard a priest give a lecture on the demonic in literature. I was only 15 at the time and was frantically reading Beat Generation poets and although he spoke of Milton, Webster, and Marlowe I felt accused and implicated. My recollection is of a crazed wiry man, dressed all in black, give one long howl that seemed to screech evil and bile. It was a sustained chord that terrified me for many years and became confused later with Francis Bacon's painting after Velázquez's Pope. The opening sequence of *The Dead Class* was however more terrifying, more sustained, unremitting and relentless. My memory is of Kantor calling this event up, I could see he was actually signalling light cues, indicating sound levels and beckoning forth actors, cajoling and remonstrating but more than this the entire proceedings seemed to be called from some lower depth, from a lacuna, from some gaping hole at the back of the theatre, at the back of the mind, from some tear in the memory. My darkly-dressed priest had reappeared and prized opened the caskets in the crypt, all my own memories of childhood bullies, cruel games and humiliation came welling back; Kantor unleashed something that would not easily be put back. How could this wound be healed? How would this wound be healed?

After the presence of Kantor in the opening moments before the performance began and his agonising and maniacal summoning up of the events, the next fundamental shock for me (now about 8.02pm) was the sight of the performers, not just their decrepit, ashen and exhausted state of being and the extraordinary sense of these hollow spectres being empty vessels through which memories were to cascade and excite, ebb and flow—but the actual age of the actors. In my naïveté and youthful arrogance I had thought experimental theatre was the domain of the young, of the next generation, not something that older people did or would wish to be associated with doing. I could see that there was an element of make-up operating here, and in the intimacy of the Arena Studio the theatrical devices and conceits were beautifully apparent but all the same some of these actors were mature possibly even 'elderly'. A short life experience of student drama festivals, Llanover Hall youth clubs, young Moving Beings and nubile experimentalists was rapidly coming to an end. This was like a Punk Rocker (exactly of this era—mid-1970s) seeing that an old Blues guitarist could actually be more subversive, innovative and outrageous.

As I was still reeling from this second shock, Kantor's next masterly theatrical device was to empty the stage; these spectres were vanquished not long after having appeared, dismissed without ceremony and yet his diabolic presence remained, taut and poised ready to recall. And then they returned from the dark recess of the

studio, from the off-stage of the mind, from the wings of memory to a familiar waltz conducted by Kantor in staccato gestures but this time with their former selves, in miniature form, clinging to their backs; ghastly puppet upon puppet; the ghostly apparitions bearing the weight of a childhood effigies of themselves.

The time now would have been precisely 8.05pm. In five minutes an entire gallery of chiaroscuro paintings had come alive through a dance of death; if the production had ended at this point it would almost have been enough, unbearable and unforgiving; disturbing in a fundamental, existential way. And yet wholly satisfying. In five minutes all my previous months of reading Kleist, Craig and Artaud, all my attempts to understand, to comprehend and imagine in tangible ways what these visionaries had foreseen was illuminated, made real, made manifest before my very eyes—lo and behold....

The fact that I can still trace in my memory, 34 years later from the experience of the event, an almost minute by minute account of this 70 minute production is testament to the impact it made on me. It also seems to beg questions of the process of witnessing in theatre, proposing other levels of empathy and engagement, implying participation and culpability. I was implicated, I became entangled, and it was engrained.

Most readers of this text will no doubt be familiar with *The Dead Class* and there is no need to continue with a description of the events that unfolded and enraptured. Of course I saw it not only on the first night in the Sherman Theatre but went again the second night and then followed the company to London. I was to see it 12 more times; in Nancy, in Brussels, in Graz, in London (again) and finally in Kraków. Was it possible to become a 'groupie' of the Theatre of Death, a fan with a morbid fascination? Was it a delusion that I felt a glimmer of recognition from Kantor as he surveyed and inspected the entrance of the audience in Kraków; now in his home town this visitor from Wales, still stalking the production seven years later?

How might one predict the consequences of presenting a single theatre production on the members of its public? Impossible of course, and a redundant exercise in any case, but I am not alone in being able to trace a single formative theatre experience that became a guiding force on the rest of my life, functioning as both compass and grail, offering both orientation and wayward pursuit. I am glad I can also name the people who were responsible; Tadeusz Kantor and the members of Cricot, and the Director of the Sherman Theatre, Geoffrey Axworthy, and thus acknowledge a heartfelt gratitude.

NOTES

1 I have travelled to Poland every year since 1977, often more than three times each year. I have seen over 500 Polish theatre performances, I have collaborated with seven different Polish theatre companies and I have produced (and co-produced with Judie Christie) more than 16 UK tours of Polish theatre productions and ensemble presentations, in addition to organising many exchanges with Polish theatre scholars and practitioners, workshops, residencies conferences and publications. The encounter described above determined this.

11.09–18.09.1976

Riverside Studios, Hammersmith
Performances of *The Dead Class*

22.09–31.10.1976

Whitechapel Art Gallery
Tadeusz Kantor: Emballages 1960–1976
Curated by Nicholas Serota, in cooperation
with Muzeum Sztuki w Łodzi

3.09–14.09.1980

Riverside Studios, Hammersmith
Performances of *Wielopole, Wielopole*
The performances accompanied by the
exhibition in Riverside foyer
*Tadeusz Kantor and Cricot 2; Drawings/
Photographs/Documents* (3.09–28.09.1980)

17.11–27.11.1982

Riverside Studios, Hammersmith
Performances of *The Dead Class*

30.11–5.12.1982

Riverside Studios, Hammersmith
Performances of *Où sont les neiges
d'antan (cricotage)*
Performances of *The Dead Class* and *Où
sont les neiges d'antan,* accompanied by
documentary exhibition in Riverside foyer
Tadeusz Kantor and Cricot 2 (17.11–5.12.1982)

"Kantor is coming" graffiti emblazoned on a concrete pillar of the
Hammersmith flyover near Riverside Studios, November 1982,
photograph Chris Harris, courtesy David Gothard.

Kantor and Nicolas Serota at the opening of *Tadeusz Kantor: Emballage 1960–1976* at the Whitechapel Art Gallery, London, September 1976, photograph Richard Demarco, courtesy Demarco Archive.

EMBALLAGES AT THE WHITECHAPEL

INTERVIEW WITH NICHOLAS SEROTA

KATARZYNA MURAWSKA-MUTHESIUS Your career as a director began in the early 1970s, when—at the age of 27—you became Director of the Museum of Modern Art in Oxford, and then, in quick succession, Director of Whitechapel Gallery in London in 1976, and later Tate Gallery in 1988. You have a reputation of a curator who has helped to establish the contemporary canon and who knows how to address the contemporary public, and at the same time you are widely known as a director who managed to transform the old cramped Tate to build the highly successful Tate Modern and to construct a new identity for Tate Britain.

Bearing this in mind, I would like to ask you about the circumstances of your decision to stage an exhibition of Tadeusz Kantor at Whitechapel, in 1976. Although Kantor was by then one of the major Polish artists, and his theatre productions at the Edinburgh Festival were very well received—he never had a major exhibition in Britain before. In a short text written about this exhibition for the catalogue *Interior of Imagination* at The National Art Gallery Zachęta in Warsaw in 2005 you said that the idea came from Jasia Reichardt, the former Director of Whitechapel.[1] As Jasia Reichardt's follower did you have no choice, or was it a conscious decision to take such a challenge?

NICHOLAS SEROTA When I was appointed Director of Whitechapel, in April 1976, Jasia had already left the Gallery. She had put in place a provisional commitment to the Kantor exhibition pending the arrival of a new director. So when I arrived, I did have a choice. But it was a choice which did not delay me for very long as I already knew that Kantor was an important figure and it seemed an excellent idea to create an exhibition in London that would coincide with performances [of *The Dead Class*] in Riverside Studios.

KMM So that was a conscious decision on your part to stage the Kantor exhibition.

NS Yes. I mean I could have stopped it but I did not want to. But I am grateful to Jasia for having made the preliminary contacts to build networks that would make such an exhibition possible. Without her it would not have happened.

KMM Was it a difficult exhibition to make?

NS No, it wasn't a difficult exhibition. I already had contacts with the Foksal Gallery from my time in Oxford. There was a general wish on the part of the Polish government to allow such productions in the West and therefore there were no obstructions at the government level and we received considerable help from colleagues in Poland in gathering the material together. However, Kantor himself was very busy in Riverside Studios. I have a recollection that we did not begin the installation very early in the morning! Kantor would join us during the day with his wife and we spent time installing the exhibition together.

He was very active in the placing of the work. Of course, the exhibition focused really on two aspects: first of all, the concept of the *emballage*, and then, secondly, *The Dead Class*. The purpose of the exhibition was to show that Kantor as a director had a counterpart in Kantor as a maker of objects, so that the strength of the *mise-en-scène* in his theatrical productions depended in part on his commitment and engagement as an artist. The two sides of his work came together. I was keen that he should be seen as a painter and sculptor as well as a theatre director.

KMM I wonder to what extent this was a challenge because Kantor was one of the very few artists who combined those two activities of the theatre director and of the artist. Nowadays this would not have been so surprising, but at that time it must have been challenging.

NS Well, it was challenging, but in 1974 I had worked with Joseph Beuys in Oxford and therefore had some experience in working with the artists who were engaged in performance. Of course, Beuys is not Kantor and he worked in a very different way, but, I think that for a young curator at that time the challenge

Opening of *Tadeusz Kantor: Emballages 1960–1976* at the
Whitechapel Art Gallery, London, September 1976, from the
left: Kantor, Ernest Bryll and Maria Stangret-Kantor,
photograph Richard Demarco, courtesy Demarco Archive.

was probably not as great as it would have been for an older person with more
conventional ideas about curating and about making exhibitions. I think I was very
open to the challenge that you describe. Kantor had performed in England and
Scotland on several occasions, but his work as an artist was almost unknown. It was
part of my role and that of the Whitechapel to make known his work as an artist,
not least to improve an understanding of his work as a theatre director.

KMM Can I go back to what you have said earlier? You said you had contacts with
the Foksal Gallery at the time of your work in Oxford.

NS I had come to know them, especially Wiesław Borowski, partly through his
engagement with Ricky Demarco in Edinburgh, but also because there were a number
of British artists who I admired and who, at that time or soon after, had been given
exhibitions at the Foksal Gallery, including Richard Long and Hamish Fulton. Wiesław was
the principal curator of the Foksal Gallery and an occasional visitor to Britain at that time.

KMM I wonder to what extent, do you think, the contacts between the Polish avant-
garde and the British avant-garde were quite close at that time or were they rather
haphazard, depending on personal encounters and limited to the happy few.

NS I would say the contacts were quite close but not very extensive. I do not think
they were haphazard. There was a conscious sense of communication and interest
going in both directions, both amongst a new generation of conceptual artists and
for an older generation in the area of Constructivist painting.

KMM Would you say that it was Kantor who played a central role…?

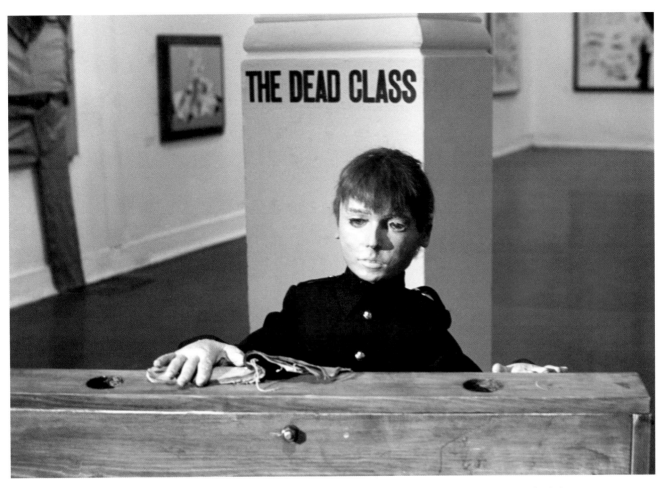

A desk from *The Dead Class*, 1975, desk and mannequin, 100 x 80 x 80 cm, Muzeum Sztuki w Łodzi, at *Tadeusz Kantor: Emballages 1960–1976*, Whitechapel Art Gallery, London, September 1976, courtesy Whitechapel Art Gallery, copyright Maria Stangret-Kantor and Dorota Krakowska.

NS In promoting this? No, I don't think that Kantor did. I think the main person was Wiesław Borowski. We all know that he led the Gallery in a very remarkable way at those years. And it was his sensibility and his awareness that brought these two related groups of artists together in Britain and in Poland.

KMM This was also accomplished not only through Wiesław Borowski's activities but also through his texts, published in *Studio International*.

NS Correct. And also, I think, the British Council had played a part in terms of making it possible for British artists to show their works in Warsaw. I think what Kantor contributed was to give a very high profile to a slightly older generation of Polish artists. And there was very considerable excitement and interest aroused by his performances at Riverside.

KMM I want to ask about the medium of *emballage*, the medium which is specific to Kantor, which he invented and named, using the French term *emballer*, and which was for him a way to abandon his abstract, *informel* paintings and to return to the real objects of the lower rank but not through representing them—and thus by creating an illusion—but by wrapping them and fixing them to his canvases, or, by making art out of the very process of wrapping. *Emballage* has always seemed to me notoriously difficult, which was defined by Kantor many times and each time, defined in a different way. Was it possible to place *emballage* within the idiom that was current in the British art world? And further, Kantor's theatre appeared to speak to his British audiences; how about *emballage*, this, arguably, most difficult amongst the visual media and types of visual art used by Kantor—was it 'read' by the Whitechapel visitors?

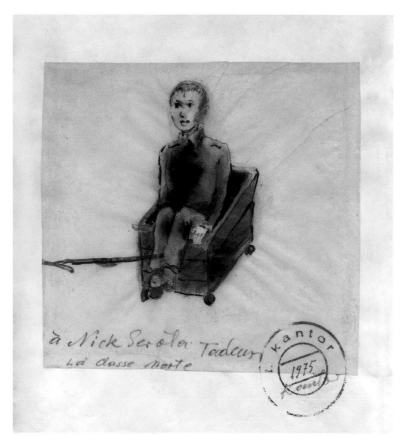

Tadeusz Kantor, *À Nick Serota Tadeusz: La Classe Morte,* drawing, 1976, private collection, copyright Maria Stangret-Kantor and Dorota Krakowska.

NS I do not think that there was a very full understanding of the resonance of the term *emballage*, which he invented. You have to remember that for British audiences at that time, not much exposed to continental European developments, most of their knowledge came either from British artists who had employed the use of objects in their work, like John Latham, or American artists such as Rauschenberg. I do not think that the full philosophical basis of Kantor's work was completely appreciated in England. Reviews of the exhibition showed some curiosity in the oeuvre of an artist who had been working for many years without being noticed by Western audiences. There was an interest in the connection with his theatre work, but I do not think there was a profound analysis of the philosophical implications of his work as an artist rather than as a theatre director.

KMM A bibliographical question: it was a touring exhibition which had originated at The Museum Sztuki w Łodzi in May 1975, which visited Stockholm and Oslo, and, after London, Nuremberg. It seems, however, that there were two publications accompanying the Whitechapel show: the Łódź catalogue and the Foksal collection of Kantor's texts.[2] The Łódź catalogue, used as the basis for the Whitechapel catalogue, has a standard format: it includes a biography of the artist and a short introduction to the various strands of his art, plus *emballage*, written by Ryszard Stanisławski, and plenty of images. The Foksal publication instead is very focused, conceptually, academically. There is no single image and, apart from the text by Wiesław Borowski explaining the history of the medium of *emballage*, it is entirely composed of Kantor's texts of the 1960s, relevant to this concept. This catalogue accompanied the Whitechapel exhibition; it was translated into English by Piotr Graff, and it bears a note that this exhibition "can be seen at Whitechapel Gallery" from 22 September. I wonder whether you remember the circumstances leading to the publication of those two separate volumes.

NS You have done a very interesting piece of analysis. I cannot recall the detail. My recollection is that we would have wanted to produce a catalogue that included images. And my recollection also is that the exhibition had been in Łódź and that this exhibition was essentially the exhibition that came to London. I could probably ask someone to look at the archives in Whitechapel and to see whether there is an explanation of this. You might also ask Wiesław Borowski about that.[3]

KMM In what language did you communicate with Kantor? The son of inter-war Central Europe, Kantor was fluent in French and German, but probably not that much in English…

NS In French.

KMM I often ask this question about Kantor and the Cricot 2 Theatre performances abroad, which were never translated, always in Polish. It was sound which mattered for him, less so the actual meaning of words.

NS Sound was very important for him, only later did you comprehend the meaning. In that sense I think he was much closer to a Central European tradition as with the sound works of Kurt Schwitters. There is an interesting connection there. Language was really important. The way the words sounded and the physical character of the actors was obviously highly important. I think it is one of the reasons why the films of the performances are so crucial. It is not possible for someone to restage a performance now without Kantor being present.

KMM In your assessment, how long-lived was the fascination with Kantor amongst British curators, artists, actors, the British art world of the 1970s?

NS I think it probably was the strongest between 1975 and 1985, the decade which was connected with his performances.

KMM Has it been stronger in the world of theatre and performance studies than among visual artists?

NS Yes, I would say so. I do not think there was a very strong interest in his paintings and objects. It was his performances which really made an impact.

KMM Did working with Kantor have any impact on your own formation as curator?

NS During that period I found myself on number of occasions working with artists who crossed these borders between performance, action, theatre and the creation of objects, including Beuys. The engagement with Kantor served to reinforce that experience and to encourage me to be open to artists who work across different media.

KMM Any other comments, recollections…

NS I believe that Kantor is an artist of continuing importance, not just in the theatre, but also in terms of objects that he made. Unfortunately, most of the objects are still in Polish collections, but it would be interesting to see his works in the context of wider debates about the way in which art developed in the 1960s and 1970s.

NOTES

1 Serota, Nicholas, "Tadeusz Kantor at Whitechapel", Tadeusz Kantor: Interior of Imagination, Jarosław Suchan and Marek Świca eds., exh. cat., Warsaw: Zachęta Narodowa Galeria Sztuki, Kraków: Cricoteka, 2005, pp. 122–125.

2 Kantor, Tadeusz, *Emballages 1960-1976*, Ryszard Stanisławski ed., exh. cat., London: Whitechapel Art Gallery, 1976; Kantor, Tadeusz, *Emballages,* Wiesław Borowski ed., Piotr Graff trans., Warsaw: Galeria Foksal PSP Books, 1976.

3 Wiesław Borowski confirmed that the reason for the Foksal publication with English translations of Kantor's texts was to introduce the British audiences to his original thoughts about the medium of *emballage* which have occupied Kantor for more than 15 years.

KANTOR AT RIVERSIDE STUDIOS

DAVID GOTHARD

My tale is relative to the stories of others and is extemporised in order to fill gaps, to avoid unnecessary historical upset and to bring the discussion and history of Kantor further. My aim is to stress the significance of Kantor, long overdue, in bridging the gap between contemporary arts and performance, a world he inhabited with Artaud, Edward Gordon Craig and Samuel Beckett. His history from the 70s intertwines with the major achievements of the Demarco Gallery where a brilliant manager, Julian Bannerman, designer of the British commemorative square for the 9/11 tragedy in New York, held the fort as Richard Demarco and the Edinburgh Arts flotilla sailed the high seas in search of creative enlightenment. This enabled myself, as a student director at the Traverse Theatre, Edinburgh, to fit into Kantor's ways and be the architect for Kantor's large-scale work travelling out of Poland. Both Demarco and Kantor knew that *The Dead Class* would be without precedent in needing the handling of a major work of 'theatrical' dimensions, even though that dreaded word "theatrical" was high risk around Kantor himself and the performance itself was subtitled, a "séance". This is an invaluable word taken for granted by Kantor but largely ignored by commentators as its analysis involves too much of an understanding of the interior of the creative and sharing being beyond the normal decorative assumptions of theatre.

Kantor, like others, was my teacher. He lay seed to an understanding of a building or lack of building as creative space governed by work that has smashed traditional confines however grounded in the history of the arts, as Kantor's work inevitably was.

The Edinburgh Poorhouse, perfect home to previous Kantor performances and forum for Joseph Beuys and Buckminster Fuller in the same year with Demarco in Edinburgh, was no longer available. As a young Director at the Traverse, with apparently a peculiar international outlook, I was asked to do the reconnaissance to Kraków during the original rehearsals of *The Dead Class*, which would allow Kantor to sleep at night knowing that the potential framework of the Festival Fringe was reliable for hosting the work. I choose my words carefully but they succinctly describe the paradoxes and parameters of Kantor's visit, even culminating in a pat on the back and a Fringe First Award from a respected television star, Andrew Cruikshank, president of the Fringe.

I arrived in Kraków to a bustle of daily carpentry and preparatory time between carpenter, though he was also a key performer, technicians and the performing artists themselves.[1] Documentation going to print had urgently to be checked by me with Kantor himself, essential to a visual artist diligent with his language, and mainly done over a week or so around the Kantor dining room table with Maria Stangret, Kantor and myself happily speaking French to each other, before we left to do major work in the Niedzica castle on the Slovak frontier, the seat of the Association of Polish Art Historians. We stayed there and later, in 1982, kidnapped the resident family of custodians into the Cricot 2 company.[2] Also, urgently, script details in English were being rehearsed, with "Kaiser Bill" and "Today, war is declared" first on the list.

This could seem all slight stuff but over the days into weeks, I was absorbing the humour, discipline and warmth of the Kantors and Cricot 2 to handle the most difficult issue of all: how to leave carrying the spirit of the Galeria Krzysztofory, the performance's home in Kraków, such that choosing the space in Edinburgh would be accurate. It has to be stressed that before getting into the complexities

Opposite David Gothard secured the agreement of Riverside's director, Peter Gill, to show *The Dead Class* in London in advance of the Riverside programme's opening. Hence it was *The Dead Class* that launched the new venue for the arts and the radical precedent was set. The building was in a state of semi-dereliction which was ideal for the performances and they could remove partitions and leave the building work in an exposed state, photograph Ian Knox, courtesy Ian Knox (JM).

Above Matilda O'Brien left, with Andrew Cruikshank at Edinburgh College of Art. Cruickshank was the President of the Fringe Festival and was a famous actor, best known as the star of *Dr Finlay's Casebook*, a popular BBC TV series in the 1960s. He presented Kantor with a 'Fringe First Award', photograph Ian Knox, courtesy Ian Knox (JM).

of performance space as technically understood, space as understood by Cézanne or Beckett, was the issue: a mood, a feel and basic practicalities had to be resolved rather than recreate the original space in any imitative way. It had to be re-born. Later, when Peter Brook had similar requirements for touring the shows of the Bouffes du Nord, as a theatre director, his requirements were of a more specific mood to do with the style of the original theatre and its dimensions. For Kantor, the unspecific understanding had to be there of knowing the requirements artistically as the final favour.

Apart from reporting back to Edinburgh, including to the Scottish Arts Council as sponsors of my trip, my job was meant to be over. There was no money to pay me beyond the expenses of the Polish trip. "But David, Kantor's French accent charmed, you know how upset I can get and even refuse to do the performance, so please would you go up to Edinburgh and just make sure that conditions will be perfect and that not only will I not lose my temper but that my health, ever an issue, will not be rocked." I paraphrase of course.

We who survive, know that such an agreement if made, is not a pact with the devil, but a moment of will and kindness that opens doors of pain, ecstasy and everyday banality for the rest of one's professional life.

The true story of Kantor in England and Scotland is, with the stories of the members of Cricot 2, as yet mainly untold. Official truths are not just for old Communist countries and the story of Kantor's international journey such that I am where I am today is worthy of Italo Calvino. Yes, dear reader, Kantor netted me for life. This will be understood by all of those who worked with him, through laughter and tears, revealing bit by bit in their Polish memoirs the real dramas and

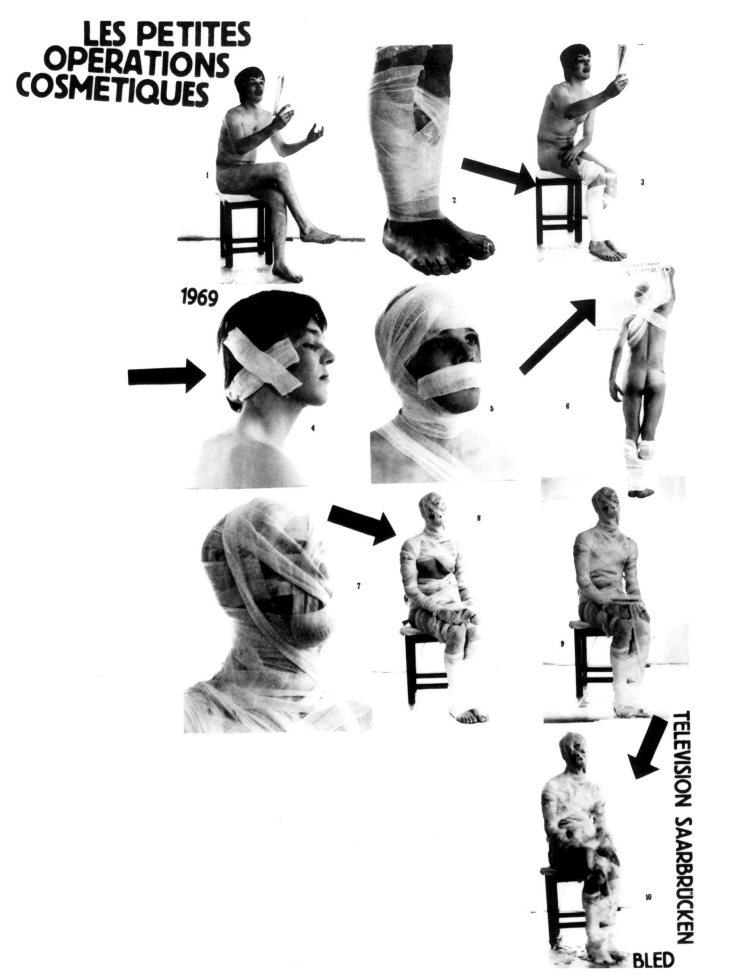

LES PETITES
OPERATIONS
COSMETIQUES

1969

TELEVISION SAARBRÜCKEN

BLED

Felix 'the Polish tramp', had walked to England from Poland after the Second World War, and ended up living at Riverside Studios. From the left: Gabi Kabza, programme coordinator at Riverside, Kantor, Felix; at the background the exhibition Tadeusz *Kantor and Cricot 2: Drawings/ Photographs/ Documentation*, 1980, photograph Chris Harris, courtesy David Gothard (JM).

excitement: Kantor's arrest momentarily in Hammersmith after the most brilliant, huge "KANTOR IS COMING" graffiti appeared on the Hammersmith Flyover on the Broadway, recorded in a photograph; Kantor's participating in a press conference on every television 6 o'clock news as part of a takeover bid for the staff of Riverside running the building without the politicians, at a time when Margaret Thatcher was trying to wipe out the local politicians for being "Commies". And so on. All the time he was teaching me. His public speeches, including the personal note of advice addressed to me, especially to do with the role of art against that of the building housing the art.

His arrival in Hammersmith, West London, was a curious homecoming of sorts. Quickly, his personal friend living nearby in Chiswick, Wanda Baczyńska arrived. Formerly she was close to his beloved professor, Karol Frycz, a prominent stage designer and admirer of Edward Gordon Craig. Wanda had to be rung for dinner on the first day of arrival. She had been of real importance in Kantor's life.[3]

A former student of his own, Maciek Dymny was also nearby, surviving in London as an artist, but recognisable for his role in a Kantor *emballage* performance wrapped in bandages.[4] I can even fit into the picture, Felix, the inevitable Polish traveller—or tramp as we called them then—who had walked from the Baltic sea coast after the Second World War and closely resembled the man adored by Kantor in Kraków when I was there, who carried his ladder around all day so that he could crawl into his attic at night.

The Riverside Studios had been vacated by the *Dr Who* team of the BBC and were being considered by the Hammersmith Council as a facility for the arts. The success of *The Dead Class* meant a precedent as The Riverside Studios' first Director,

Riverside Studio's were formerly the BBC studios where the popular *Doctor Who* series was filmed, photograph Chris Harris, courtesy David Gothard (JM).

Peter Gill, opened the building one year after Kantor's performance with his own radical British work, but enveloped in a programme of international concern in all the arts, for which I was made responsible. Peter Gill's *The Cherry Orchard* formally opened at Riverside in January 1978. I became artistic director in 1980, when Peter Gill was rewarded by setting up the National Theatre Studio, a legacy of Riverside Studios. Since the World Theatre Season of Peter Daubeny, London had no place for international programming; but I was eased and provoked by the fact that each foreign visit by the likes of Dario Fo, Shuji Tereyama (an admired friend of Kantor's), Joan Miró and Catalan puppets—in the visual arts alone, overlapping with theatre performance in the first year—meant that the heroes to a local, political board kept receiving the rubber stamp because of the huge success of previous events.

Margot Fonteyn with Rudolph Nureyev queued in Crisp Road to see *The Dead Class*. The BBC, noticed through a producer, Rosemary Wilton, that I had given everything to answer Kantor's apparently simple request "to nip up to Edinburgh for a day", a day that became several months in 1976, including the corralling of one small town of importance, Peebles, in the borders of Scottish and English raids, such that the whole of the Cricot 2 company could be accommodated properly for its Scottish run, till Richard Demarco came back from his sailing ship. Consequently, I was invited to talk about *The Dead Class* on prime time television coverage of the Edinburgh Festival with an excerpt from the piece that gripped the art viewer by the throat. Kantor abroad, London and its rich consequences of production and press, my own life, and the birth of a great London arts forum, lasting for a decade, were all ignited. Ten years later it came to an end as its gallery, managed by Milena Kalinovska, was nominated for the Turner Prize.[5] Into the 80s, Riverside and I never

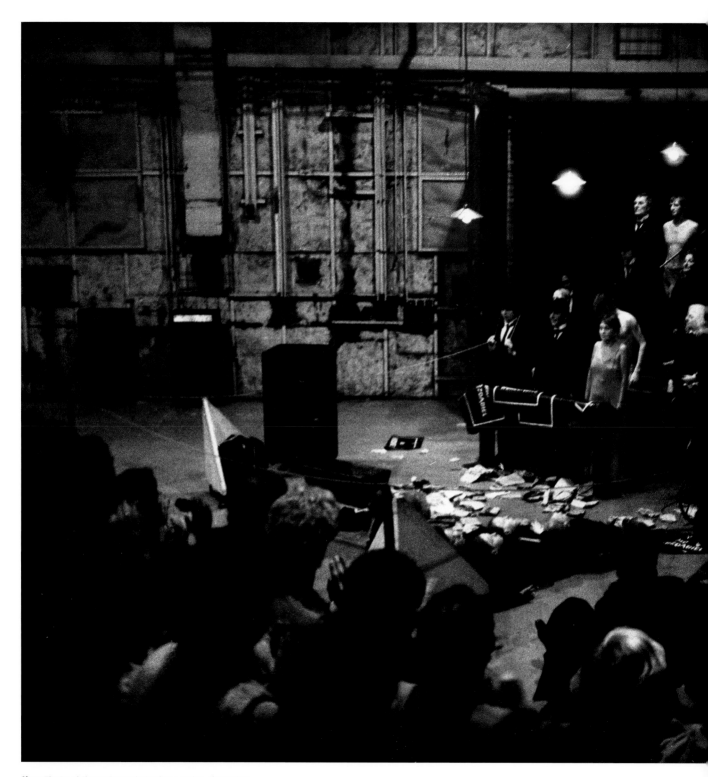

Above *The Dead Class* at Riverside Studios, London, September
1976, photograph Demarco, courtesy Richard Demarco Archive.
Opposite Leaflet for *The Dead Class* at Riverside Studios,
London, September 1976, courtesy David Gothard.

lost our celebration of infiltration by Kantor. The Polish Constructivist works from Łódź, the doyens of the Polish avant-garde art and poetry, Henryk Stażewski and Zbigniew Herbert followed over the years in person. Worth mentioning too, that a generation of schoolboys, such as Simon McBurney were dragged to see the work and had the seed sown for the birth of Theatre of Complicite and much more in the British arts.

In 1980 Riverside hosted *Wielopole, Wielopole* and at the same time an exhibition of Kantor's work was shown in an improvised gallery. Nearly all work was hung with pegs on suspended string. All of cultivated London and its young artists had to see it on the first of more visits. By the early 80s martial law had been declared but already Kantor's light in the darkness was strong enough to get me into Poland under martial law as the second person from London so that I could negotiate the visit of Cricot's 2 coming out to perform here in 1982. Kantor himself, had temporarily left for Paris with Andrzej Wajda silently unacknowledged at the other end of the plane, despite or because of his film of *The Dead Class*. He returned. Kantor loathed Wajda's film of *The Dead Class*, especially the use of landscape and location.[6] If I can be a little droll there would be an element of rivalry over who was the second most famous living Pole after the Pope, a sort of bull's eye joke prevalent at the time, encouraged by Kantor in the privacy of Cricot 2.

Only a few years on from those nervous early steps, the next few were beginning with Kantor in the wake of a Polish Pope desperately wedging open the door of normality and freedom. A few years on I was carrying parcels and messages from Samuel Beckett to his translator, Antoni Libera, in a Warsaw suburb close to the church of Father Popiełuszko, down the bus stop from Jacek Kuroń.[7] This led to a quiet but occasionally public intertwining between Beckett, Poland and myself as Director of an English theatre, Riverside, where Libera's Krapp played by David Warrilow kept Beckett involved on a final project. Nobody of a certain generation forgets the energies of important messages in the bad old days. My first boss at the English Stage Company at the Royal Court Theatre had been the great British film director, Lindsay Anderson, whose work in Poland helped nurture my spirit. The great actor, Tadeusz Łomnicki—when I saw his great Polish *Krapp's Last Tape* directed by Antoni Libera—begged me to persuade Lindsay to return to Poland to direct him as Lear. They had done a brilliant production of John Osborne's *Inadmissible Evidence* together in earlier days in Warsaw. All of us represented a fragile network of continuity in the relationship between both our cultures. The network somehow got through, came to work and loved Samuel Beckett, who can never be understood intellectually without a more simple understanding of his moral and creative stance at the end of the horror of the Second World War. Like the great New York Abstract Expressionists, Francis Bacon and other great artists of the post-war survival generation, the need to begin again was the battle of their personal creative souls leading to the landscape after battle shared by Kantor. Breath, basic materials of survival, landscape and the camp as materials and above all, humanity itself, rose up through memory and unforgettable image without their being obliterated or cast aside in the continuing journey for the modernism of the twentieth century.

In the middle of the third Cricot 2 visit to Riverside, probably timed by me a little, the Riverside board, an independent trust, had sadly agreed to wind down Riverside because the funding from Hammersmith itself was to cease. My electricians had illegally bugged that board meeting; when the wonderful and legendary chairman of Riverside—and former Secretary General of the Arts Council—with tears in his eyes, came to saying that they had therefore to make all staff redundant, I interrupted to invite everybody to a press conference next door with Kantor, Tony Banks—who was the leader of the Arts Greater London Council—and myself. The ITN TV news was waiting for the live six o'clock transmission, as Riverside was huge news. I invited Sir Hugh to join us on the panel next door. You have to understand that this was the historical period that Margaret Thatcher was to abolish the GLC because of its radicalism. For a period she succeeded. Arts organisations were what we call footballs in this dispute. In order to open the safe Hammersmith Lyric Theatre, with the Queen in attendance, the Tories needed to dump a Riverside that they had never understood. This meant that the GLC could embarrass Hammersmith by giving us the wherewithal for forming a new company financed by the GLC. So Riverside carried on. For the record there is a brilliant transcript of a Kantor speech that is partly addressed to me as to the role of buildings in the development of the arts relative to the creative spirit. This brought me back to day one with Kantor when he lovingly tricked me into finding the space that *The Dead Class* would need in Edinburgh. At a related meeting that day, Kantor spoke to Riverside staff in the Green Room, turning it into a very personal piece of advice. His use of the word "sentimental" was an affectionate and witty device that he only used for Ellen Stewart at La MaMa Theatre New York and myself. It meant that he would always try to be supportive to both of us, despite money, because of the battles that we fought for the proper spirit of performance and art. For myself, life with Kantor was a perpetual seminar, normally with myself translating his French for journalists or others.

Finally, Kantor, in London from the outset, loved being in the home country of Edward Gordon Craig, the great neglected English artist of universal importance

Actors of Cricot 2 made a poster to support the Riverside's protests against the GLC's funding cuts. Riverside Studios declared a 'work in' to keep the building open and the shows running at the end of November 1982. David Gothard walks on the right; Erica Bolton stands in the middle of the group, photograph Chris Harris, courtesy David Gothard (JM).

to modernism, passionately passed on to Tadeusz by Karol Frycz. He knew that Craig's importance had to be simply and strongly stated till the rut and pit of theatre and performance is abolished. It is the key to the purgatorial situation where we still find ourselves even as lovers of theatre study more and more their Kantor without his Cézanne: the need for theatre, for performance, to smash open its creative space to a world that Cézanne and Beckett, again, would recognise, to bridge the internal space of the artist and participant, rooted in the history of painting, with the more obviously external. He loathed art as decoration. It is in the territory hinted by Craig of "one that has never been used by man, to give form to your thoughts, then you are well on the way towards creating a new art".

Kantor loved Paris but he knew the importance of London.

David Gothard with his Polish friends in a garden close to Kraków, from the left: Milada Ślizińska, the Foksal Gallery curator, Kazimierz Mikulski, the painter and Cricot 2 actor, David Gothard and Maria Stangret-Kantor, the artist and Cricot 2 actress, photograph Wiesław Borowski, courtesy Wiesław Borowski.

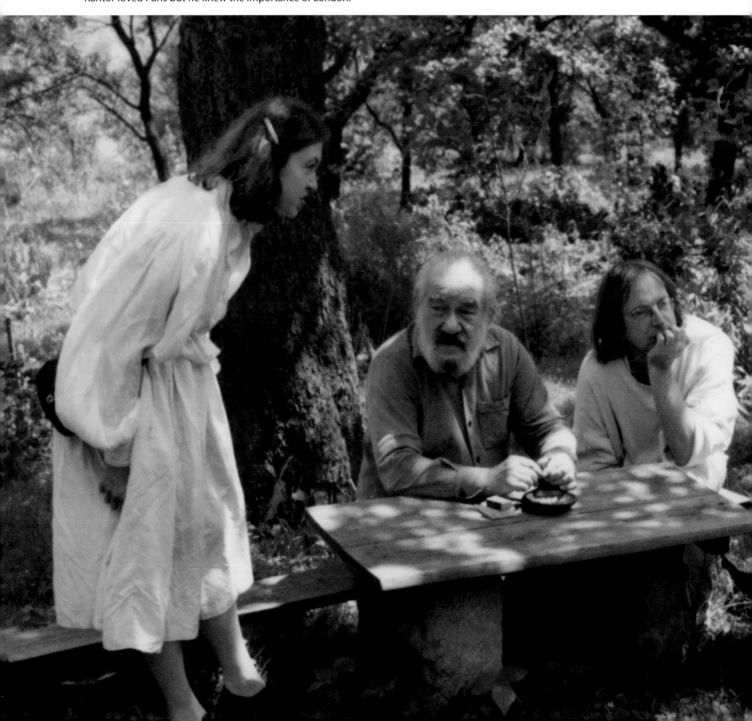

NOTES

1 Jan Książek, the Cricot 2 carpenter took part as an actor in all the spectacles of the Theatre, from *Lovelies and Dowdies* to *Today is My Birthday*.

2 Dominika Michalczuk, the daughter of the Niedzica Castle's Director, was given a role of Rabbi's pupil in the performance *Où sont les neiges d'antan*, shown in Riverside Studios in London in 1982. In her memoirs of the tour she wrote: "I remember an amusing episode, when we were not able to continue with our rehearsals in London, because a rock band was practising behind the wall. Kantor turned furious and demanded to shut up the competitors straight away. And indeed, in a moment music stopped. It would not have been surprising, had it not been for the fact that the group behind the Wall was Queen…. Kantor was very enthusiastic when we were visiting Madame Tussaud's in London, watching the wax figures for hours (he showed his great interest in the figures and was comparing them to his own, made for *The Dead Class*)—Michalczuk, Dominika, "Przeciwko tym mitom", "*Zostawiam światło, bo zaraz wrócę*"—*Tadeusz Kantor we wspomnieniach swoich aktorów*, Kunowska Jolanta ed., Kraków: Cricoteka, 2005, p. 179.

3 Kantor met Wanda Baczyńska during his studies at the Academy of Fine Arts in Kraków. She died in London on 29 July 1982, a few months before the next visit of Kantor, who was deeply moved by her death.

4 *Minor cosmetics operations*, 1968, *Tadeusz Kantor: Emballages 1960–1976*, London: Whitechapel Art Gallery, 1976, no. 67; also *The Impossible Theatre*, Warsaw: Zachęta, 2006, pp. 110–117.

5 It was specifically the programming of the gallery of Riverside Studios under the management of Milena Kalinovska which was under threat. Indeed, after my departure, it closed. There was a specific gallery. The ambiguity is that Riverside art was also in the studios themselves and in the public forum or lobby where the Lisson, for example, tested new sculpture in the public space. The programming of Riverside Studios' gallery was the Turner Prize nomination.

6 Andrzej Wajda made a film of Kantor's *The Dead Class*, bringing some episodes outside the Krzysztofory Gallery, into an open space, the meadows and the Plac Nowy (New Square) in the Kazimierz, district of Kraków. Kantor, although he initially accepted this idea, was not happy with the results. Nonetheless, the film by Wajda remains the only full record of the first version of *The Dead Class*.

7 Antoni Libera is a Polish writer, translator and stage director. He translated and directed, amongst others, Samuel Beckett's *Krapp's Last Tape* with David Warrilow at the Leicester Haymarket and Riverside Studios 1989–1990. Beckett, with whom he was in regular contact, called him "my deputy in Eastern Europe"; Jacek Kuroń, a prominent Polish social and political figure, appointed twice Minister of Labour and Social Policy (1989/1990; 1992/1993), was at that time one of the democratic leaders of opposition in the People's Republic of Poland.

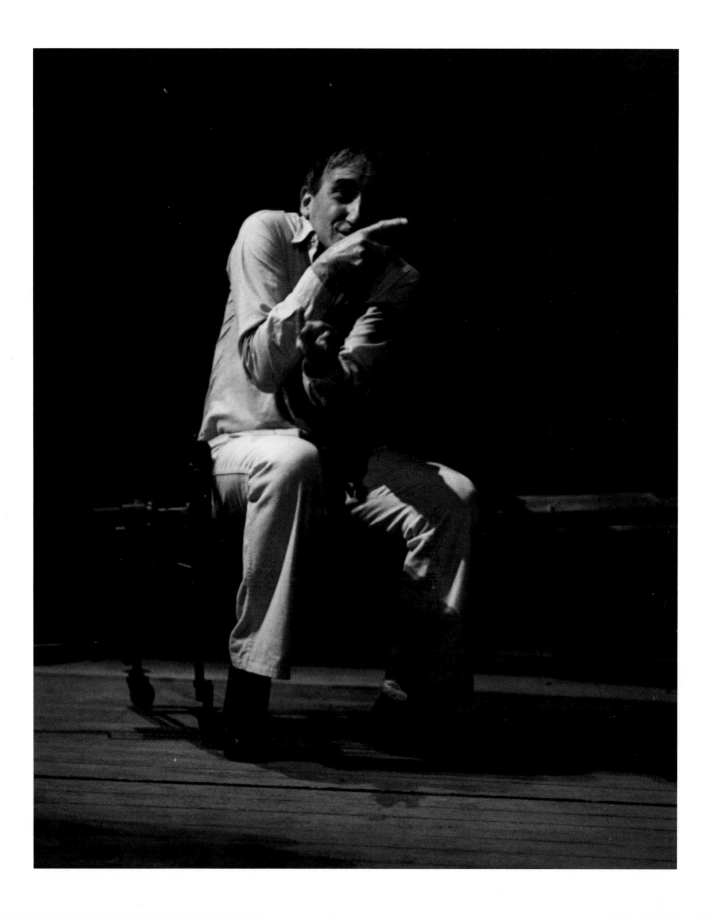

TADEUSZ KANTOR: THEATRE AS THEATRE

KRZYSZTOF CIESZKOWSKI

For those of us who were born in England in the wake of the Second World War, the children of Polish parents exiled from an unknown country far away across an immutably frozen continent, there were heroes all around us. Those closest to us, our parents and the colleagues from their wartime experiences, the past they carried with them and that would never leave them—we knew there was heroism here, and that we would never be able to live up to it.

There were cultural heroes whom we encountered distantly at social occasions for the Polish community in London—Marian Hemar, Feliks Topolski, Marian Nowakowski, Zygmunt Nowakowski, Andrzej Panufnik, Władek Sheybal. There were those for whom the entire hall stood up in homage and pride when they entered—Generał Anders, *pani generałowa* Renata Bogdańska. There were also those for whom our respect was tinged with sadness—General Tadeusz Bór-Komorowski. And there were also more distant heroes whose memory was kept alive only by those around us, in this strange enclave of England—Marshall Piłsudski, General Sikorski. We were conscripted into the Polish Boy Scouts, and marshalled to mass with a Polish sermon on Sundays, but these things seemed laughably irrelevant to the problem we had with our identity and with our heroes.

The cultural heroes of this small, seemingly anachronistic, circumscribed world of exile often seemed sadly parochial to us, their efforts and achievements appeared to belong on a community scale rather than a national one—whatever the nation. Only later, after 1989, in the new perspective which then became available, were we able to re-evaluate their achievements, and to regret that we had not paid more attention to them at the time, when history had briefly placed us close to them.

Then there were cultural heroes whom distant Poland sent us, in a whole variety of ways. Some we could easily acknowledge and adopt—the films of Andrzej Wajda, Andrzej Munk and Krzysztof Zanussi, the acting of Zbigniew Cybulski and Tadeusz Łomnicki, the poetry of Tadeusz Różewicz and Zbigniew Herbert. Other aspects of this cultural exchange were stranger, often merely bizarre—films like *Barwy Walki* and *Seksmisja*, the oddly ritualised folklore of Mazowsze and Śląsk, who pretended to be showcasing happy Polish folklore to an English audience, while aware that this audience consisted almost entirely of émigré Poles and their families, observing critically the ways in which the PRL had appropriated folk culture.

There were always two cultural Polands—the 'false' one of the Polish People's Republic, maintained by mendacity and lies, by foreign oppression and alien values, and the 'true' one of the Polish diaspora, frail and increasingly elderly and anachronistic, but nevertheless still the keepers of the flame. The Embassy had its Polish Cultural Institute, and the diaspora had its base in POSK (Polish Social and Cultural Association) and the The Polish Club Ognisko, and each refused to acknowledge the existence of the other—so much so that a request in the POSK bookshop for the poetry of Różewicz elicited the ill-tempered snarl "we do not stock Różewicz here, he is *reżimowy* [he belongs to the regime]".

The visual arts seemed to have little place in this cultural exchange. Contemporary art was alien to both the Cultural Commissars of the PRL and the increasingly elderly ex-servicemen who ran the cultural life of the Polish community. Neither made much attempt to hide their contempt for contemporary art. Here in London, no issue of *Dziennik Polski* was complete without a tired jibe at Picasso and at modern art in general—the taste of those who ran the *Dziennik* had progressed no further than Jan Matejko and Juliusz Kossak. The activities of Halima Nałęcz, Marian Szyszko-Bohusz and Mateusz Bronisław Grabowski and others, the achievements of the Drian Gallery, the Grabowski Gallery and the Centaur Gallery, seemed to be peripheral to the life of most of the Polish community. Such at least was my perception at the time, from the point of view which I was afforded by chance or by accident.

Opposite Tadeusz Kantor in *Wielopole, Wielopole* at Riverside Studios, London, September 1980, photograph Chris Harris, courtesy David Gothard.

We came to hear of Tadeusz Kantor through English (or rather British) channels, not through Polish ones. Richard Demarco brought Kantor's sculptural work, along with that of other contemporary Polish artists, to the Edinburgh Festival in 1972, and the Whitechapel Art Gallery showed a retrospective of Kantor's *Emballages* in September–October 1976, just at the time that Nicholas Serota took over as director there. Kantor had already brought his version of Witkiewicz's *Kurka Wodna* (*The Water Hen*) to Edinburgh in 1972, and in 1973 his *Nadobnisie i koczkodany* (the title rather lamely translated as *Lovelies and Dowdies*). However, in August 1976 *Umarła klasa* (*The Dead Class*) came to the Edinburgh Festival, and this was a cultural event of no small magnitude—it made a huge impression on those who saw it, and could not but impinge on the awareness of those who didn't, such was the level of discussion of it in the media at the time. I would compare its impact in Britain to that of Diaghilev's *Ballets russes*, the Indonesian *gamelan*, and the theatrical work of Peter Brook earlier in the century.

But it must be conceded that the UK was far behind most other countries in recognising the remarkable achievement of Tadeusz Kantor, as regards both his fine art and his theatrical activity. The rest of Europe seemed to have settled down to a critical awareness of his work long before Britain did—nothing new there, then.

In September 1980 Kantor brought his Cricot 2 Theatre to London with a production of *Wielopole, Wielopole*. Let me quote from my diary of 12 September 1980:

> to the Riverside Studios, Hammersmith, and my interview with
> Tadeusz Kantor; the idea had originally been to try and talk with
> him to get material for a piece I want to write for *The Literary Review*,
> and Sarah FP suggested I record an interview for the Archive, in
> Polish, which I would then transcribe and translate. Telephoned
> the Riverside and arranged to meet him; I introduced myself to
> him, and it was his suggestion that we sit on the stage, in among
> all the props that in an hour or so would be used in a performance
> of *Wielopole, Wielopole*—at a grey table, a pile of sand on the boards
> of the stage, the mannequin of the priest on a chair near us, a
> cupboard, the sliding door behind a row of wooden rattles (used
> during Lent in country-churches instead of church-bells); a
> stagehand was tinkering with the bed, whose centre turned around an
> axis. It was a good interview—I'd brought along a list of questions,
> or topics, but these were soon discarded, and I let Kantor lead the
> conversation—he read out extracts from essays he had written, on
> his theories & ideas, on the past, time, repetition, etc.. I interjected
> occasionally, but generally he talked. It recorded well. He talked
> animatedly, using his hands to give expression and emphasis.
> Aged 65; reminded me of a photo of Brecht, and of the older Peter
> Sellers—long jaw, long nose, thin grey hair.

I had already interviewed several people whom I particularly admired—Ernst Gombrich, RB Kitaj, and others—and the idea of interviewing Tadeusz Kantor was a felicitous one. I was writing extensively at the time for *The Literary Review*, *Art Monthly*, the *Times Literary Supplement*, *History Today*, and other journals.

The interview with Kantor constituted, for me, an extraordinary 45 minutes, a piece of theatre unlike any I had previously experienced. As I mentioned in my diary, we sat on stage, among the props and mannequins that were about to be utilised in the performance of *Wielopole, Wielopole*, a few minutes later. I had prepared a list of questions, but soon abandoned them, and merely made a suggestion or two, to turn the direction of Kantor's increasingly animated monologue in a direction that interested me. He talked as if he would never stop, as if he wanted to summarise everything he wanted to say, as if he had decided to utilise the opportunity of my presence with a tape-recorder to put on record a summation of his thoughts and beliefs.

He spoke about religion, spirituality, his conception of art, symbolism and Maeterlinck, myth, mythology, "*realność najniższej rangi*" (reality of the lowest rank), Bruno Schulz, abstraction, Constructivism, his opposition to the negativism of Dada, childhood, memory, his perception that memory lacks continuity but instead focuses on a casual material image which pulsates, illusion and repetition, his repudiation of realism in the search for truth, his work with happenings, performances, actions, manifestations, the metaphysical aspects of illusion, ritual, mannequins and dolls, repetition as an existential protest, repetition as a mockery of power and pomposity, repetition as the essence of illusion, Witkiewicz, etc..

And as we talked, the time for the start of the performance of *Wielopole, Wielopole* came and went, the stage-technicians of the Riverside Theatre kept appearing and looking nervously at us and trying (unsuccessfully) to catch Kantor's attention, and the audience in the foyer and the bar of the theatre must have been glancing at their watches and wondering why the performance they had come for had been delayed.

I felt that Kantor could have talked for ever, that he wanted to talk and talk for as long as he could. I remained rather intimidated by him, even though he was faultlessly polite and courteous to me, but I felt he was in full flow and that what he was saying was valuable, was of great importance, to him and to me. He had copies of his essays and statements with him, and skilfully plucked out an appropriate passage to illustrate what he wanted to say. His monologue flowed on with increasing vitality, and all I had to do was nudge him in this direction or that.

As luck would have it, the tape in my cassette-recorder eventually ran out, and while I was opportunistically turning the tape over to continue recording, the stage manager, a Person from Porlock if ever there was one, interrupted us with the not-unexpected news that the audience was becoming restive, and so could we wind up our—our what? our interview? our performance? our theatrical duet? Later, I wrote up an article on the basis of the interview, it appeared in *Art Monthly* under the title "Illusion and Repetition", but to my mind this piece gives little of the flavour of this interview.[1]

Here are a couple of excerpts from the interview:

> To nieprawda, że człowiek nowoczesny to umysł, który zwyciężył lęk. Nie wierzcie! Lęk istnieje. Lęk przed światem zewnętrznym, lęk przed losem, przed śmiercią, lęk przed nieznanym, przed nicością, przed pustką.
> To nieprawda, że artysta jest bohaterem i zdobywcą nieustraszonym, jak nas poucza konwencjonalna legenda. Wierzcie mi, to człowiek biedny i bezbronność jego udziałem, wybrał bowiem swoje miejsce naprzeciw lęku. W pełni świadomy.
> To w świadomości rodzi sie lęk. Stoję przed Wami w lęku, oskarżony, sędziowie surowi, lecz sprawiedliwi.
> I to jest różnica między Dadaistami, których czuję się potomkiem, a mną.
> "Proszę wstać!—wołał Wielki Szyderca, Francis Picabia—Levez-vous, vous êtes accusés." A oto moja—dzisiaj—korekta tej imponującej niegdyś inwokacji: stoję przed Wami, sądzony i oskarżony. Trzeba mi to usprawiedliwić, szukać dowodów, nie wiem, mojej niewinności czy mojej winy.
> Stoję przed Wami, jak dawniej… stałem w ławce… w klasie szkolnej… i mówię: ja zapomniałem, ja wiedziałem, wiedziałem, na pewno, zapewniam Was, Panie i Panowie, ale zapomniałem.[2]

It is not true, that modern man is a mind which had conquered fear. Do not believe this! Fear exists. Fear of the external world, fear of destiny,

of death, fear of the unknown, of nothingness, of emptiness. It is not true that the artist is a hero and a fearless conqueror, as conventional mythology has led us to believe. Believe me, he is an unfortunate person, and vulnerability is his role, he has chosen this role in the context of fear, in all consciousness, and in the awareness of this, fear is engendered.

I stand before you in fear, accused, O my judges, severe but also just. And here is the difference between the Dadaists, whose inheritor I feel myself to be, and myself. 'Arise!' ordered the great cynic Francis Picabia. "You are accused." And here today is my corrective to this invocation once so impressive: I stand before you, accused and convicted. I must justify myself, discover reasons for my innocence or for my guilt.

I stand before you as once I stood at my classroom desk, and I say to you: I have forgotten, I knew, I definitely knew, I assure you that I did know, ladies and gentlemen, but I have forgotten.[3]

Dlatego, Ja—Pan zna Bruno Schulza?—dla mnie Bruno Schulz który jest jakimś moim, że tak powiem, ojcem, prawda? To znaczy, wydaje mi się, że tu jest ta ciągłość tradycji naszej kultury polskiej, prawda, że ja znajduję w przeszłości swoich przodków, że Bruno Schulz mówi: nie jest ważna fasada, ważne są te śmietniki, na których w ogródku w pokrzywach siedzi ta Tłuja, ta wariatka, prawda, która również istnieje w *Umarłej klasie*, prawda, i śpiewa żydowską piosenkę, prawda? Tutaj, fasadą jest ten pokój, natomiast najważniejsze rzeczy się dzieją za tymi drzwiami, tam, nie w tym pokoju. Ten pokój przedstawia nasze życie, banalne, głupie, powtarzające się nieustannie, nudne, no, życie dzisiejszego człowieka konsumującego tę naszą cywilizację. Ale tam się odbywają te prawdziwe rzeczy. Czasami one wtargną do tego pokoju, i wtedy jest to spięcie o którym mówię.

That is why—do you know the work of Bruno Schulz?—for me, Bruno Schulz is, as it were, my father, in other words, it seems to me that here is the continuity of the tradition of our Polish culture, that I find in the past my progenitors, that Bruno Schulz says, appearances are unimportant, what matters is the tramp-woman, the mad-woman Tłuja who sits on the rubbish-heap, and who also appears in my *Dead Class*, singing a Jewish lament.

Here, the facade is this room, but the important things are those happening behind those doors. This room represents our life, banal, stupid, repeating itself without end, the life of today's person consuming our civilisation. But the real things are those happening out there. And sometimes they force their way into this room, and this gives rise to the dramatic tension which I seek to pin down.

Krzysztof Cieszkowski: I wracając do tych peryferii—czy Pan mówi że pamięć, pamięć dzieciństwa, to są takie peryferie—i sztuka teatralna to jest eksploracja tych pamięci.
Tadeusz Kantor: Eksploracja pamięci. Zaraz Panu (...)
Gdy maluję obraz, proces powstawania regulowany jest jedną "wolą", co w rezultacie nazywa się jednolitością formy, jednością, i tak dalej. Wytwarzając spektakl teatralny jest o wiele trudniej tę jedność zachować i utrzymać. Obrazy, pomysły związane z przestrzenią, ruchem, akcją napływają w czasie prób w takiej obfitości (…), że trzeba dużej świadomości celu (…), aby nie dać się ponieść wyobraźni, która musi być kontrolowana.

Jest to o tyle jeszcze istotne, że w tym spektaklu nie istnieje tekst literacki—(dramat pisany), do którego (jakikolwiek mam do niego stosunek, jakąkolwiek pełni funkcje w procesie… spektaklu), można by znajdować odniesienia, i który mógłby pomagać w "sterowaniu". Rozważając te niebezpieczeństwa niemal morskiej wyprawy (…)—odkryłem pewien system posługiwania się specjalną metodą. Otóż—rekonstruując wspomnienia dzieciństwa (a taki jest sens spektaklu, nie "piszemy" fabuły wedle wzorów znanych z literatury, fabuły opartej na ciągłości.

To znaczy, ja nie stwarzam opisu mojego dzieciństwa, bo twierdzę, że to nikogo nie obchodzi. Założyłem, że taki opis jest nieprawdą, a mnie chodzi o prawdę, to znaczy, o realność.

A więc, jeżeli ja bym napisał tekst o moim dzieciństwie, to by nie była prawda, bo to byłaby stylistyka, bo byłaby ciągłość.

A bardzo mi chodzi tutaj o prawdę, tzn. o taką strukturę, która nie będzie "cementowana", "lutowana" stylistycznymi, formalnymi (…), dodatkami (…). Ta rekonstrukcja wspomnień dzieciństwa ma zawierać tylko te momenty, obrazy, "klisze", które pamięć dziecka zatrzymuje, dokonując wyboru z masy rzeczywistości, niezwykle istotnego. W dziecięcej pamięci zachowuje się zawsze tylko jedna cecha postaci, sytuacji, wypadku, miejsca i czasu…. ojciec przyjeżdżający (na urlop) ciągle klnie i pakuje się…. I ma żółte buty, w mojej pamięci…. matka ciągle wyjeżdża i znika (…). Dlatego we wspomnieniach dziecka jest tylko jeden wyraz i jedna cecha.[4]

Krzysztof Cieszkowski: Returning to these peripheries, are you saying that memory, the memory of childhood, is this kind of peripheral area, and that your theatrical work is an exploration of this memory?

Tadeusz Kantor: That's right, an exploration of memory. Let me read this: When I paint a picture, the process of its creation is controlled by one will, which results in a unity of form. In creating a theatrical spectacle it is much harder to achieve and maintain this unity. Images and ideas connected with space, movement and action arise with such fecundity that one has to retain a strong sense of one's aim in order not to allow this unity to fall apart.

What is also significant about the present spectacle is that it does not have a literary text—whatever my attitude to a written text, however it might assist in the process of the spectacle, a text to which one could refer, and which would help give it direction. Considering the dangers of this almost marine enterprise, I discovered a specific method. Reconstructing the memories of childhood, and such is the sense of this spectacle, I have not drawn on the kind of continuous narrative provided by literature, I have not reconstructed a narrative of my childhood, because I maintain that this is of no concern to anybody. Such an account would not be true, and I am concerned with truth, with reality. A written text about my childhood would be a stylistic construct, would be continuous. And I am very concerned with truth, in other words with a structure which is not held together by artificial connections.

This reconstruction of childhood is intended to embody only those moments, pictures and images which the child retains by selecting from the great mass of available material. A child's memory retains only one aspect of a person, a situation, event, place and time. My father coming home on leave swears and keeps packing. And has yellow boots. My mother keeps departing and disappearing. Thus a child's memory retains only one element.

To conclude—I claim no profound or unique understanding of Tadeusz Kantor or of his work, I am merely returning with pleasure and satisfaction to an unforgettable 45 minute conversation.

Reading about him and thinking about him, I retain an ambivalence towards him. Was he a tyrant, a control-freak, a magus? Do I have to accept his claims that he was the *fons et origo* of virtually every current in the art of the 1950s, 60s and 70s—Abstract Expressionism, *Tachisme, Informel,* Arte Povera, *emballages,* wrapping up objects and coastlines, installations, performances, happenings, etc.? The sheer fertility of his creativity overawes me, but his *emballages* and most of his painted and collaged work leave me cold and largely indifferent.

I wonder at what I perceive as his incredible vanity, a quality he surely had no need of. The awards—Złoty Krzyż Zasługi (Gold Cross of Merit, 1954), Medal 10-lecia Polski Ludowej (Medal of the Tenth Anniversary of People's Poland,1955), Krzyż Oficerski Orderu Odrodzenia Polski (Order of Polonia Restituta, 1956), nagroda II stopnia Ministerstwa Kultury i Sztuki (The Ministry of Art and Culture Award, II, 1962), Nagroda Ministerstwa Kultury i Sztuki (The Ministry of Art and Culture Award, 1981), and the Krzyż Komandorski Orderu Odrodzenia Polski (Commander's Cross of the Order of Polonia Resituta), accepted from General Jaruzelski on 31 August 1982.

Let me repeat that date: 31 August 1982. To say that this leaves a bad taste in one's mouth is to understate the feeling I had when I became aware of this—and Krzysztof Pleśniarowicz's excuse for it, that Kantor had agreed before 13 December 1981 to accept this bauble is, if anything, even sadder.

This can be seen in parallel with another event in December 1980, when Kantor insisted on *Wielopole, Wielopole* being staged in the Gdańsk Shipyard, and, when a performance was heckled and people shouted accusations that he was profaning national, religious and patriotic values, he asked for the assistance of the Służby Bezpieczeństwa (the security forces) in protecting him *"przed faszyzmem"*—"against fascism". These documented anecdotes cast a dark shadow on Kantor's memory.

And what price did Kantor pay for the freedom the Polish People's Republic gave him to travel abroad when and where he wished? Did not everybody at that time have to deliver a quid pro quo in return for receiving their passport? What was Kantor's quid pro quo? Am I just being malicious in wondering about this? Does a rebel or a hero have to be a martyr, or can he have a less salubrious side?

And whoever said that geniuses were nice guys? So what if he stayed in first class hotels and let the rest of his theatrical company stay in third-rate accommodation, as I have read? So what if people remember his towering rages and the occasional brutality with which he sometimes treated his actors?

The arguments about the legacy continue. Actors and collaborators remain fiercely loyal, if at daggers drawn with one another. The legacy remains—the work, the achievement. And listening to the remarkable interview which I had the privilege of recording almost 30 years ago, on the otherwise deserted stage of the Riverside Theatre, among the mannequins and the stage-props, I am grateful that I had the opportunity to catch a moment when he was in full and eloquent flow—until the tape ran out.

NOTES

1 Cieszkowski, Krzysztof, "Illusion and repetition: Tadeusz Kantor interviewed", *Art Monthly,* December 1980–January 1981, no. 42, pp. 6–8.

2 Kantor read out during the interview the text of "A Little Manifesto", written on the occasion of his receiving the Rembrandt Prize, was awarded to him by the Goethe Foundation in Basel in 1978. The Polish version of this text is published in Kantor, Tadeusz, "Mały manifest", *Teatr Śmierci. Teksty z lat 1975–1984,* V/Pisma, vol. 2, Pleśniarowicz, Krzysztof ed., Wrocław: Ossoliaeum, Kraków: Cricoteka, 2004, p. 23.

3 Author's translation from Polish. For an alternative English translation, see Kantor, Tadeusz, "A Little Manifesto", trans., Michal Kobialka, in Kobialka, Michal ed., *A Journey Through Other Spaces: Essays and Manifestos, 1944–1990,* Berkeley: University of California Press, 1993, p. 250.

4 The text of Kantor's read out during the interview, and published in Kantor, Tadeusz, "Pamięć dziecka", *Teatr Śmierci,* pp. 359–360.

KANTOR IN LONDON : FROM DAVID GOTHARD'S ARCHIVES

JO MELVIN

David Gothard, Ian Knox, Rebecca O'Brien and Erica Bolton had all been working for Richard Demarco. David Gothard wrote numerous letters for funds, while working at the same time also for Riverside Studios. Peter Gill, the Director of this new arts venue in London, which would not open for 15 months, agreed for the space to be used for Kantor and Cricot 2. Leaving David in Edinburgh to help during the festival, Ian Knox, Rebecca O'Brien and Erica Bolton went ahead to Riverside to prepare for the performances of *The Dead Class*, travelling back and forth to organise it. During the summer Erica Bolton obtained the support of the Greater London Council and the Labour councillors in Hammersmith. She designed the seating for the audience and organised the scaffold structures to make the audiences seating. When carrying the scaffold poles from the street into the studios, Erica caught Chris Harris's attention. He offered help and became a 'resident' photographer.

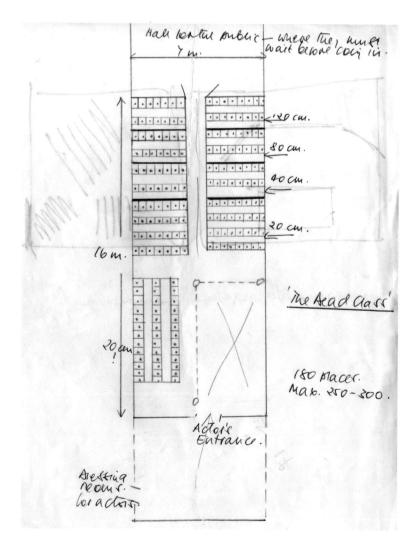

Left Erica Bolton's design of the Riverside Studios' stage and the sitting for the audience for *The Dead Class* performance, 1976, courtesy David Gothard.
Opposite The audience leaves after one of the first performances of *The Dead Class* at Riverside Studios, 1976, photograph Chris Harris, courtesy David Gothard.
Two members of Cricot 2, Andrzej and Teresa Wełmiński recalled Kantor's irritation with the London audience, who used to eat during the performances. Kantor devised a scheme to address the issue. The cast stood in two short rows facing each other at the entrance to the studio. The audience had to file between the rows and they were each asked the following questions: "Have you come to watch the performance or have you come to eat?"

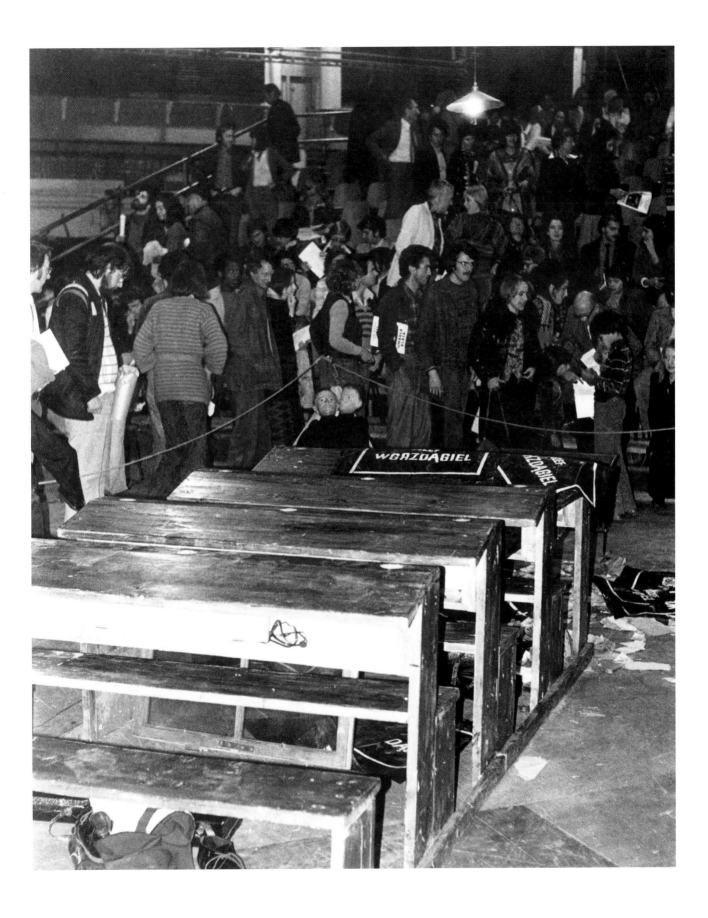

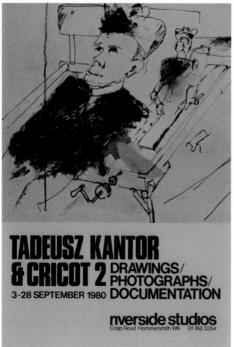

Above Exhibition at Riverside Studios, 1980, photograph Chris Harris, courtesy David Gothard.

Wielopole, Wielopole performance came to London via Edinburgh from Florence, where it was created and premiered in July 1980. Kantor brought to London the photographs documenting its production taken by Maurizio Buscarino, and hung them on lines by cloths pegs strung around the gallery at Riverside Studios.

Left An advert for the exhibition *Tadeusz Kantor and Cricot 2: Drawings/ Photographs/ Documentation* at Riverside Studios, 1980, courtesy David Gothard, copyright Maria Stangret-Kantor and Dorota Krakowska.

Erica Bolton & Jane Quinn
130 Hammersmith Grove, London W6 7HB. Tel.(01)748 9440

PRESS RELEASE

TADEUSZ KANTOR AND CRICOT 2 EXHIBITION AT RIVERSIDE

To accompany Tadeusz Kantor and Cricot 2's season of THE DEAD CLASS and OU SONT LES NEIGES D'ANTAN? at Riverside Studios, an exhibition of documents and photographs from the Cricoteca in Cracow will be on show in the foyer at Riverside from 16th November - 5th December. The exhibition has been organised by Wieslaw Borowski, Director of the Foksal Gallery , Warsaw.

THE CRICOTECA exists as a permanent centre of documentation and information about Cricot 2, bringing together all the publications and material relating to the past and present activities of the Company and the evolution and influence of Tadeusz Kantor's ideas on contemporary art. The archive contains theatrical and critical texts, posters, sets and costumes, designs, models, paintings and tapes. The Riverside exhibition will be drawn from this material and will also include Tadeusz Kantor's latest manifesto delivered at an international meeting in Poland earlier this year where he received the Rembrandt Prize.

Opening hours: Tue-Sat 11 am - 11 pm, Sun 12 noon - 10.30 pm, Mon 11 am - 6 pm.

<u>ADMISSION FREE</u>

PRESS ENQUIRIES ERICA BOLTON/JANE QUINN 748 9440/9183

riverside studios

THE DEAD CLASS

dramatic seance of t. KANTOR

17 - 27 November 1982

Riverside Studios acknowledges with thanks consistant support from the Greater London Council, the Greater London Arts Association, and the Arts Council of Great Britain. Riverside also acknowledges a special guarantee for this production from the Visiting Arts unit.

Thanks also to La Spiaggia Restaurant, King Street, W6 for their hospitality towards the Polish company.

RIVERSIDE TECHNICAL STAFF:

Production Manager	STEVEN SCOTT
Stage Manager	ZIGGY CHAPMAN
Chief Electrician	DAVID RICHARDSON
Master Carpenter	MALCOLM WATSON
Assistant Electrician	TIM BALL
Assistant Carpenter	SIMON READ
Electricians	JOHN MONK
	MAX
Technician	DANNY SCOTT
Wardrobe Mistress	ANN HERDIMAN SMITH

Riverside is also proud to present a new show:
OU SONT LES NEIGES D'ANTAN
(Where are the snows of yesteryear)
on its first trip outside Poland. 30 November - 5 December
BOOK NOW.

Left The announcement for *The Dead Class* produced by Bolton and Quinn, 1982, courtesy David Gothard.
Acknowledgment of the support from the Greater London Council, Greater London Arts Association and The Arts Council. Particular thanks are given to the Arts Council's visiting artists unit for giving a special guarantee to enable this production to take place. The technical staff are listed and thanks given to La Spiaggia restaurant for its hospitality to the Polish team.
Right *Tadeusz Kantor and Cricot 2* exhibition press release produced by Bolton and Quinn, 1982, courtesy David Gothard.
The exhibition, organised by Wiesław Borowski, accompanied performances of *The Dead Class* and *Où sont les neiges d'antan*. It presented documents and photographs from Cricoteka and was shown at the Riverside Studios foyer between 16 November and 5 December 1982.

riverside studios

Crisp Road Hammersmith W6 9RL Administration 01-741 2251 Box Office 01-748 3354

1982

The Hammersmith Riverside Arts Trust Ltd has ceased trading and is going into liquidation; the staff of Riverside Studios has declared a work-in to keep the building open and the shows running. Please support the Riverside Staff over the coming weeks by using the building as much as possible - attend the shows, eat and drink here and shop at the bookshop - and by telling others that RIVERSIDE IS OPEN. With your help we can keep it open and give us all a future.

OU SONT LES NEIGES D'ANTAN

30 November to 5 December

RIVERSIDE TECHNICAL STAFF:
Production Manager Steven Scott; Stage Manager Ziggy Chapman; Chief Electrician David Richardson; Assistant Electrician Tim Ball; Electricians John Monk Max; Master Carpenter Malcolm Watson; Assistant Carpenter Simon Read; Technician Danny Scott; Wardrobe Mistress Ann Herdiman Smith.

Riverside Studios acknowledges with thanks consistent support from the Greater London Council, the Greater London Arts Association, the Arts Council of Great Britain and, for this production, a special guarantee from the Visiting Arts Unit of Great Britain.

Thanks also go to La Spiaggia Restaurant in King Street, Hammersmith for their hospitality towards the Polish Company.

DON'T MISS.....
 GRAEAE THEATRE COMPANY in M3JUNCTION 4
 7 - 12 December

 CHRISTMAS FESTIVAL WEEK - a week bursting at
 the seams with all kinds of shows and events.
 14 - 19 December

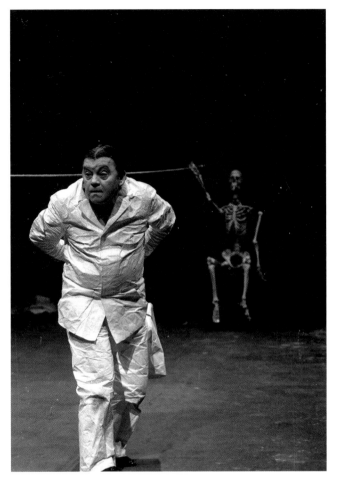

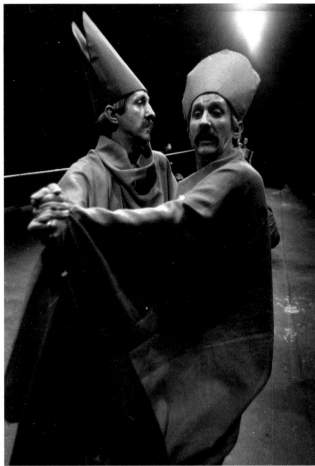

Opposite The announcement of Riverside's 'work in' coupled with notification of *Où sont les neiges d'antan*, 1982, courtesy David Gothard.

Visitors were encouraged to use the building as much as possible, and to eat and drink there, to purchase from the bookstore and spread the word by telling others that "Riverside is open". A separate flyer produced for *Où sont les neiges d'antan* had "we are open" stamped on it in red ink. Erica Bolton and Jane Quinn prepared all press information for Riverside, beginning from the first productions of *The Dead Class* in 1976. Support was huge and Kantor's involvement made a great impact. It was broadcast on the TV and radio news and reported in national and local newspapers.

Top left Stanisław Rychlicki as one of *The People of the Street* in *Où sont les neiges d'antan*, Riverside Studios, London, November/December 1982, photograph Chris Harris, courtesy David Gothard.

Top right *The People of the Street* as Cardinals (Wacław and Lesław Janicki) in *Où sont les neiges d'antan*, Riverside Studios, London, November/December 1982, photograph Chris Harris, courtesy David Gothard.

Right Teresa and Andrzej Wełmiński as *The Bride and The Bridegroom* in *Où sont les neiges d'antan*, Riverside Studios, London, November/December 1982, photograph Chris Harris, courtesy David Gothard.

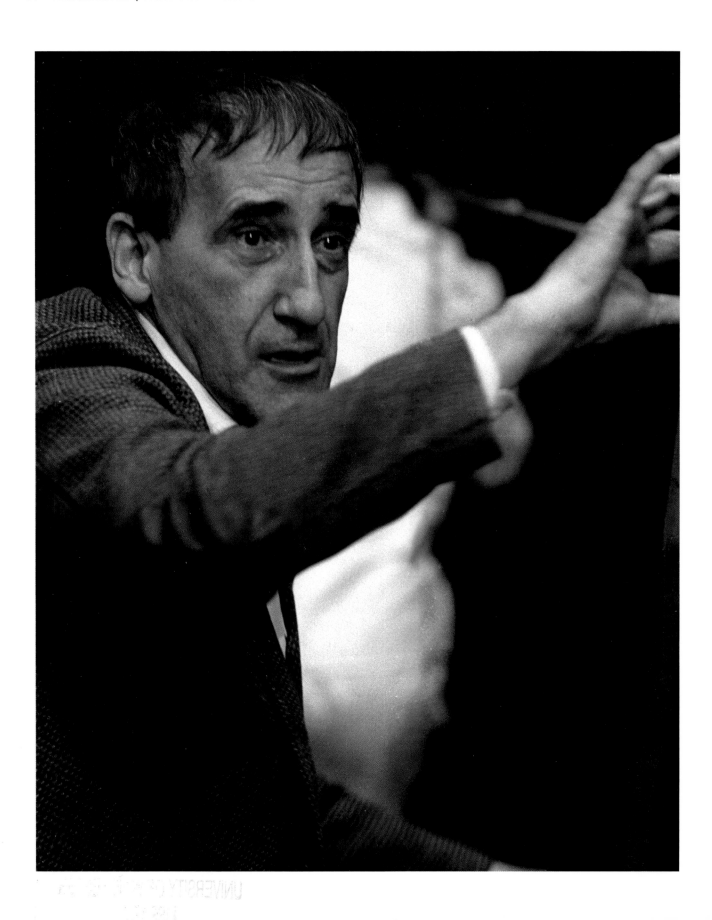

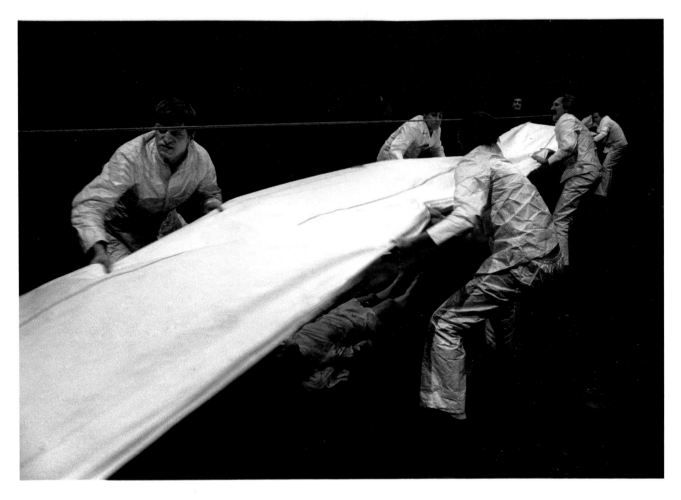

Opposite Tadeusz Kantor measuring *This straight line* during *Où sont les neiges d'antan* at Riverside Studios, London, November/December 1982, photograph Chris Harris, courtesy David Gothard.
Above The concluding scene of *Où sont les neiges d'antan*—actors pulling paper wedding veil, Riverside Studios, London, November/December 1982, photograph Chris Harris, courtesy David Gothard.

"Kantor is coming" graffiti emblazoned on a concrete pillar of the
Hammersmith flyover near Riverside Studios, November 1982.
photograph Chris Harris, courtesy David Gothard

The local newspaper, *The Richmond and Twickenham Times*
remarked on 19 November 1982 that the graffiti statement was
perhaps a portent and that Kantor was coming "for the last time".
John Thaxter noted that on the opening night of *The Dead Class*,
the Riverside trustees met to discuss whether or not to wind up
the Riverside Trust and close the centre due to the funding cuts
and that half the audience stayed to hear the decision.
On this visit, Kantor was briefly arrested in a case of mistaken identity,
a story that added to the mythology surrounding his presence.
On the 23 November, 1982 *The Evening Standard* reported that
Kantor had been picked up by the police as he walked to a matinee
performance of *The Dead Class* because he was dressed in similar
clothes to a man wanted in connection with a murder. As he did
not speak English, he persuaded the police to accompany him to
Riverside Studios where the staff took over the explanations.

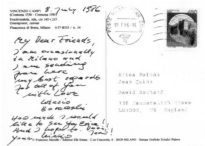
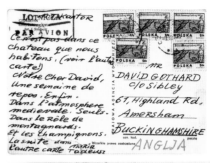

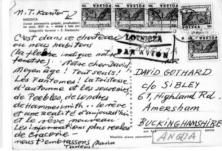
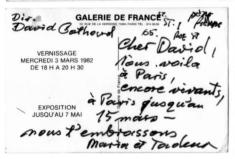

Postcards from Kantor to David Gothard, from the *An Impossible Journey* exhibition at the Sainsbury Centre for Visual Arts, UEA, Norwich, 2009, courtesy Jo Melvin.

Below, the English translation of Kantor's address to David Gothard and the staff of Riverside Studios. Its full text runs as follows:

In England today the institution has reached a lower social structure, maybe the lowest for the Arts in four years times perhaps, who knows? It could be the same situation as here tonight at The National Theatre and the RSC. We are just at the beginning of the collapse a national phenomena.

No David... it's not a surreal situation, it is a SOCIAL SITUATION. The last, latest history at the Riverside is not an EXAGGERATION, it is just an example of the general crisis! The institutions, I repeat, are not at a lower social level and that produce FRUSTRATION. It is only the artists who can put a stop to it. Please don't talk only about the Riverside. I regret that a meeting has not been arranged for that, it would be the artists calling for a CONFERENCE. The artists, the GOOD ARTISTS ought to be here!

I imagine myself as an artist. I'll help you sometimes—it's only a pity that there is no more time that I can give you a longer lecture… we have worked during thirty years, others as well (look at Peter Brook, he sent a telegram, and he's gone long ago.) You have not made

use of our experience! GOOD ART does not mean automatically LA BONNE INSTITUTION (GOOD INSTITUTION).

Why we exist? Because we refuse to be an institution!

We-exist-ONLY-WHEN-WE-ARE-PRODUCING-WORK!

You are young! We are with you!

I am very grateful David. Nous vous aimons... and Madame Kantor joins in "we love him".

Malgre que je suis un "TERRORISTE" et je suis un sentimental!

Kantor
Riverside Studios, greenroom.5.xi '82 after the show GH'

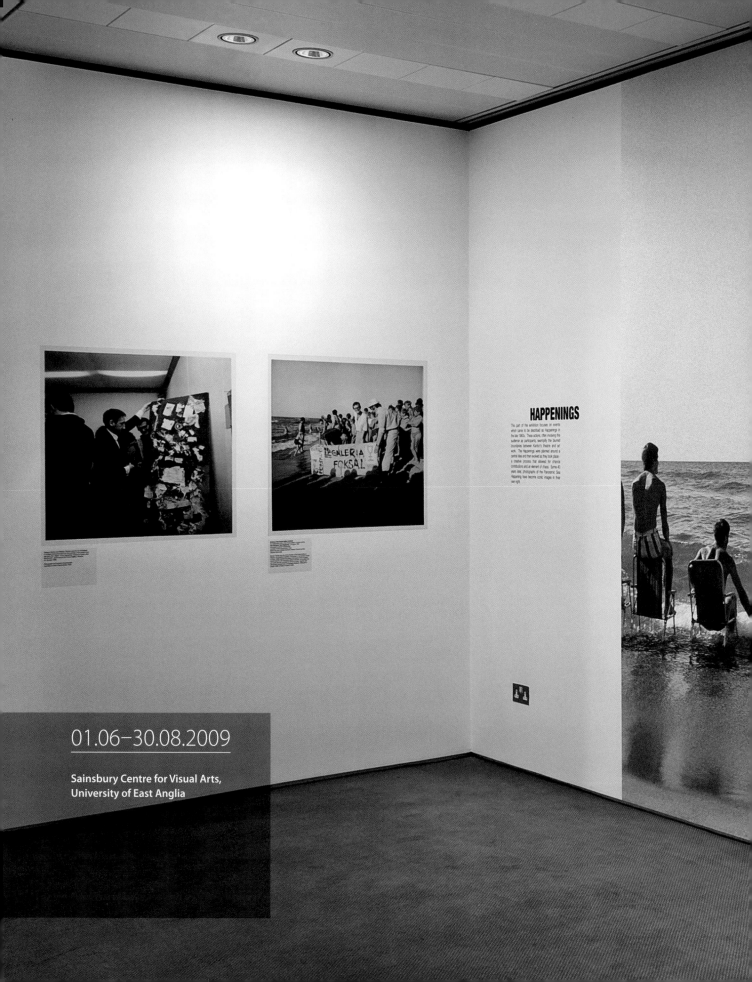

HAPPENINGS

This part of the exhibition focuses on events which came to be described as Happenings in the late 1960s. These actions, often involving the audience as participants, exemplify the blurred boundaries between Kantor's theatre and art work. The Happenings were planned around a central idea and then evolved as they took place in a creative process that allowed for chance contributions and an element of chaos. Some 40 years later, photographs of the Panoramic Sea Happening have become iconic images in their own right.

01.06–30.08.2009

Sainsbury Centre for Visual Arts,
University of East Anglia

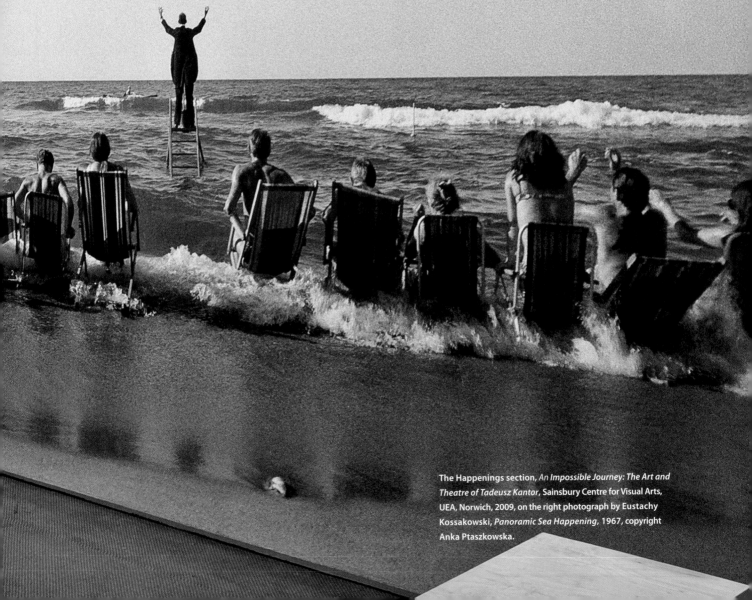

The Happenings section, *An Impossible Journey: The Art and Theatre of Tadeusz Kantor*, Sainsbury Centre for Visual Arts, UEA, Norwich, 2009, on the right photograph by Eustachy Kossakowski, *Panoramic Sea Happening*, 1967, copyright Anka Ptaszkowska.

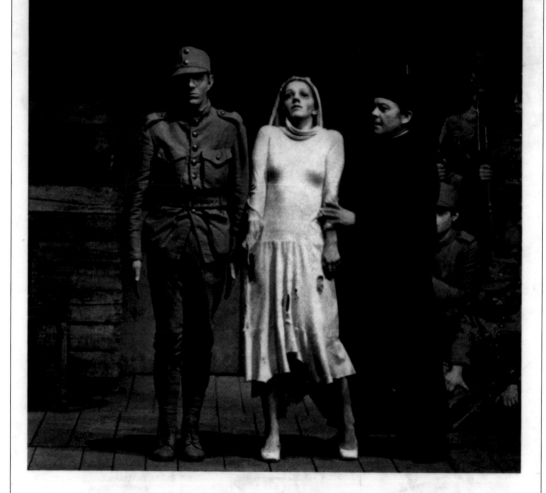

wielopole
wıelopole

an exercise in theatre by
tadeusz kantor

KANTOR AND THE ART OF IMMATURITY

GEORGE HYDE

When I went to teach in Poland in 1976 I spoke some Russian but no Polish. Poles had to learn Russian, so I got by. Then, my pursuit of my most interesting student considerably changed the pattern of my life over many half-litres. She and her partner taught me about Polish writing. He was studying art, but had obligatory Russian, which I helped him with. Polish at first seemed to me like a bizarre dialect of Russian. I kept complaining about the orthography ("szcz" etc.), and suggested that Poland would do well to adopt the Cyrillic alphabet, an idea which wasn't too popular. As Nabokov once remarked about Czech, the same Slav roots sport exciting new growths. For example, the common word *oczywiście* means "of course", but its semantics contain the roots of words for "eye" and for "knowledge", so it sort of implies "clear to the (naked) eye". When I tried it on a UK Professor of Russian, he fell about laughing. It sounded to him archaic, like a bit of the lost *Ursprache*. In Russian the equivalent word is *konechno*: as decisive as a meerkat saying "simples". The root is *konets*, or "end", which you could read in every Soviet movie. Sort of Russian finality? Polish subjectivity? Is reality more veiled in Polish? Kantor went through a period of wrapping objects (*emballages*) in order to blur their outlines, as a tribute to their strangeness.[1] It was a crucial stage in his progression towards abstraction.[2]

I felt acutely the strangeness of the reality I had walked into. The Polish sign for "NO SMOKING" encountered everywhere was intriguing. To a Russianist eye it looked as if it should mean something like "flaring up is debarred". The Polish collocation, *PALENIE WZBRONIONE* somehow seems to be lost in more etherial semantic layers than the Russian *nie kurit'*, which is so direct and to the point: simples, in fact. A literary example spiritually close to Kantor speaks volumes. Tolstoy's historical epic is called *Voina i mir* or *War and Peace* in English. But the Russian word *mir* also means world, universe, or pre-revolutionary peasant council, and Mayakovsky cheekily entitled a long poem *Voina i mir*, which is translated as *War and the Universe*. Imagine my astonishment when I discovered that in Polish the word for "peace" was *pokój*. This is also the Polish for "a room" (or without article, since Polish has none.) So the title of Tolstoy's novel in Russian aligns 'peace' with a massive, expanding, somehow universal space: like the Pax Sovietica by imperial diktat. For Poles, 'peace' was, it seemed, a small personal space to withdraw into. Kantor is especially eloquent on the subject of 'rooms', their boundaries, and the way they preserve (like the 'camera obscura') the traces of the things that they have contained and events that took place in them.[3]

People's Poland manifested a general contempt for authority. I remember saying to a friend that two Poles gathered together was a recipe for anarchy.[4] This culminated in a political movement that brought communism to its knees.[5] Subversion of the alien socio-political order was accompanied by assiduous cultivation of an inner sense of subjective truth. Outside the door was a cold state of war, that charged space in which Kantor's happenings made such a huge impact.[6] Inside, was the 'room', which constituted an alternative private space with a rich mixture of empathy, survival, desire, fantasy, and defiance, stewed in the juices of Catholicism, Nationhood, and family values: exactly as Kantor presents it in *Wielopole,Wielopole*, which Mariusz Tchorek and I translated for Marion Boyars, 1980. The threshold between inner and outer space was a rubicon. In Poland you can say to the entering guest, "*proszę rozebrać się*", or "please undress". In winter, outer clothing is often very bulky. Kantor's improvisation with the cloakroom in his abstract realisation of *Lovelies and Dowdies* drew attention to the conflicting semantics of inner and outer space by inverting the relationship between the theatre and its cloakroom.[7] In the process, echoes of the concentration camps and the persecution of the Jews crowded into the confines of Kantor's grotesque personal space.[8]

Lots of youngsters seemed to be 'artists'. Basic living expenses in the nanny state were so low that you could almost forget about earning a living. There was massive State over- employment, and the joke went that "they pretend to pay

Cover of the book *Wielopole, Wielopole: an exercise in theatre by Tadeusz Kantor,* trans. G Hyde, M Tchorek, London: Marion Boyars, 1990.

us, and we pretend to work". Going through the motions, like a Kantor puppet or one of his infernal machines, was enough.[9] Another joke: "average monthly salary three thousand zloties, average expenditure ten thousand zloties, and you can save the difference". This was a subtle allusion to the black market, which undermined the sense of what anything was "worth". Norman Davies described Poland as "God's Playground".[10] People's Poland was likened by Poles themselves to Alice's Wonderland, where nothing was what it seemed, and a constant unfathomable process of metamorphosis went on. 'Things' behaved strangely; being animated by daemonic presences. They were always just out of reach, or suddenly grotesquely abundant. The boundaries of time and space seemed peculiarly malleable. There was a sense of running on the spot, but no-where to get to. It was on the whole a huge joke, though the traumas of recent history were ever-present. In Kantor's theatre abstraction encompassed people, things, time and space in a metaphysical frenzy.[11] Not that he set out to represent post-war Poland: his theatre was passionately anti-representational.[12] But great artists inevitably tell the truth about their age.

Pokój, private (or shared family) space, meant 'peace', however fraught it might be with its own problems, and (like everywhere else) suffocating. I chose for my second English Institute dramatic production Pinter's *The Room*. My student actors latched on at once to the dynamic of Pinter's text, which constructs an awkward existential space for characters whose discourse is somehow being directed from outside by their past and by ghostly authority figures. The outside world, glimpsed briefly, is violent or unintelligible. The characters are all in a sense children, like Kantor's "family" of actors.[13] Rehearsing this gnomic Pinter play in bleak classrooms, scratching about for a few props and costumes, or for a bit of technical apparatus, and relying on inspiration and improvisation, nurtured the paranoia Pinter's text projects, and drew me closer to Kantor's world. When I was introduced to Polish theatre, especially Grotowski and Kantor, by my young friends, and to local student drama festivals, everything fell into place, symptomatic of a society coping with its alienated existence by virtue of pure style, desperate improvisations, and the blackest of black jokes. This was true even when directors tackled Polish classics, the national equivalent of Shakespeare. The whole of Poland and its culture had become that *pokój*, a hermetic inner world constantly redefining its boundaries, exposing its wounds and picking at its sores, yet deriving sustenance from its Swiftian disgust and dogged satirical inventiveness. Kantor's work invokes national traumas and historical horrors, but they become formally part of his 'scores', not pretexts for self-indulgent emotion.[14] He would never have presented himself as a 'social critic'.

What style they had, my young actors! On and off the stage. I remarked on this to a Russian friend I met in Warsaw at the time, and she said to me bitterly yes, style was the only thing we left them. Queer, archaic forms of reciprocity had taken the place of civil society. There were many analogies with Ireland, screwed up and strangely stimulated by oppression. Ireland was caught in the linguistic predicament analysed and transcended by Yeats, Joyce and Beckett. Post-war Poland did not have the language of the conqueror imposed on her in quite the same way, though there had been times and places when using Polish was forbidden.[15] Vaclav Havel's play *The Memorandum* posits a situation where a bizarre invented language has been suddenly imposed upon the working of an office.[16] Kantor's "theatre of the lowest rank", with actors borrowed (in his imagination) from some labour exchange or job centre, operated with the "degraded reality" of a colonial situation where some sort of new set of jargons had taken the place of normal human social discourse.[17] His theatre is an anarchic circus and the name he gave his company, Cricot 2, successor to the pre-war Cricot, is an anagram of the Polish for "it's a circus" where Dada-like insults to 'reality' could be thrown around under the watchful eye of an authoritarian master of ceremonies. But Kantor himself, standing in for the bigger, unavailable father-figure who endlessly demanded his own obscure gratification, and projected his own anxieties, transposes the action into a personal sphere.[18] The theatrical

space was layered with shabby objects and battered bits of furniture which, as Kantor said, had come from the rubbish dump but nevertheless acquired a cult status as relics.[19] Like the debris of war, or the human remains of the concentration camp victims, this trash was on its way to eternity.[20] The theatrical space itself was turned upside-down and inside-out, as in *Lovelies and Dowdies*, or *The Water Hen*.[21] The action of his productions, especially his two best known, *The Dead Class* and *Wielopole, Wielopole*, obsessively reiterated variations on themes derived from the claustrophobic inner space of that Polish 'room' that stands out (or 'in') against the violence and emptiness of 'outside', even while it echoes and reproduces the traumas of the larger, historical space that contains it.[22] And the little town of Wielopole was, of course, Kantor's birthplace.

Kantor's preoccupation with *pokój* began with the war-time production of Wyspiański's *The Return of Odysseus*, 1944, just as his troubling animated puppets began with the symbolic *chochoł* of Wyspiański's *Wesele*. [23] The theatre for the presentation of Kantor's early 'event' was literally a room in a Kraków flat, hidden from the patrolling Nazis. Above all, the rooms of Kantor's imagination are spaces created for unpredictable encounters, enabling and enacting a process of learning, with some sort of light breaking through painfully and intermittently in the darkness. When I read English at Cambridge the slogan was "English for Maturity".[24] The idea, derived from Leavis and Arnold, was that by studying the classics of English Literature one enhances one's chances of maturing morally and intellectually. This was offered as the rationale of three years' reading. It wasn't a bad idea, even if the realities of late adolescence, and the human taste for the bathos, made it dubious in practice. But to read Polish literature, especially under the informal tutelage of my young friends, was to experience the seductive allure of a special kind of immaturity. This sort of fascination was compounded when I met later (in England) the Pole, Mariusz Tchorek, who became my fellow translator of one of Kantor's great texts, or 'scores', and co-opted him as a part- time teacher (of a shared unit on modern Polish writing) in my long-suffering School of English and American Studies, where I held a brief for Comparative Literature. He knew Kantor personally, and had worked very closely with him, though not in his theatre. Mariusz was surprised that I knew Kantor's work and its modernist artistic contexts. When I met him (actually for the second time, I had met him before in Poland) he was experiencing a serious depression, and I sat with him while he downed bottle after bottle of Pils. At first he could say little more than "that bloody woman! That bloody woman" over and over again. I thought perhaps he was quoting from Witkacy's *The Water Hen*, but actually it was something a bit more personal. I became his confidant, as I had been of my young artist/photographer and his lady, and continued my exploration of the Polish language. I had come home with a Polish speaking wife and two Polish speaking children and Mariusz's interventions into our family life were very supportive.

He was surprised at all this Polish being spoken, and equally surprised that I carried around with me a rudimentary personal map of Polish culture, which is pretty recondite, and even contrived to baffle outsiders: Mariusz liked to say that Poland was a sort of Tibet. Beginning with Mickiewicz's great closet drama Dziady, or *Forefathers' Eve* in the Romantic era, and progressing through the Symbolism of Wyspiański into the high modernism of Witkacy, Schulz, and Gombrowicz, there is a tradition of a very strange kind which has never been properly recognised outside Poland for its unique creativity. [25] Room for a book there, as Leavis used to say. You might call it (by analogy with "English for maturity") "Polish for Immaturity", in the sense that the big recurrent theme in Polish writing is that of a nation frustrated and infantilised by history. The creative dimension of this sad phenomenon is that the national culture has an existential openness which Mariusz (for instance) found too little of in the English Puritanism he roundly condemned. Poland has always been in an existential state of becoming, a recipe for turbulence but also a kind of freedom. When we speak of the fascination with immaturity in these writers, we recognise that this is where it springs from, and is foregrounded in the way it is.

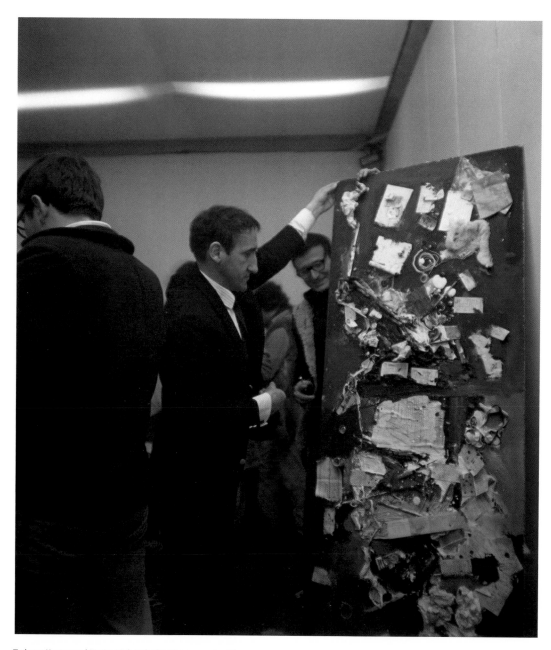

Tadeusz Kantor and Mariusz Tchorek after the happening *The Anatomy Lesson after Rembrandt*, at the Foksal Gallery, Warsaw, January 1969, photograph Eustachy Kossakowski, copyright Anka Ptaszkowska.

Mariusz Tchorek in Norwich, early 1980s, unknown photographer,
courtesy of The Tchorek-Bentall Foundation, Warsaw.

Each of the modernists whose work I now began to study in depth for our seminar has a unique version of a society that has not yet found itself. The idea of *polskość*, "Polishness", in Witkacy and Gombrowicz especially, vis-a-vis the outside world, takes the form of a kind of "sharp knowing in apartness" (a phrase Lawrence used of Jane Austen) where the critical faculties are highly developed but there is very little to fall back on in the way of shared moral certainties.

In the midst of this long learning process, mine and 'adolescent' Poland's, I was presented one day with a dishevelled pile of manuscript, a hoard of riches carried casually, as often as not on the back of a bicycle, shuffled, reshuffled, dog-eared, stained, and crumpled, rather like Tracey Emin's bed. The papers were scrawled over with corrections in a brown ink italic hand which was Mariusz's trade-mark. The truly Kantoresque experience of this bicycle-manuscript, spread out on a cafe or pub table, bits of which would flutter away and have to be chased down the road, plunged me into an alternative bicycle-reality reminiscent of Flann O'Brien's *The Third Policeman*.[26] There were raised eyebrows in the School of English and American Studies at my proposal to employ this unknown outsider as my co-teacher of a unit on Polish writing; but Poland was already in the news, Polish theatre had made quite an impression in the UK and elsewhere, students enrolled in satisfactory numbers, and I was exonerated, almost. Moreover Mariusz was becoming known (and much appreciated) in his role as a personal counsellor, and used to say that being an outsider made his clients feel closer to him. Even so, my colleagues could not understand why I should be spending valuable research time trying to sort out the untidiest of manuscripts and agonising over finding acceptable English versions for abstruse Polish turns of phrase. "I'd drop those Poles if I were you", said my academic appraiser. Kantor would have laughed.

At the time, the late 70s, it still looked as if Communism had come to stay, a priceless gift to the Gogolian tradition of the absurd.[27] Kantor is the conscience, or consciousness, of the Soviet empire, as Kafka was of the Austro-Hungarian. Kantor's chrysalis-like wrapped people and objects, his very own *chochoły* engaging in obscure acts of abortive self-definition, are abstracted from the rich literature of Polish modernism, with the 'density' (a favourite Kantor word) he used to challenge Grotowski's doctrine of emptiness. My young Polish artist friend said to me once over our bottle "we are all children of the *chochoły*". The authors enlisted as partners in Kantor's dance of death, Schulz, Witkiewicz, and Grotowski, are given new currency, 'deconstructed', by a theatrical genius who was not himself a writer, was even, in a Dada sense, anti-literature, but was a marvellous seer, painter, and performance artist. When I was grappling with the bizarre text of *Wielopole, Wielopole*, Mariusz, defending his often impenetrable English, would try to get us off the hook by saying "But he is not a writer...." It was indeed important to keep in mind the fact that Kantor called his texts *partytury*, or 'scores', by analogy with music. Every performance would be different because of the collage-like substance of the whole, although (like a Mahler symphony, a suggestive analogy Mariusz often returned to) in the end it was the same overpowering work of art, fusing the sublime and the ridiculous, a massively accommodating whole. The points of reference in these rich collages were located in an eclectic reworking of high and low traditions as inevitable and inexorable as Mahler's. But still, there *was* a text, and it had to be served up to a British reader in a comprehensible form.

From Schulz (and from Kafka and Chagall, etc.) came the Jewishness that is all-pervasive.[28] Schulz, like other Polish Jewish authors, has an overwhelming sense of a vulnerable real place, and a real community, even when these are fraught with dream-like displacements, as they are in the work of Chagall. Kantor's best-known production, *The Dead Class*, is a rich elaboration of Schulz's story *Emeryt*, or *The Old Age Pensioner* (the English does not convey the radical ambivalence of the Polish title). In Schulz's tale the old man, confronted by the run-up to death, does what oldies in fact often do: he decides to educate himself a little, finally. But instead of taking classes in bee-keeping or car maintenance he goes back to

school quite literally in order to re-enact the whole process of learning, including all its frustrations, humiliations, and defeats, and lend his existence authenticity. The sympathetic headmaster wants to give him a privileged place in the class, but he masochistically refuses. The learning process resolves itself when one day in the school playground a high wind comes and carries him away, he's so frail. Kantor's last two productions seem to echo this story in their affirmation of 'personal knowledge' in the face of death.[29] Schulz's poignant story sounds the theme on which Kantor everywhere plays, but especially in *The Dead Class*, elaborate variations. The learning process is dramatised in lesson after lesson in Kantor's classroom where the traumas of the Polish condition are re-enacted, by analogy with the historical realities of a nation endlessly sent back to start all over again. The emotional authenticity and intensity of the enactment lends the theme a massive universality. Gombrowicz called this power game "bummification" or "bottomisation", depending on your preferred translation of *upupienie*: sitting you down on your *pupa* (bum) and numbing your brain by means of a kind of verbal lobotomy. Schulz wrote in the brief inter-war period which my favourite student described to me as "a short holiday", the Polish Republic of Piłsudski, who was subsequently cast in the role of the idealised redeemer of the nation, the hero on his white horse, a character to whom Kantor returns.[30] It remains to be seen whether Poland is not on another such short holiday. Stuck on their school benches, surrounded by mouldering books, with chrysalis-like unformed or abandoned images of themselves alongside in the shape of Kantor's beloved dummies, characters enact their own versions of Poland's eternal immaturity, and ours. The texts range from Polish nonsense rhymes to Latin maxims and Bible study, with Gombrowicz and Witkacy as constant points of reference.

There is no direct political comment. When I taught in Poland my students were often asked by routine police narks: *Czy Pan Hyde komentuje?* "Does Mr Hyde pass judgement?" i.e. of a political kind? I told them they should answer: "Yes, thank you for asking, he likes it here very much." Another question redolent of Kantor, asked of students who came to stay with us in England, was: "*Czy w domu w Norwich jest taki bałagan jak w mieszkaniu w Lublinie?*", "Is his house in Norwich a tip like his flat in Lublin?" Kantor was inevitably under constant scrutiny but set himself above and apart from direct political intervention or comment, enjoying the *bałagan* of his circus. When Communism ended, he at last offered some observations about the crudeness and ugliness of the communist contributions to Polish life and society, but it was no part of his purpose to try to 'overthrow' the system whose absurdities offered such rich material.[31] The Swiftian spirit of contradiction spoke volumes without the need for didactic 'comment'. The Polish 'back to school' spoke for itself. Schulz, himself a schoolteacher, was yoked together with Witkacy (Stanisław Ignacy Witkiewicz, the brilliant son of a famous Zakopane art critic, artist, and writer) and Witold Gombrowicz, to bear witness to the struggle to reinvent a world constantly referred back to first principles. Witkacy, whose assumed name was itself a bid to outwit The Name Of The Father (by scrambling its components) provided many of the play texts that Kantor 'minced' in his Constructivist production machines (*The Water Hen*, *The Cuttlefish*, *Lovelies and Dowdies*, etc.).[32] But perhaps the best starting point (alongside Schulz) for an appreciation of his work would be Gombrowicz's *Ferdydurke*.[33]

Ferdydurke enjoyed a brief vogue outside Poland in the 1960s, as a new appreciation of absurdity was being born. The generation reared on *The Goon Show* in England really liked it, even if they did not entirely understand it. The novel is built up on a grotesque configuration of opposites as embodied in the conflict of the eponymous deranged protagonist and Professor Pimko. The focus of their conflicts is the perennial theme of immaturity, its fascination and its horror, with troubling erotic overtones. There are many vivid theatrical episodes like (for example) a face-pulling competition, and another one which Gombrowicz calls "violation by the ears", which means sort of talking someone to a standstill by filling their ears with nonsense. Mariusz and I would act out almost without thinking the bizarre mummery of Gombrowicz's text, in our quest for the appropriate turns of phrase to

Tadeusz Kantor, *À Georges Hyde Tadeusz Kantor*, drawing,
courtesy George Hyde, copyright Maria Stangret-Kantor
and Dorota Krakowska.

communicate the existential absurd in English, and it was usually my turn to be the obtuse Pimko.[34] The inhabitants of Kantor's classroom fall without trying into the schoolboy routine of pulling faces, as in *Ferdydurke*, when language failed; and as Mariusz and I tried out our different version of the translated text on each other it seemed to me we were often participating in our version of Gombrowicz's 'violation'. Like the overgrown children they are, Gombrowicz's characters, and then Kantor's, compulsively repeat scenarios they cannot comprehend, hoping that they will gradually acquire some sort of rationale. This is a manifestation of existence preceding essence, by means of which the ambivalence of form, or even 'pure form', the subject of endless speculation by Witkacy, displaces content as such.[35]

Jean Piaget, in his seminal studies of childhood, hypothesises (like Lacan) a splitting process at the root of consciousness and of language itself. For Lacan, language itself is in the first instance essentially other, 'a foreign one', being in its alien order and authority the property of the Father.[36] Piaget notes how monologues spoken aloud and serving as "an adjunct to immediate action" (cf. *Hamlet*) constitute a highly developed stage on the way to true socialisation after the age of seven or so, and such monologues, redolent of childhood, are integral to Kantor's texts, which evolve from them in an illustrative manner.[37] This has been referred to as the "here I come" mode of communication, which is what we have a version of in Kantor's late *I Shall Never Return,* located in the transitional space of a pub around closing time.[38] A state of arrested development vis-a vis the "symbolic order" (the mature process of social integration) is glaringly apparent in the Polish modernist writers who underpin Kantor's world. But the sharp intelligence that illuminates this persistent psychopathology makes it artistically powerful and liberating.

Kantor's tragicomic vision of Polish reality was nurtured by Communism, but artistically owed nothing to it. In the end it is more useful to invoke psychological theories like Lacan's and Piaget's as interpretative keys to his work, rather than anything socio-political. If we equate the "imaginary wholeness" that Lacan locates in the mirror experience with Realism, socialist or otherwise, we find the diametrical opposite in Kantor's composite fragments of authenticity. The 'symbolic order' of Kantor's world is (in the Lacanian way) monitored by a powerful 'other'.[39] But the fact that this is impersonated on stage by Kantor himself, located within the represented space of the performance, also places him in the role of the therapist, re-living and re-presenting the experience of 'the body in pieces'. He gives us a clue as to how to live out the contradictions of our experience. His theatre participates in the melancholia of death, like Kafka's fictions, but it is a therapeutic overcoming of the death wish. The 'common enemy factor' that held People's Poland together was just another Oedipal construct, and no substitute for the "mutual respect" which Piaget locates in the formation of moral conscience on the level of the identification with the symbolic order: maturity, in other words.

NOTES

1 Nabokov moved briefly to Prague in 1923. In 1934 he published *Despair*, containing various Czech allusions. The novel's identity crisis relates to Nabokov's pervasive cultural relativism.

2 Heir to Meyerhold's Constructivism, Kantor also developed a theory of the actor which built on Brecht's notion of the Alienation Effect, as (for instance) in his "Manifesto of Zero Theatre", 1963.

3 Kantor, Tadeusz, *Wielopole, Wielopole*, London: Marion Boyars, 1990, explores the tricks played by memory with special reference to the "objectivity" of the family photograph album.

4 There is a famous historical precedent for this. In the Polish-Lithuanian Commonwealth, any member could call an instant end to the proceedings by shouting *nie pozwalam* (I do not allow).

5 The Solidarity banner, as my young friend pointed out, was an inspired image of "the people" as a random group of individuals, not a mob or a pressure group or a party delegation.

6 The streets of the People's Republic were blessedly free of the 'visual noise' of advertisements, so 'happenings' like Kantor's *The Letter*, 1967, were the more startling.

7 Witkacy, *Lovelies and Dowdies*, also known as *Dainty Shapes and Hairy Apes*, 1973. In the version on the film (dir. Krzysztof Miklaszewski, 1985)) the performance artist Jerzy Bereś, who often performed naked, appears to be stripped totally naked by the cloakroom attendants.

8 Kantor's Jewish jokes are as outrageous as Woody Allen's.

9 The massive mousetrap in *Dainty Shapes* is one among hundreds of dangerous and disturbing bits of machinery inserted into 'the plot' of Kantor scenarios. Additionally, actors are fused with or incorporated into machines. Kantor records his visit to the Palais de la Découverte, founded in Paris in 1937, as crucial in his development.

10 Davies, Norman, *God's Playground*, Oxford: Oxford University Press, 1981. This astonishing history book gets the measure of the virtual image of the Polish state, as reflected in Polish writing, like nothing else.

11 He called his productions "text mincers", because in Kantor's vision the formal imperative bears all before it and displaces "content".

12 To examine his own chronicle of the stages of his artistic development is to be struck once again by the spiritual journey leading from "autonomous" to "informel" to "zero" to "impossible" to "death" to "the lowest rank"; beyond this progression there was literally only "found objects".

13 The Cricot 2 actors were a motley crew but the presence of Kantor's wife and the Janicki twins, as well as the omnipresent Kantor himself, lent an uncanny feeling of family reality to the group.

14 For example, when Uncle Staś comes back from Siberia in *Wielopole, Wielopole*, an emotive moment if ever there was one, he 'plays' the Chopin carol on a hybrid hurdy-gurdy violin, while the family complain that he smells and has lice.

15 Between 1795 and 1918 the partitioning powers did their best to suppress Polish, while during the Nazi occupation people were shot for using it in public places.

16 In Havel's play *The Memorandum*, London: Eyre Methuen, 1981, the director of an office suddenly discovers a memo written in a strange language, which he is told is called Ptydepe. The deputy director has introduced this new language to facilitate the better running of the office and gradually everyone has to learn it, against their wishes and better judgement.

17 In the People's Republic this meant the "pełnomocnik" or "plenipotentiary" who directed the work force; cf. Havel.

18 This figure gradually became more and more insistent as Kantor's art evolved.

19 This became something of a Kantor catch-phrase: he was thinking primarily of his beloved Duchamp, Schwitters, and the Cubist use of bric-a-brac which they turned into art.

20 Kantor in a sense 'immortalised' People's Poland like no-one else.

21 cf. n. 7; For *The Water Hen* the Krzysztofory gallery was made to look like a workhouse, and sections of Witkacy's text were thrown into this space, inhabited by Kantor's 'actors', thereby generating a 'happening', or sequence of variations, tangential to the text: a kind of chain reaction.

22 There is no English volume to represent this production, but an issue of *Gambit International Review*, John Calder, 1979, contains a valuable transcript; Kantor, *Wielopole, Wielopole*; An army (Austrian) lives in a wardrobe in 'the room' and marches in and out of the domestic space, bearing away Kantor's father, Marian, soon after his marriage. He never came back.

23 Andrzej Wajda's film of *Wesele* may be the best place to observe this. The proper translation of the word *chochoł* is 'mulch' (the straw protection provided for certain small trees in very cold weather). Wyspiański sees the "mulch" as an embodiment of the suppressed spirit of Poland.

24 This phrase is actually David Holbrook's. His book *English for Maturity*, Cambridge: Cambridge University Press, 1967, was considerably at odds with the tenor of its age, and its arguments reach back to Arnold's

Culture and Anarchy and other Victorian classics, especially as transmitted by FR Leavis and his influential followers in English departments.

25 cf. n. 27

26 O'Brien, Flann (O'Nolan, Brian), *The Third Policeman*, written 1939/1940, published 1967. The author claimed he had lost the manuscript.

27 I remember a drunken conversation in Katowice when a friend said "Poland needs a Gogol" and someone answered "She's got one. His name is Gogol."

28 It should be said that in 1976 the Jewish heritage of Lublin, where I lived, was virtually ignored, indeed had been pretty deliberately obliterated. The Jewish Museum in Kraków was more like a museum of the SS. This has all changed, but too late for some.

29 Like Nabokov's last works, Kantor's form a kind of epilogue and index to his life's work. *Today Is My Birthday*, 1990, was posthumous, and before it *I'll Come Again No More* and *Where Are the Snows of Yesteryear* re-run the "savage parade" (Rimbaud) to which only the author has the key.

30 When I lived in Poland there was still a messianic cult of Piłsudski.

31 Kantor was sceptical about dissident theatre of the period he ironically calls "the dictatorship of the proletariat", saying "we have to fight for freedom/Within ourselves...." (Kobialka, Michal, *A Journey through Other Spaces*, Berkeley: University of California Press, 1993).

32 Stanisław Ignacy Witkiewicz, 1885–1939.

33 Witold Gombrowicz, 1904–1969, published *Ferdydurke* in 1937. His post-war novels, also close to Kantor in spirit, lack its comedy, and their absurdist world view is blacker and more absolute.

34 Mariusz once said that I was so privileged to be allowed to teach literature to young people that I should be prepared to do it for nothing. He was suspicious of all academicism and sniffed it out in unlikely places. Why, he said, did Lawrence (one of my research interests) hide behind two initials? Was this not the English self-righteousness and hypocrisy? He said the same of my Cambridge teacher, FR Leavis. As far as I could tell whe had never read either of them.

35 For a good account of this see Gerould, Daniel, *The Witkiewicz Reader,* Evanston: Northwestern University Press, 1992.

36 "Le nom/non du pere" initiates the Oedipus story and forms the keystone of Lacan's *Les Complexes Familiaux*, 1938, and all subsequent research.

37 His last three works are sets of variations on the childhood theme.

38 This is Halliday's "personal" function of language, in the hierarchies of childhood acquisition. We see in Kantor's work everywhere how hard this personal function is to maintain; Lacan tells us that at the age of around seven, the "mirror stage", the child first apprehends an image of himself which he knows is other than the fragmented self he is.

39 Kantor both is and is not that 'other', cast in the mould of the (absconded) Father.

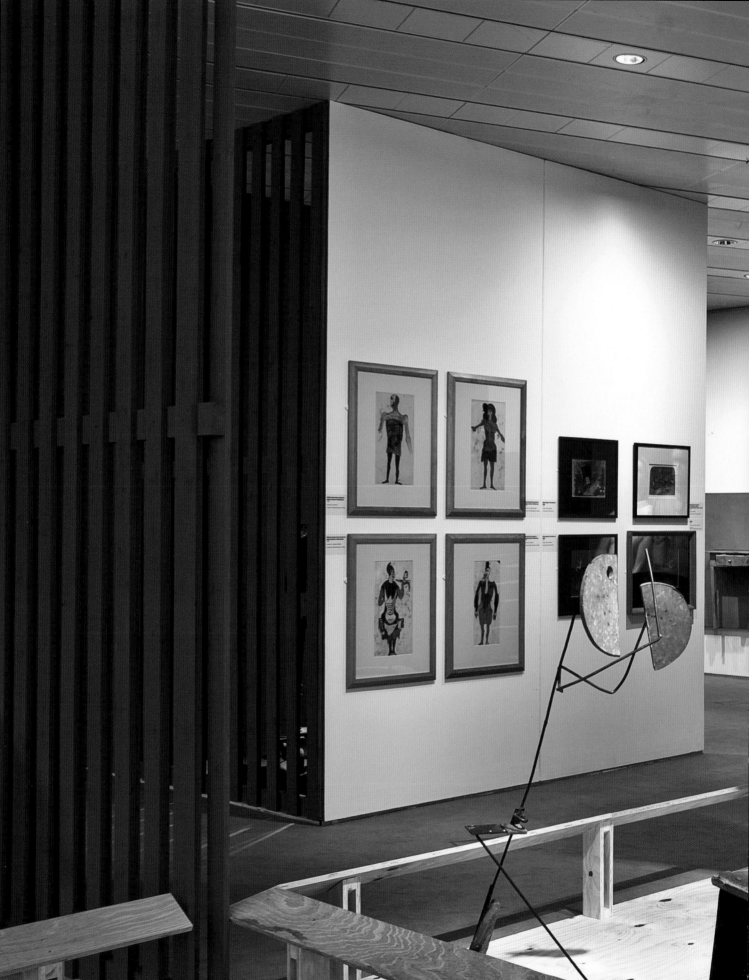

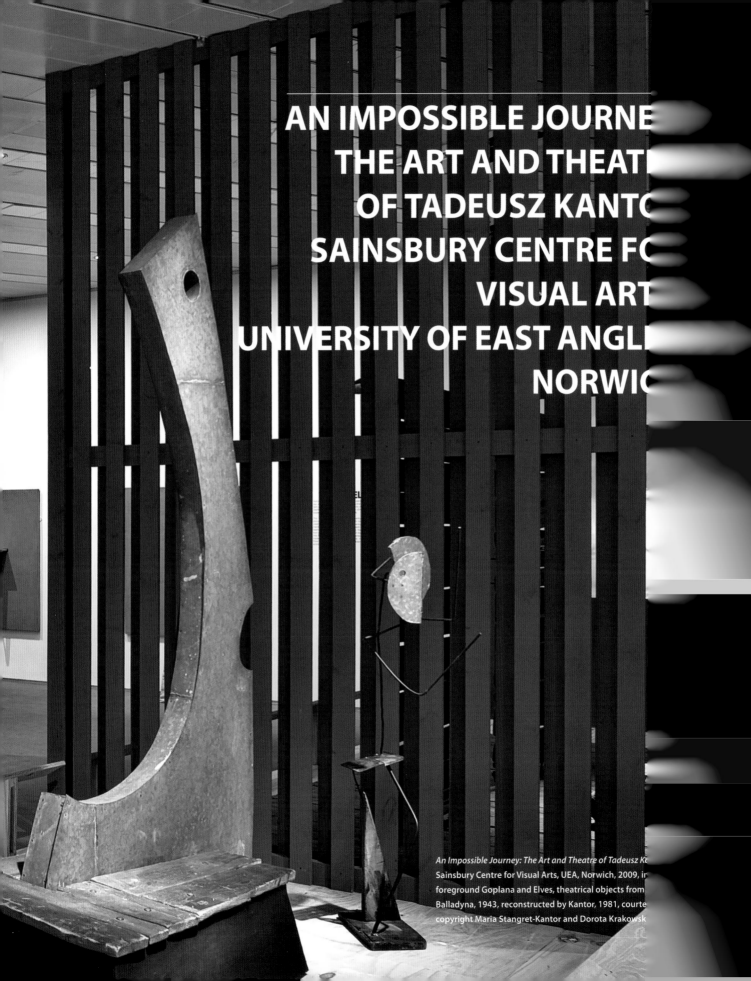

AN IMPOSSIBLE JOURNE
THE ART AND THEAT
OF TADEUSZ KANTC
SAINSBURY CENTRE FC
VISUAL ART
UNIVERSITY OF EAST ANGL
NORWIC

An Impossible Journey: The Art and Theatre of Tadeusz K
Sainsbury Centre for Visual Arts, UEA, Norwich, 2009, ir
foreground Goplana and Elves, theatrical objects from
Balladyna, 1943, reconstructed by Kantor, 1981, courte
copyright Maria Stangret-Kantor and Dorota Krakowsk

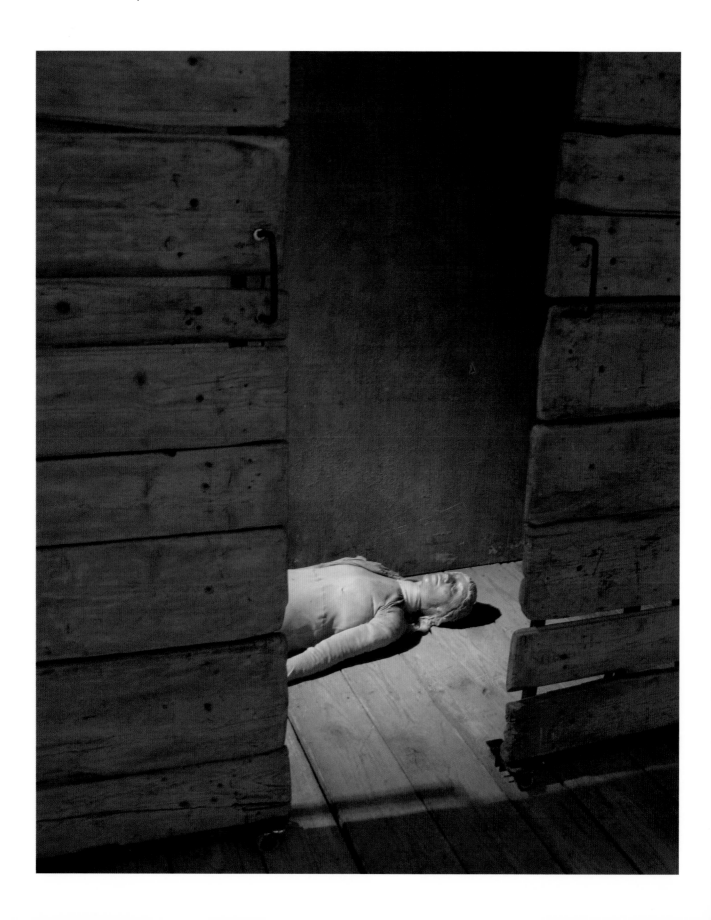

INTRODUCTION

JONATHAN HOLLOWAY

Having studied Tadeusz Kantor as a drama student, my active involvement with his legacy began seven years ago, in Barcelona, hearing David Gothard talk about his archive. The following year I chaired a Total Theatre Lecture at the ICA in which David again spoke about Kantor.

In 2008, sat on a train just outside Warsaw, on a research visit across Poland for Contemporary Art Norwich, my mind again turned to Kantor. I began to think about his divided career between the visual arts and theatre. I realised that each stop on the trip (Warsaw—Łódź—Kraków) took in a different part of his extraordinary story. I pondered on the fact that his story illuminated the twentieth century in a way which seemed doubly relevant at the end of the first decade of the twenty-first century.

In Łódź I discussed with Jarosław Suchan what Kantor exhibitions had gone before. In Kraków I met with Natalia Zarzecka and the Cricoteka team and discussed collaboration and what exhibits existed. I visited the Cricoteka 'museum' where the spirit of a possible exhibition became clearer, in particular the concept of an exhibition as a labyrinth.

At this stage I still envisaged an exhibition in an underground, dingy, cellar type space, but Amanda Geitner and Veronica Sekules proposed the idea of doing the exhibition at the Sainsbury Centre and we all jumped at the chance. From that spark began a massive journey, led and shaped by many extraordinary people. Kasia Murawska-Muthesius brought vision, skill and energy to the development and realisation of the exhibition, and the Sainsbury Centre's technical team brought solutions and practical brilliance.

Our job—as creators, curators and enablers of art—is to make universal truths resonate on an individual and collective basis. I believe that the collective effort to deliver this exhibition reflected Kantor's own collaborative approach. More than that, by presenting Kantor's work juxtaposed with a wide range of contemporary Polish arts, we were able to illuminate the human condition and cast light on the changing boundaries and borders which are our every day experiences.

Mannequin of Mother Helka, *Wielopole, Wielopole,* at *An Impossible Journey: The Art and Theatre of Tadeusz Kantor,* Sainsbury Centre for Visual Arts, University of East Anglia, Norwich, 2009, photograph Tomasz Tomaszewski, copyright Maria Stangret-Kantor and Dorota Krakowska.

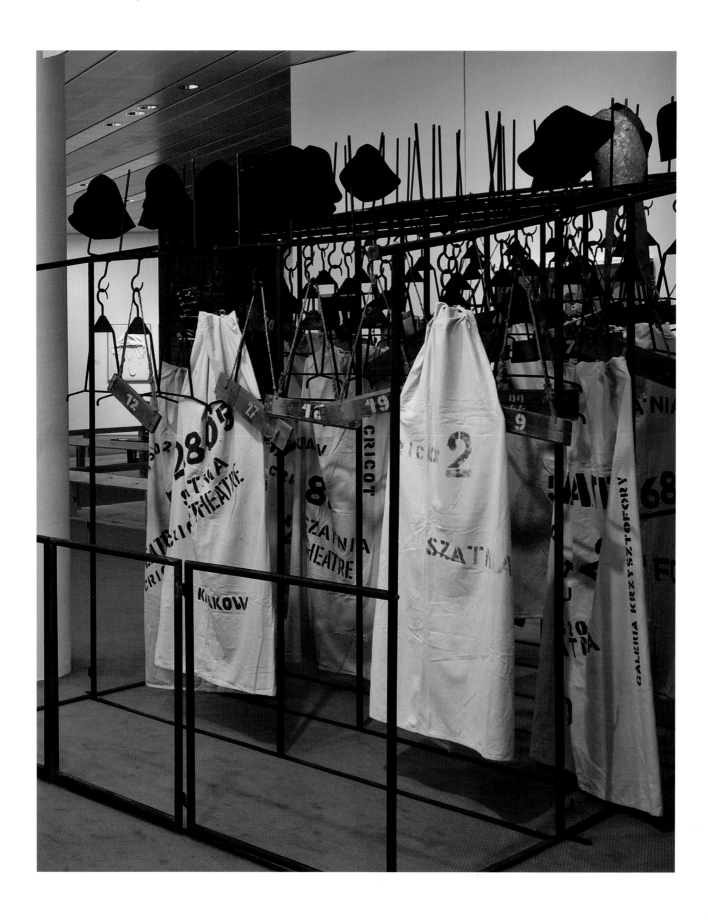

EXHIBITING KANTOR

AMANDA GEITNER

In the summer of 2009 we opened two exhibitions at the Sainsbury Centre for Visual Arts, University of East Anglia, as part of the POLSKA! Year: *An Impossible Journey, the Art and Theatre of Taduesz Kantor* and *Take A Look At Me Now, Contemporary Art from Poland.*

Our experience of Poland began with an introduction to Raster Gallery, Warsaw, who had come to Norwich as selectors for East International 09. Together with a group of curators from Norwich, we made the first of three trips to Poland in March 2008 with the intention of developing an exhibition for Contemporary Art Norwich 09 that built upon an orientation towards Eastern Europe established over many years by East International at the Norwich University College for the Arts. We were all interested in what might be the relevance of the 20 year anniversary of the fall of the iron curtain across Eastern Europe for artists working in Poland today, and were curious to see whether twentieth century history continued to inform their work, or if more recent issues of economic growth, migration and subsequent global recession would dominate.

During conversations with Polish colleagues on that first trip a second strand of interest emerged as Jonathan Holloway, Director of the Norfolk and Norwich Festival, began to pursue his interest in the work of Tadeusz Kantor. Following a meeting with Natalia Zarzecka, Director of Cricoteka Kraków, Jonathan was lit up with the desire to bring Kantor to Norwich—"if only we had a fabulous subterranean space"—and so, working together with the Polish art historian living in Norwich Kasia Murawska-Muthesius, we started to plan a major exhibition of Kantor's art and theatre for the Lower Gallery, underground at the Sainsbury Centre.

There were several key challenges in making an exhibition of the work of Taduesz Kantor for a British audience. At the heart of the project was the desire to show the full breadth of Kantor's work—to show canvas and collage alongside mannequins and chairs. We wanted to take material that is shown in the still spaces of fine art galleries and place it in context with material that was once made animate as participants in theatre and to allow our experience of all the work to be enhanced by the excitement of this proximity.

We realised that our potential audience could be clearly divided into those who knew Kantor's work intimately or not at all. Our aim was to make the work legible and relevant to those being introduced to it for the first time while revealing new aspects of the work to those who were most familiar with it.

As our exhibition design discussions began these thoughts were expressed in our concerns about the space we were to create—was it to be gallery or theatre, or both? What form of installation could accommodate all the work and reference the contexts of its production and subsequent life? We wanted an installation that would seduce, surprise and sometimes disorientate. We wanted something of the studio, the theatre and the cellar, something of a journey, with a sense of labyrinth that would lead the viewer on, in turns concealing and revealing the works on show. And finally the exhibition was to look magnificent—yet we were keen to avoid too obvious an artifice, too theatrical an approach. The Sainsbury Centre is a gallery and allowing work to be seen, enabling visitors to have a wonderful aesthetic experience, is fundamentally what we are about. We did not want to play the master at his own game and try to mimic the ambience of Kantor's original happenings and performances.

The final effect achieved in the installation came in to focus as the design team at George Sexton Associates DC proposed the use of a wooden shuttering—a hit and miss fencing—from raw painted timber that divided the spaces and art works within the exhibition. This system allowed for an encounter with an object at the turn of a corner as well and the ability to catch glimpses of the works beyond. With this approach we hoped to make a journey through the space that was mysterious and enticing and an installation that also enabled us to subtly make connections between the works, visually linking images and themes within the exhibition. The selection of works was generous and the space was densely hung, with enough

The Cloakroom from *Lovelies and Dowdies* blocking the entrance to *An Impossible Journey: The Art and Theatre of Tadeusz Kantor* at the Sainsbury Centre for Visual Arts (SCVA), University of East Anglia, Norwich, 2009, courtesy SCVA.

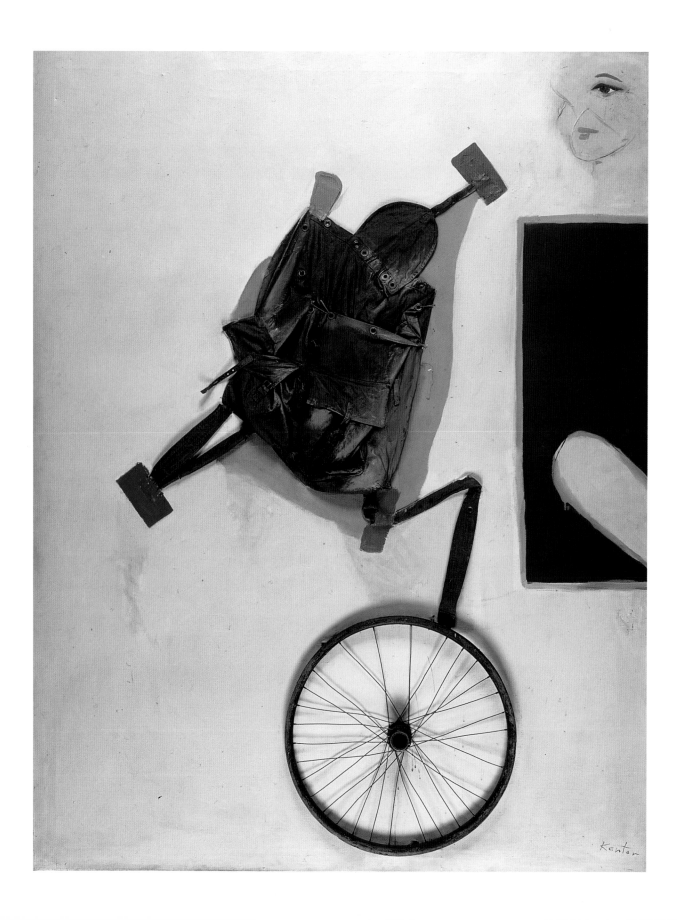

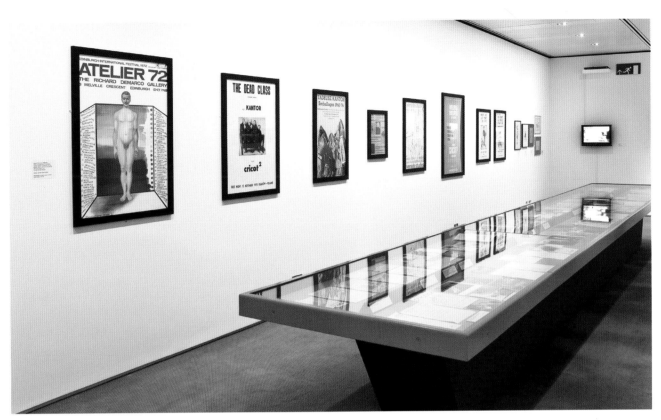

Opposite Tadeusz Kantor, *Emballage IV*, 1967, assemblage,
205 x 160, collection of Muzeum Sztuki w Łodzi, exhibited at
An Impossible Journey: The Art and Theatre of Tadeusz Kantor at
Sainsbury Centre for Visual Arts, Norwich, 2009, copyright Maria
Stangret-Kantor and Dorota Krakowska, courtesy Cricoteka.
Above Archival section of *An Impossible Journey: The Art and Theatre
of Tadeusz Kantor* at the Sainsbury Centre for Visual Arts (SCVA),
University of East Anglia, Norwich, 2009, courtesy SCVA.

space to allow each work to breathe and a rich enough juxtaposition to allow the
works to talk to one another.

At the centre of the exhibition was *The Dead Class* installation. Many years after
the first *Dead Class* performance the quiet arrangement of mannequins and desks
was disturbing enough to make people gasp as they turned the corner to face the
children that looked back at them. The display of this work was an interesting
example of how Kantor's work continues to have relevance—the original performance
cannot be recreated in a gallery context but we can understand these objects as
sculptures that function independently from their theatrical origins.

There were many conversations about how to provide an audience unfamiliar
with Kantor's work with enough information to decipher his objects and images and
to understand the broader political and social context of their production. It was
decided that archival, biographical and documentary material would be shown in the
Link spaces—three galleries along a large corridor that connects the Lower Gallery to
the main building. In this way the visitor could look at the Link display before seeing
Kantor's work and perhaps again afterwards—so that this material served as both
introduction and conclusion to the exhibition. The archival material, particularly the
rich selection of documents and photographs relating to Kantor's work in the UK
brought together by Jo Melvin, could be presented as its own smaller exhibition—
neither compromising, (nor being compromised by) the spectacular installation of
work in the Lower Gallery.

An Impossible Journey was made possible by the generous loans of extraordinary
works from collections in Poland, Germany and the UK. It is not surprising that such
powerful work should provoke strong opinions in those that continue to engage with
it and it was these opinions that we solicited and tried to balance in the development
of the exhibition. Ultimately, we made in Norwich a Kantor exhibition unlike those
that have gone before and created an unprecedented opportunity to see the artist's
work in England. The record of the exhibition here stands as both legacy and
testimony to the impact of the project.

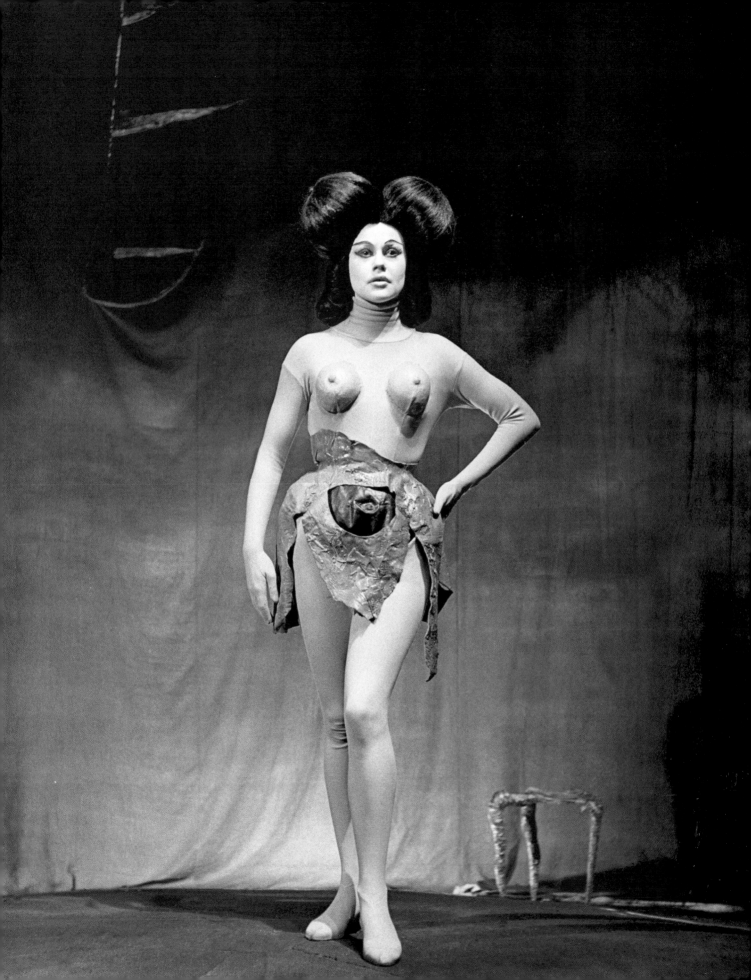

KANTOR IN NORWICH

VERONICA SEKULES

Opposite Ewa Wawrzoń as Daisy in *The Rhinoceros* by Eugene Ionesco, stage design and costumes by Tadeusz Kantor, Teatr Stary, Kraków, February 1961, photograph Wojciech Plewiński, courtesy Cricoteka.

Above Tadeusz Kantor, *Daisy*, design of female dress for *The Rhinoceros* by Eugene Ionesco, stage design and costumes by Tadeusz Kantor, Stary Teatr, Kraków,1961, tempera, ink, collage, cardboard, 51 x 26.8, collection of National Museum in Kraków, exhibited at *An Impossible Journey: The Art and Theatre of Tadeusz Kantor* at Sainsbury Centre for Visual Arts, Norwich, 2009, courtesy Cricoteka, copyright Maria Stangret-Kantor and Dorota Krakowska.

Kantor had quite a legacy in East Anglia, and a core group of local artists who really understood his work, some of whom knew him personally. But to the majority of the local audience he was a mysterious unknown figure. Very few had experienced his theatre, most people had never heard of him. The entire project needed to enliven the presentation of his work as much as possible, and the role of the education project was to activate interest, engagement and the desire to learn more. However, some basic practical considerations always need to precede the planning of an education programme for any new exhibition project. These will range from, for example, the time of year when it is due to happen, the age and ability level to which the subject will appeal, to the spaces available for group viewing or study. The timing alone can play a large part in how ideas will develop. For example, the autumn is prime time for teaching, as it is the beginning of the new academic year when everyone is ready to make a fresh start; the spring is exam time when there is more pressure only to undertake those things which will be specifically relevant. During the summer, people travel, take time off, are more geared towards informal than formal learning. But for a museum located within a university context, it is also the time when academic conferences happen, when new ideas are generated and exchanged.

The Kantor exhibition in England spanned the spring and summer periods, which inevitably guided our approach towards facilitating a combination of academic and informal learning. His work was very much conceived in an adult avant-garde context and while there were many lessons to be learned in theatre education, early indications from teachers suggested that they felt that his Theatre of Death was too challenging for them to tackle with children. Having decided therefore to focus on adults, we initiated a lunchtime talk series, performance events for the gallery's monthly Late Shift, creative projects with artists and communities, and academic symposia. To begin with, we felt it was also important to reference the legacy of Kantor's work through relationships with the learning programme from the other exhibition at the Sainsbury Centre, *Take A Look At Me Now,* about contemporary Polish art. Both exhibitions had symposia, which appealed to quite different audiences, but coincidentally they both explored the grounding of Polish contemporary art in performance. The Kantor symposium, which is of course discussed in detail in this book, straddled academic discourse and personal reflection, recalling people's collaborations with Kantor as a major, charismatic artistic personality. But what was particularly striking for us in England was the extent to which the performative theme continued to underpin the work of the next generations, but in completely different ways. For example, for the symposium for *Take A Look At Me Now*, two academics, Krzysztof Fijalkowski and Karol Sienkiewicz, examined the grounding of Polish Contemporary art in a more recent tradition of shared experimental performance, Sienkiewicz concentrating on the studio of Grzegorz Kowalski, where many key figures in Polish contemporary art, such as Paweł Althamer, Artur Żmijewski, Katarzyna Kozyra and Anna Molska, were trained. Even for some of those artists who did not explore performance directly, there was a certain drama or theatricality about the way in which they presented their work. Some articulated their position as being a reaction to Kantor, or even rebellion against his manipulative power.

Bringing performance into the exhibition without undermining its integrity as a tribute to such a remarkable artist was always going to be tricky. Sharing resources with the Norwich Festival, we were able to initiate *Kantor Encounters*, a programme of performance directed by Jonathan Holloway, which allowed the investigation of Kantor's legacy to be appropriately and subtly explored and enhanced. Actors guided the public round the exhibition in a halting, strange way, echoing performative strategies used by the director himself.

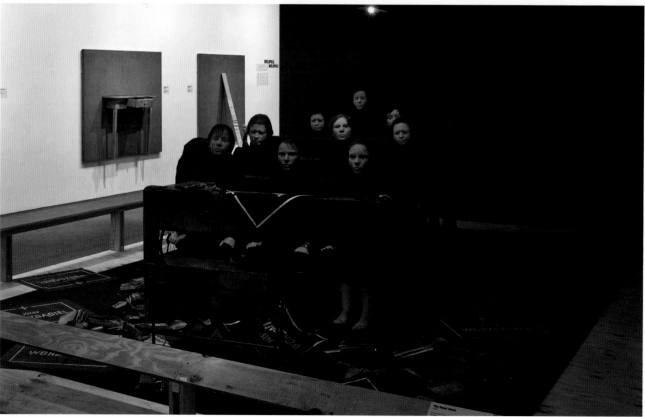

Niezwykle naiwne wydają mi się powszechne dziś
tendencje dzielenia Europy na Zachód i Wschód.
Europa jest niepodzielna. Europa k u l t u r y. ...
Gdzieś na rozstajnych drogach Czasu musi istnieć
"Café Europe" .. kogo tam nie ma ...

("Café Europe", 1990).

I find extremely naive the widespread tendencies
to divide Europe into West and East.
Europe is not dividable. The Europe of Culture. ...
Somewhere on the crossroads of Time, there must be a
'Café Europe' ... and of course everybody is there ...

Opposite top Educational space at *An Impossible Journey: The Art and Theatre of Tadeusz Kantor* at the Sainsbury Centre for Visual Arts (SCVA), University of East Anglia (UEA), Norwich, 2009, courtesy SCVA.
Opposite bottom Mannequins and school benches from *The Dead Class*, exhibited at *An Impossible Journey: The Art and Theatre of Tadeusz Kantor,* Sainsbury Centre for Visual Arts, UEA, Norwich, 2009, courtesy SCVA, copyright Maria Stangret-Kantor and Dorota Krakowska.
Above Enlarged diagram of Kantor's *Café Europa,* 1990, *An Impossible Journey: The Art and Theatre of Tadeusz Kantor,* Sainsbury Centre for Visual Arts, UEA, Norwich, 2009, courtesy SCVA, copyright Maria Stangret-Kantor and Dorota Krakowska.

At the heart of the tour was an encounter with an ashen-faced figure, supposedly a distant relative who had inherited Kantor's scant documentation, and who was being driven half crazy by frustration that he was no longer able to grasp the spirit of what Kantor had bequeathed the world. As he offered the audience a shot of vodka, he invited them to share his concern that they were in danger of letting a major influence on theatre history go almost un-noticed. It made the experience of viewing the exhibition more thought-provoking, the audience feeling both enlightened and culpable, now having a more of a stake in the reputation of the artist.

We knew that none of Kantor's performances or plays could be literally re-enacted. Much as we would have liked to re-stage *Panoramic Sea Happening* in a new context, even including some of those people who had originally taken part, there would have been something drily derivative and empty, without having his charismatic presence at the helm.

But adapting ideas, examining them in new contexts, drawing conclusions from things he had begun, that was a different matter. There were other kinds of powerful legacies from his work that we wished to explore, with the aim of enabling lessons to be learned in more creative ways. Without in any way encouraging pastiche, we were keen to investigate how new thinking, with new practitioners could move some of his ideas forward.

We also had a clear context within which his work could acquire new relevance for us. One of the Sainsbury Centre's creative learning projects, *The Culture of the Countryside*, funded by the Heritage Lottery Fund, is based on the idea that the way of life and heritage of a place is best understood by comparison with elsewhere. We begin from perspectives that art may give us, art which comes from another part of the world, in order to investigate current attitudes, our own peoples, customs, localities. Kantor's work was inspiring in this context, especially in terms of the fact that he could make extraordinary works of art from highly personal events, grounded in the village where he grew up. *Wielopole, Wielopole*, combining the personal narratives of his parents' marriage, his father's departure for the First World War, with the Passion of Christ took the idea of local, rural culture beyond the mundane, to epic proportions.

So, as part of our education programme, we commissioned a group of four artists to look carefully at his oeuvre and without in any way copying or diluting any ideas, to come up with a series of proposals for creative projects we might engage in which would be appropriate for East Anglia and yet would serve as a tribute to Kantor's legacy. We set up the project to take place in the seaside town of Mundesley where there was an active amateur dramatic group, Mundesley Players, who agreed to lead the participation, which also involved other local residents and young artists from Paston College.

The project culminated in a series of public events, which were held each Sunday throughout September 2009. A tribute to Kantor's seminal, *Panoramic Sea Happening* opened the season and inspired a new beach movement performance choreographed by Marcela Trsova, *Time and Duration*, a meditation on coastal erosion. An invited group of about 30 people, all dressed in black, faced the sea, arranged in arrow formation. As the tide came in, and water lapped over the feet of the people in the front, they moved silently to join the back row, until the whole group formed a single line. As the water reached them, they all dispersed. For the second event, a large amount of furniture was deposited at Gold Park green in the centre of the village, and arranged into a realistic-looking temporary home installation, for Gemma Watts' performance piece, *Seven Hour Home*. Mundesley players created absurd scenarios for its supposed inhabitants. As they got into the swing of their improvisations, their movements and relationships took on a Kantor-esque absurdity, watched over and guided, much as Kantor had done with his actors, by the artist, the director and the producers which by a nice turn of fate, were all women. Another female artist, Jacqui Jones, photographed some 40 local residents and the results were digitally projected one night on the exterior wall of

Kantor Encounters performance at *An Impossible Journey: The Art and Theatre of Tadeusz Kantor*, Sainsbury Centre for Visual Arts (SCVA), University of East Anglia (UEA), Norwich, 2009, courtesy SCVA.

Mundesley Maritime Museum, a tiny building picturesquely placed on a green on top of the cliff overlooking the sea. This provided a focus for local celebration, everyone coming out to share a drink and discuss the images. The fourth project, Julia Parry Jones' *Extraordinary*, celebrated local memory and association with resonant objects, evoking ideas shared with Kantor about the associative power of what might in other circumstances be classed as rubbish. A group of local people selected artefacts from the *Seven Hour Home,* which they altered and embellished to create a new heritage, celebrating their associations and memories. The results were displayed in home and shop windows and became the focus of a town trail.

These projects ended up being totally different in spirit, atmosphere and even in their individual aims from anything produced by Kantor. No Kantor audience would have recognised his legacy there. They were entirely about the locality where they were generated and they were about the work of new artists responding to it. They said something very interesting however, about the role of influence and the ways in which an artist's work can enable new things to happen in realms quite different from those they had envisaged.

02.06.2009

Sainsbury Centre for Visual Arts
University of East Anglia
Kantor was Here
Symposium speakers

Wiesław Borowski
Richard Demarco
David Gothard
George Hyde
Klara Kemp-Welch
Jo Melvin
Sandy Nairne
Veronica Sekules
Uta Schorlemmer
Jarosław Suchan
Natalia von Svolkien
Sarah Wilson
Noel Witts
Natalia Zarzecka
Katarzyna Murawska-Muthesius

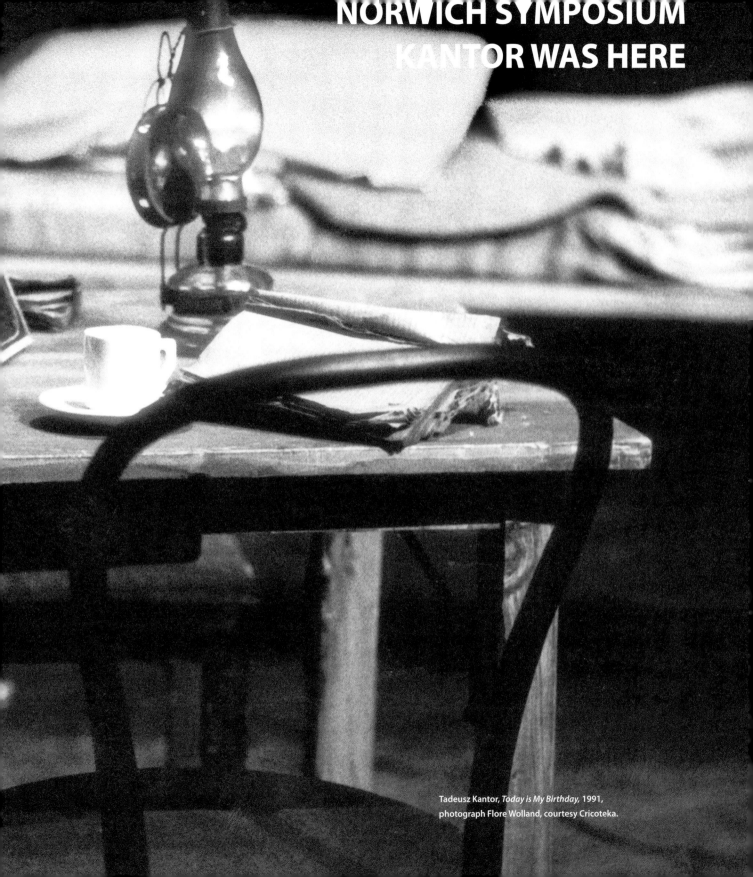

Tadeusz Kantor, *Today is My Birthday*, 1991,
photograph Flore Wolland, courtesy Cricoteka.

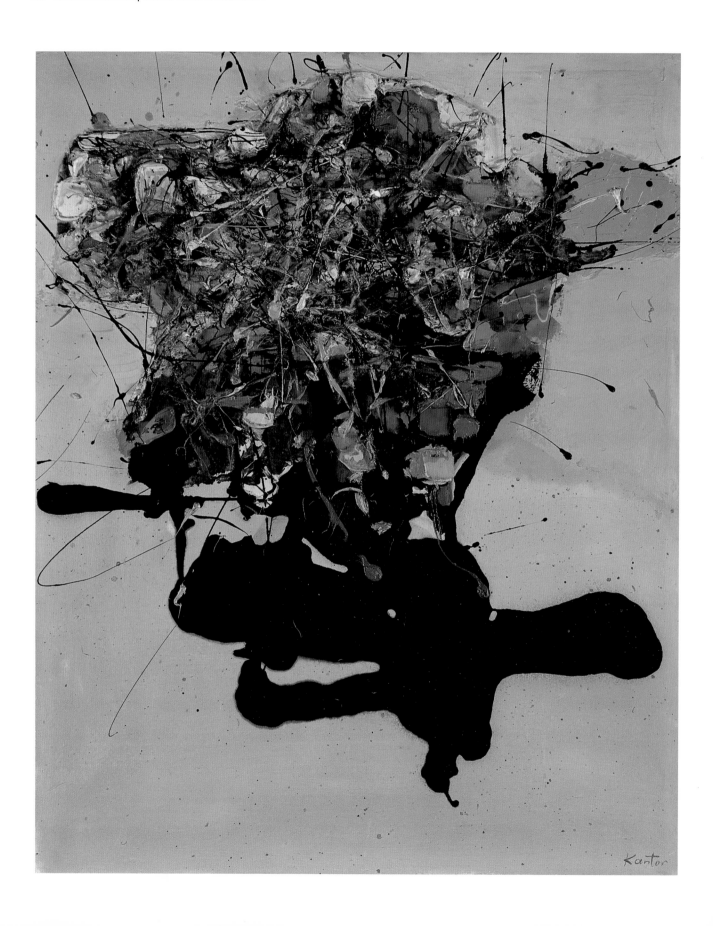

KANTOR'S ART FROM INFORMEL TO INSTALLATION

SARAH WILSON

One does not look at the work of art in theatre in the same way that one looks at a painting, to discover its aesthetic values… rather one looks to experience it in a concrete way…. I do feel a strong commitment to the time I live in and to the people around me.
Tadeusz Kantor[1]

Kantor's painting is an essential source of his creativity, informing his absurdist theatre.[2] His insistence on the direct experience of a play versus the painting, which offers a framed "aesthetic feeling" was paralleled by developments in the art world, no longer satisfied by the boundaries of a canvas. As contemporary art practice developed through the late twentieth century, so Kantor's own expressive means progressed from paint to *emballage* to happening and to installation, in a marriage of art and theatre. The spilling out of painterly aesthetics into theatrical space required a concomitant development from the spectator. The practice of painting, within the decorum of the *Informel*—moves later, following the practices of French Nouveau Réalisme, towards an incorporation of lost objects—reborn as Kantor's "Poor Object". All these elements enter the total theatre concept, Kantor's *Gesamtkunstwerk*. He is a key precursor, I conclude, for today's installation art.

When Kantor visited Paris in 1947, it was unbombed, unbowed, and able to reassert its presence, almost immediately as an intellectual capital; Jean-Paul Sartre's existentialist philosophy acquired international prestige. French was the language of communication outside Poland for Ryszard Stanisławski, Oscar Hansen and for Kantor himself.[3] In the Eastern-bloc Soviet satellite countries Paris was still capital of the arts (with the Moscow-backed Communist intellectual weekly, *Les Lettres Françaises*, circulated widely). The Biennale de Paris from 1959 had a Polish component.[4] The Sainsbury Centre for the Visual Arts, which staged *An Impossible Journey: The Art and Theatre of Tadeusz Kantor* in summer 2009, houses the Robert and Lisa Sainsbury collection. A perfect time-capsule of 1950s–1960s taste, it demonstrates the Paris-centric universe of the Western intelligentsia at this time.[5]

Kantor had trained at the Academy of Fine Art, Kraków. He says that in 1946–1947 his earliest paintings "represented different types of work"—washerwomen, ironing women. These were created within the milieu of the Young Visual Artists' group he created in Kraków and the context of his manifesto of "exponential realism" written with Mieczysław Porębski.[6] But like most of his contemporaries, after contact with Paris he moved towards a post-Picassoid mode of abstract shapes outlined in black contours, such as *Spatial Forms*, 1947—analogous to both French and Polish contemporaries such as Jerzy Skarżyński. Kantor would evolve, however, to become arguably the most prominent Polish representative of the *Informel* movement.[7]

To explain the twin sources of this Paris-born art movement one should contrast two figures, Jean Fautrier and Georges Mathieu: Fautrier's *œuvre* was intimist, *matièriste*, filled with poetry and pain; Mathieu's was extrovert, gestural, an exercise in power. Fautrier exhibited his works in Paris in 1943, the year when—after months of Jewish deportations—Paris became aware of the concentration camps. His *Otages* (hostages) were shown in 1945; their context was not post-war rejoicing, but a reprise of violence during the *épuration*. This purge period witnessed a plague of French-on-French reprisal killings (estimated a little later as counting 60,000 victims) and the vicious shaving and branding of women—*les tondues*.[8]

Fautrier built up layers of pastes he called *hautes pâtes*, on paper sprinkled with powders and chemicals, then mounted on canvas. Matter was worked with a palette-knife: a quasi-indexical gouging bore witness to horror, while features such as an eye or the T of a rib-cage were painted cosmetically onto the flat surface.[9] His collaborations with Georges Bataille through the Nazi occupation period add an intellectual overlay to *Otages*.[10] Bataille's dialectic of *victime* and *bourreau* (victim and executioner) was transposed almost immediately to Sartre's existentialist and absurd theatre.

Tadeusz Kantor, *Informel*, 1959, oil on canvas, 100 x 80, private collection, copyright Maria Stangret-Kantor and Dorota Krakowska, courtesy Cricoteka.

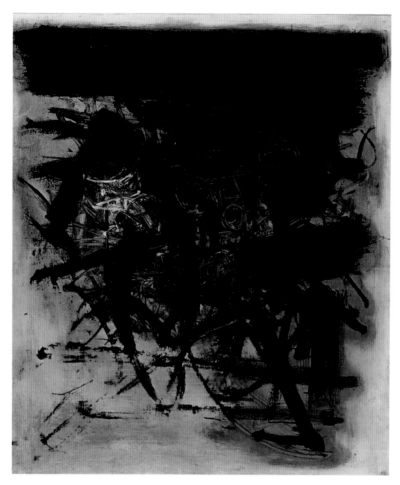

Left Georges Mathieu, *Upside Down*, 1951, oil an canvas, 100 x 81cm, image courtesy the artist and the Courtauld Institute of Art Slide Library.
Opposite Christo, *Wrapped Woman*, London, 1963, female model and plastic wrapping, dimensions unknown, courtesy the artist and the Courtauld Institute of Art Slide Library.

Georges Mathieu's riposte to a climate of death and violence was also to dramatise.[11] His *Informel* became a performance of free gesture, personal signature, in a deliberate competition with Jackson Pollock; an anarchistic, neo-Dada dimension entered the post-war *Informel*.[12] Like a sword-wielding actor in a historical epic, he titled huge canvases with the names of French battles. His notion of art's "liberty", the necessary "void" of the *tabula rasa*, became conflated with notions of zen and the sacred.[13] Yet his *japonisme*, coming after the atomic bomb, encountered the technological age of cybernetics and Heisenberg's uncertainty principle.[14]

We last considered Kantor's *Spatial Forms*, 1947. The International Exhibition of Surrealism that year responded to a Paris in moral shock via spatial installations (devised by Marcel Duchamp and Friedrich Kiesler) in which dark madness and black humour ruled—where furniture had limbs….[15] Already art had left the frame of painting and gallery walls. The substantial catalogue soon found its way to Kraków. Surrealism was seen as subversive—as "on the left"—despite the contempt in which Breton's Trotskyism and American wartime career were held by French Communists; its influence was far less visible than abstraction, however, in the all-Poland major exhibition of modern art Kantor organised there in 1948.[16]

It is clear that Kantor's later painting such as *Metamorphosis*, 1953, engages with the menacing hybrid, Surrealist forms of Roberto Matta. The move to freer, more Mathieu-like gestures comes later. Compare Mathieu's *Upside Down*, 1951, with Kantor's equally top-heavy, though more Pollockian, splashy work, *Informel*, 1959 (following a major Paris trip in 1955). This is more colourful, loose, *tachiste* (literally blob-like): imagination, emotion and instinct, prevail. In 1964, for his

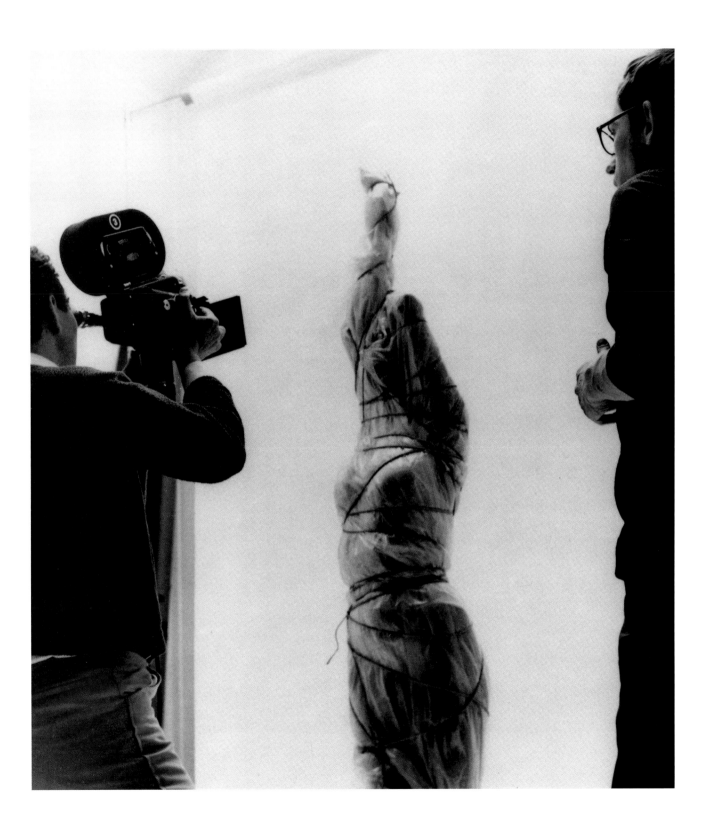

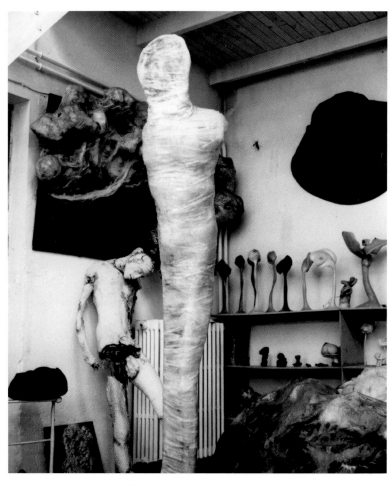

Alina Szapocznikow, *Zero Gravity, or the death of Komarev,* 1967, metal, polyester, gauze, 235 x 70 x 40 cm, photograph taken in Malakoff studio, Paris, by Roman Cieślewicz courtesy Piotr Stanisławski.

exhibition at the Galerie Alice Pauli in Lausanne, Kantor wrote a long poem-text about his painting:

> 1947
>
> … the human personnage is created/between the organism/ living/suffering/and the mechanism/functioning/automatically/ absurdly/Imperious/is the law of metamorphoses….
>
> 1955
>
> … Space thickens forms/changing its molecules/In this gigantic/ mobility/rapid decision/ intervention/spontaneity of action/ brushes constantly/with chance….
>
> 1961
>
> … the action of painting/takes place in this process/of permanent annihilation….[17]

In this context, listen to Artur Żmijewski: "I am composed of accidental flows and vertiginous emotion, and since I am unfortunately constantly off balance, I keep on returning to it… there is even more anaemia than I thought lurking in my organism. It is always ready to gush out, it would seem, after each extremely directed deed…."[18]

The relationship between emotion and the "extremely directed deed" reminds us how the expressionism of the *informel/abstraction lyrique* was always related to its opposite (memories of fascism, confinement and control). This dialectic is played out later, both in Kantor's theatre and in Żmijewski's own commemorative pieces like *Berek (The Game of Tag)*, 1999 or *Powtórzenie (Repetition)*, 2005. The abject dimension of the *Informel*—the antithesis to its own discourse of freedom

and liberty—is horrifyingly explicit in Kantor's Informel paintings such as *Head with informel comment* or *Emballage man*, both of 1967. (One should insist that the writer Céline's "disgusting" antisemitism is at the heart of Julia Kristeva's influential study of abjection, *Powers of Horror*.[19])

As early as 1961, before the wellspring of *Informel* painting dried up in Kantor's work, he was aware that the international proliferation of the movement was a trap. During his semester lecturing in the Hamburg art school in 1961, he published a text "Is the Return of Orpheus possible?" in which he could see no way to return from "the mad journey through the infinite tunnel of the *Informel*"....[20] Yet to push the *Informel* into theatre was the next step. Kantor's text "Informel Theatre", and fragments relating to Cricot 2, from 1960–1962, emphasise matter, formlessness, spontaneity, decomposition, dissolution, disintegration, destruction and coincidence....[21] These terms are a direct transposition into Polish—and Kantor's inimitable list-based "concept poetry"—of ideas from Georges Mathieu's *Au-delà du tachisme* of 1962. In itself an attempt at "going-beyond" *tachisme*/the *informel*, this also transposed vocabularies from a different arena: Romanian philosopher Stéphane Lupasco's thoughts on energy, matter and the logic of contradiction in an age of science and cybernetics.[22]

Kantor's "Zero Theatre" manifesto of 1963, used a similar strategy. He took a word and set of associations from the discourses of the art world, in this case the German Zero group artists (themselves punning on the German *Stunde Null*—zero hour—and Roland Barthes' *Le Degré Zero de l'écriture*, 1953). At this Situationist moment where appropriation and détournement were seen as neo-Marxist critical and deconstructive strategies, Kantor gave 'Zero' a 'poor' rehabilitation in the Polish context.[23] As the Zero Group artists, Otto Piene, Heinz Mack and Günther Uecker were based in Düsseldorf at this time, Kantor's intellectual dialogue at a distance with Joseph Beuys seems all the more probable. (Beuys was teaching at the Kunstakademie from 1961; the artists would meet thanks to Richard Demarco in Edinburgh in 1973).

Kantor's work now moved from an *Informel* painting towards *emballage*, via an incorporation of props into the canvas—or an unfolding of the canvas into costume, covering, stage drape. This mirrors the practices of Pierre Restany's French group, the Nouveaux Réalistes. The Bulgarian Christo's *Wrapped Woman,* London, 1963, precedes Kantor's *Human Emballages* (Łódź, 1965 and after). Christo's wrapping is deeply linked to his political memories (dead partisans in the streets of Sofia) and the wrapping and binding practices of peasant life in the Bulgaria he fled, after training at the School of Fine Arts as a Socialist Realist painter.[24] Like so many members of the School of Paris he was a refugee and a nomad who had had to leave, taking the minimum with him. Every object Christo wrapped, table, chair, sewing machine, might unwrap to tell its story; *de-emballage* of loss, dispossession, dysfunctionality. Even closer to Kantor is Alina Szapocznikow's *Zero Gravity or the death of Komarev*, 1967, an inclining, bound figure of the Soviet cosmonaut who became literally lost in space, spinning forever in the void. Alina took her figure sculptures in the streets of Łódź and filmed them: the performative element and the blurring of the parameters between art and life again approach Kantor, her contemporary.

Just as in Georges Perec's writing, the Holocaust began to features by omission (and Kantor's word and letter-based performances surely owe a debt to Perec) so it did in Nouveau Réalisme. Arman's *Accumulations* consisted of paint tubes, money and lipsticks—but also gas masks, spectacles and teeth. Never explicitly political, these works were nonetheless made in the era of Alain Renais's *Nuit et Brouillard,* 1955, with its filming of objects at Auschwitz and *Hiroshima mon amour,* 1959, with its filming inside the Hiroshima museum. Restany called for a "sociology of the real" (close to Henri Lefebvre's analyses of everyday life); yet the burned, charred, *disjecta membra* attached to Nouveau Réaliste artworks registered more violence, more atrocities more abjection, on home ground and beyond, at the time of the Algerian War and the Eichmann trials in Jerusalem, 1961.

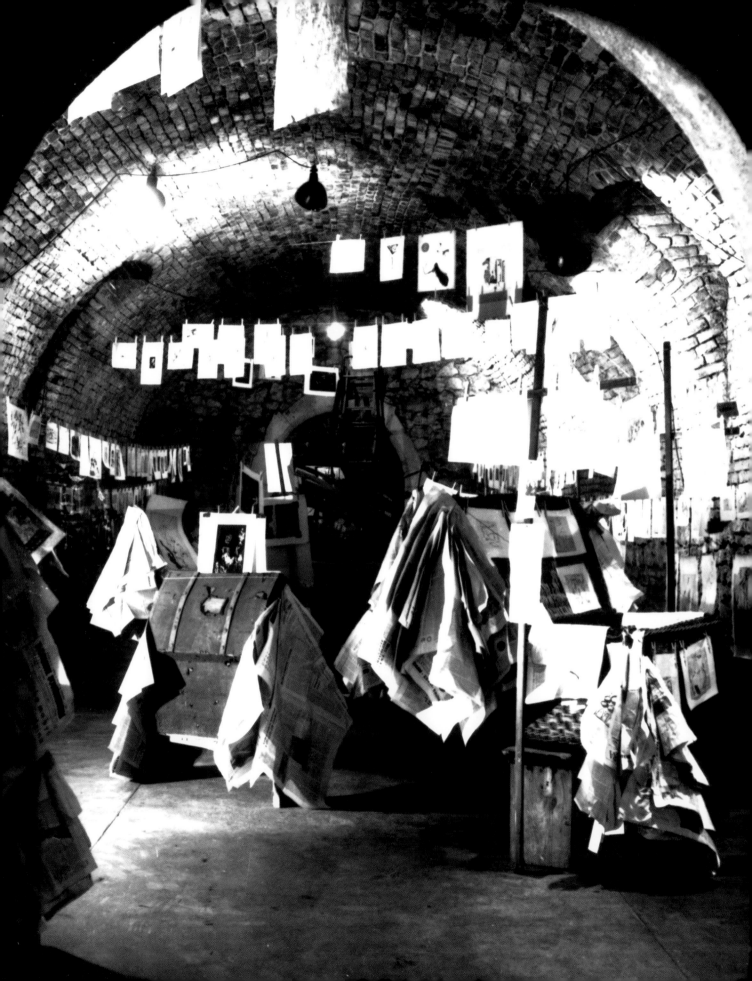

The battered American Jerry can on a Rauschenberg/Niki de Saint Phalle collaboration could indeed look back to the Liberation and the "make do and mend" aesthetic, but her *Tirs*—shooting performances aimed at paintings or objects—extend in their subject matter beyond France's colonial problems (*OAS altarpiece*, 1962) to the global Cold War arena (*Khrushchev-Kennedy*, 1963).[25] Her *Tir for Jasper Johns* uses a target as "attributes" of the painter (the *American Embassy Tir*, 1961, was a happening also involving John Cage and David Tudor). She shot at the "attributes" of her 'targeted' painter friends. She kills them. There is an always present "Theatre of Death" in Nouveau Réalisme, in the long dead ripped poster for a past event (used by Raymond Hains and Jacques de la Villeglé) the useless musical instrument found in the flea market, the dismembered dolls (used by Daniel Spoerri, whose father, a Protestant pastor, converted from Judaism, had been executed by the Nazis). Now, Kantor's similar *Human Dummies* such as the broken, eloquent body-part *Daisy*, 1958/1961, originally conceived as part of a decor for Ionesco's play *The Rhinoceros,* are exhibited as art objects.[26]

Thus the *narrative* potential of the humble everyday object, and the object's own memory and story (not its "readymade" status) is perhaps the key feature of the proliferating Nouveau Réaliste universe. Beyond Kantor's personal travelling, Nouveau Réaliste ideas and forms spread almost immediately to Eastern Europe, not only via journals but via Pierre Restany and the International Association of Art Critics as, surely, did both the ideas and the images of the contemporary Italian Arte Povera movement.[27] Kantor's "Annexed Reality" manifesto of 1963 with its section "The Poor Object" can be understood, then, only in dialogue with these contemporaries: "the simplest/most primitive/old/marked by time/worn out by the fact of being used,/POOR."[28]

Kantor's fascination for detritus—for the scrap of paper, the discarded note—had its apotheosis in his 1963 *Anti-exhibition*, with its list of 937 exhibits at the Krzysztofory Gallery in 1963. Kantor here brings writing itself into the 'poor aesthetics' category with its display of odd notes, scribbles, schemes and blueprints pinned to washing lines. Retrospectively at least, and beyond the evident fusion of gallery with "underground" theatre space, we can see this pioneering installation in dialogue with Duchamp's suspended strings in the first Papers of Surrealism, 1942, with the *Eros* Surrealist show and Pinot-Gallizio's *Cavern of anti-matter* (both Paris, 1959), even with Claes Oldenburg's New York 1961 *The Store* with its paint-impregnated objects (the year Kantor showed in *15 Polish Painters* at the Museum of Modern Art, New York).[29] Again Kantor emphasises the distance from the easel painting; the change required of the spectator in an "active environment".

> The lack of 'pictures'/those frozen formal systems,/the
> presence of the fluid, vivid mass/of tiny charges/reflecting/
> energy/changes the audience's perception/from analytic
> and contemplative/into a fluid almost active/involvement/
> in the field of living reality….[30]

So a Kantor umbrella fixed to a painting is never just an umbrella; whether stuck to the canvas like a struggling black insect, or ghostly plaster corpses. They irresistibly remind us of the dialogue between despair and an almost Chaplinesque vaudeville humour in Beckett's *Waiting for Godot* with its tramp-like protagonists. As a painting series they evoke an absent play—and were prizewinners at the Sao Paolo Biennale of 1967.

Kantor was keen to rename as "The first *emballage*" his description of the production at the Cricot 2 Theatre, 1956, where all actors and extras were contained in an immense black sack.[31] Yet from Mathieu's performances and Niki's shootings onwards, art itself was on a performative edge. Jean-Jacques Lebel introduced happenings to Paris (with his own Sadean twist), and invited American avant-garde figures such as Yoko Ono and Carolee Schneemann to the city. Schneemann's *Meat Joy* was performed as part of the Festival de la Libre Expression in Paris' American Center in 1964; here fish, chicken and sausages were thrown onto participants who writhed in a melange of paint and transparent plastic—but also quantities of used

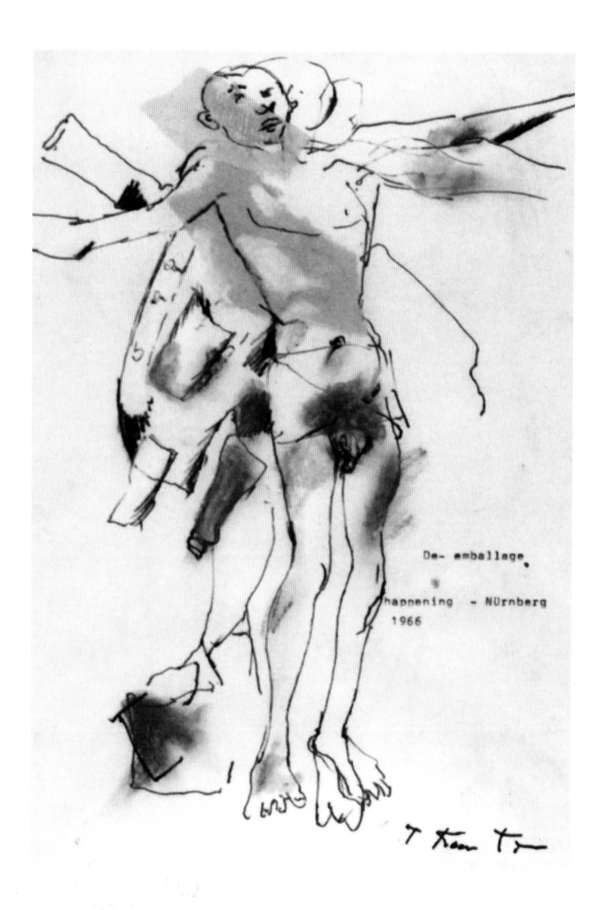

De- emballage.

happening - Nürnberg
1966

Tadeusz Kantor, *De-emballage. happening Nürnberg 1966*, pastel, felt-tip, collage, paper, 26 x 17 cm, private collection on loan to The National Museum in Kraków, copyright Maria Stangret-Kantor and Dorota Krakowska.

paper scraps. The crossing of the line between actor, participant and spectator here is crucial.[32] By 1971, continuing the *emballage* procedure, Françoise Janicot's feminist performance, *L'encoconnage* (where her bound face represents women's silencing) was in dialogue with contemporary works by performance artists such as Michel Journiac and Gina Pane. For all, the boundaries between performance relics and art objects was unclear.

At this moment in the 1960s, the practice of *emballage* and the move to happening-type events demonstrates Kantor's overt and continuing dialogues with the art world. His painting had been shown internationally in the most prestigious venues such as Documenta 2, Kassel, 1959, and the Venice Biennale, 1960, the year of his substantial solo show at the Saidenberg Gallery, New York. The move to Happenings and Fluxus in the art world is shown by his presence in *Art and theatre*, Kunsthalle, Baden-Baden, 1966, and the *Happenings and Fluxus* show at the Kölnischer Kunstverein in Cologne, 1971. Of course he was continually the major figure of the Kraków art world during the whole period, founding the Krzysztofory Gallery, while exhibiting in the Foksal Gallery, Warsaw and other key avant-garde Polish venues.

Kantor's work sits also upon on a historical threshold: it is structured by intense memories of the past and its legacies and a humanism linked to his conception of both every poor artefact and his international mission as an artist. The *emballages* also recall shrouds, and the bodies those of saints and martyrs with a Christ-like pathos (see the coloured drawing *De-emballage*, 1966). How could Kantor have anticipated that his reanimation of the Catholic theologies around humility, weakness, failure—with an ironic nod to Yiddish theatre and Jewish humour—might lose their resonance for new secular generations in the West?

And for the contemporary art world, the narrative fictions of theatre itself, its spaces, its social rituals have become "too much". This was the premise of the 'anti-Kantor' exhibition, *The Impossible Theatre* (Vienna 2005/London/ Warsaw 2006): "For most (contemporary Polish artists) Kantor is simply an example of pseudo-artistry, inseparably bound to the 'demiurgic function of art'. The minimalism of the 1990s opposes it and counteracts it by means of cognitive forbearance. Hence the resentment towards the Kantorian grandeur and gigantism of art form. Therein, perhaps, hides also a deep-seated fear of kinship, affiliation, or a sort of inferior cousinhood."[33]

How ironic that the major exhibition Warsaw-Moscow, used Kantor's decors for *Wielopole, Wielopole* (with his performance film) as a complete "art installation" in 2004. The grandiose *Theater without Theater* retrospective (Lisbon/Barcelona 2007–2008) placed Kantor with Artaud and Beckett as the great precursors.[34] In Marin Karmitz's *Silences* (Strasbourg /Lisbon, 2009) Kantor's *The Dead Class*, 1975, 1989, appeared in dialogue with Ilya Kabakov's *Labyrinth (My Mother's Album)*, 1990, and Bruce Naumann's *Shit in your Hat—Head on a Chair*, 1990, with its obvious debt to Beckett.[35] *The Dead Class* and *Wielopole, Wielopole* reappeared as installations in 2009 in Norwich. While contemporary scholarship has firmly insisted upon Kabakov as a pioneering figure for installation art, Kantor's additional role—albeit *avant-la-lettre*, and its later impact in Poland, should be reconsidered. In contrast with Kabakov's context of Socialist Realism, Kantor's contemporaneous experience as an *Informel* painter, and his relationships with objects, environments and happenings at the time of Nouveau Réalisme in France, Beuys and the Zero Group in Germany and Arte Povera in Italy make him Kabakov's unique, paradoxically 'Western' counterpart.

A generation who cannot 'see' Kantor's painting finds it easier to walk through *The Dead Class*—without the play—to "gain aesthetic feelings" (see epigraph). With his "gigantism of art form", Kantor anticipated the expansion of art itself to the now preferred medium of spaces and time-capsules to traverse. In our "suspended, non-historical time" of a "present which has lost its past and future" we are now used to these spaces, we have become the actor-spectator-participants, the living amongst the dead....[36]

The tables have turned; they may turn again.

NOTES

1 Kantor, Tadeusz, "Credo 1942–44", in Kobialka, Michal ed., and translated, *A Journey Through Other Spaces: Essays and Manifestos, 1944–1990*, Berkeley: University of California Press, 1993, p. 33.

2 See Małgorzata Kitowska-Łysiak, on Kantor and the "Visual Arts" (2002) http://www.culture.pl/en/culture/artykuly/os_kantor_tadeusz.

3 Note Stanisławski's close relationship with the heroic Pompidou Centre curatorial generation for *Presences polonaises*, Paris, 1983, and *Europa, Europa*, Bonn, 1994; see also the French inscriptions on Oskar Hansen's projects in *Moore* and *Auschwitz* (sic) (Tate Britain, 2010).

4 Jan Lebensztein won the 1959 Paris Biennale Grand Prix; Yehuda Nelman figured in the Group des Informels; http://www.archives.biennaledeparis.org/fr/1959/index.htm

5 Wilson, Sarah, *Paris 1945–1975—The Sainsbury Family Collection*, Norwich: Sainsbury Centre for Visual Arts, University of East Anglia, 1989, np.

6 Kantor, "My Early Paintings" and "Work" from "My Work—My journey" (Excerpts), 1988, in Kobialka, Michal ed. and trans., *A Journey Through Other Spaces. Essays and Manifestos, 1944–1990*, Berkeley: University of California Press, 1993, p. 18 (a frustrating lack of apparatus hampers non-Polish scholars here).

7 See *Warszawa—Moskwa, 1900–2000,* Warsaw: Zachęta Narodowa Galeria Sztuki, 2004, p. 278. Kantor's *Spatial Forms*, 1947, keeps company with Starzyński's *There are no Potato-Beetles*, 1950, and, with slightly more residual figuration, Marian Bogusz's *Silesian landscape*, 1948.

8 See statistics (revised by later scholars) in Paulhan, Jean, *Lettre aux Directeurs de la Résistance*, Paris: Editions de Minuit 1951, re-edited by Jean Jacques Pauvert, 1968, pp. 12, 23.

9 See Bois, Yve-Alain, "The Falling Trapeze", *Jean Fautrier*, Curtis L Carter, Karen K Butler, eds., New Haven and London: Yale University Press. 2002, pp. 57–61 (no attention to the pre-1940s career).

10 See Wilson, Sarah, "'Fêting the Wound': Georges Bataille and Jean Fautrier in the 1940s", Gill, Carolyn, ed., *Writing the Sacred: Georges Bataille*, London: Routledge, 1995, pp. 172–192. Contrast accounts of the *informel* by Jean Paulhan, 1962, Hubert Damisch, 1970, or Enrico Crispoliti, 1971, with Bois, Yve-Alain, Rosalind Krauss, *Formless: A User's Guide*, New York: Zone Books, 1997.

11 For the most recent account of the problematic concept of "*École de Paris*" and its quarrels around abstraction see Adamson, Nathalie, *Painting, Politics and the Struggle for the École de Paris, 1944–1964*, Farnham: Ashgate, 2009.

12 Compare the post-war emphasis of *Paris Post War. Art and Existentialism*, London: Tate Gallery, 1993, with my neo-Dada emphasis in *Paris, Capital of the Arts,* London: Royal Academy, 2002, pp. 243–245.

13 Wilson, Sarah, "Voids, palimpsests, kitsch: Paris before Klein", *Voids*, Paris: Éditions du Centre Georges Pompidou 2009, pp. 192–198.

14 Mathieu, Georges, *De la Révolte à la Renaissance*, au delà du Tachisme, Paris: Gallimard, 1973.

15 I refer to Kurt Seligmann's *L'Ultra-Meuble*, 1947.

16 Prière de toucher, catalogue of the *Exposition Internationale du Surréalisme*, Paris: Galerie Maeght, 1947. Porębski confirms that this catalogue, which reproduced Duchamp's 1942 environment, was known in Kraków, see Chrobak, Józef and Marek Świca eds., *I Wystawa Sztuki Nowoczesnej: Pięćdziesiąt lat później*, exh. cat., Kraków: Starmach Gallery, 1998, p. 20.

17 Kantor, Tadeusz, "Repères", Le Rocher, Chexbres, February 1964, *Kantor*, Lausanne: Galerie Alice Pauli, 1964 (my translation. nos. 1–11 *informel* paintings 1957–1963; nos. 12–22 *Objets picturals*, 1964; no. 23 Painting, 1964). I suggest that this poetic/autobiographical mode as preface—and personal practice is imitated from the Dutch curator William Sandberg.

18 Żmijewski, Artur, in *The Impossible Theatre*, p. 78.

19 Kristeva, Julia, *Powers of Horror: An Essay on Abjection*, Léon Roudiez, trans., New York: Columbia University Press, 1982 (French, 1980).

20 Kantor, "Ob die Rückkehr von Orpheus moglich ist?", Hamburg, Staatliche Hochschule für Bildende Künste, 1961; published in German in Schorlemmer, Uta ed., *"Kunst is ein Verbrechern". Tadeusz Kantor, Deutschland und die Schweiz. Errinerungen—Dokumente—Essays—Filme auf DVD,* Nürnberg: Verlag für Moderne Kunst, 2007/ Kraków: Cricoteka, 2007, p. 70.

English quote from Wiesław Borowski, "History of the *Emballage*" in Stanisławski, Ryszard ed., *Emballages: Kantor*, Łódź: Muzeum Sztuki, 1975, np.

21 See "The Informel Theatre" and "The Informel Theatre Definitions" (undated), in Kobialka, *A Journey Through Other Spaces*, pp. 51–55.

22 Mathieu, *De la Révolte à la Renaissance*, and Lupasco, Stéphane, *L'énergie et la matière vivante*, Paris: Julliard, 1962; Lupasco, Stéphane, *Science et art abstrait*, Paris: Julliard, 1963.

23 Kantor's "The Zero Theatre", 1963, in Kobialka, *A Journey Through Other Spaces,* pp. 59–70, is complex, messy and far from a *tabula rasa*, I refer to the strategy of the title.

24 Tabakova, Nia Nikolaeva, *Utopia and Memory: Christo before Jeanne-Claude 1935–1963*, MA dissertation, The Courtauld Institute of Art, 2006.

25 See Carrick, Jill, *Nouveau Réalisme, 1960s France, and the Neo-avant-garde. Topographies of Chance and Return*, Farnham: Ashgate, 2010.

26 Daisy features in *The Impossible Theatre*, p. 86.

27 See Leeman, Richard ed., *Le Demi-Siècle de Pierre Restany,* Paris: INHA-Les Éditions des Cendres, 2009, and Meyric-Hughes, Henry, Ramon Tio-Bellido, *AICA in the Age of Globalisation,* Paris: AICA Press, 2010.

28 "The Poor Object" in the manifesto "Annexed Reality", 1963, reproduced by Kobialka, *A Journey Through Other Spaces*, p. 74.

29 Crucial for contextualising Kantor's art, *15 Polish Painters* curated by Peter Selz for the Museum of Modern Art, New York, 1961, showed five works (Pittsburgh, London and Montreal collections).

30 Kantor, "Anti-exhibition" in *Emballages. Kantor,* Łódź, 1975, np (translated from the 1963 catalogue).

31 See "1956 :.. (1957)" in "*Emballages* 1957–65", in *A Journey Through Other Spaces*, 1993, p. 77; surely this is from "The First *Emballage/* Le premier *emballage*", Kraków: Krzysztofory Gallery, 1969, see p. 406.

32 See extensive current bibliographies on Lebel, Schneeman and happenings.

33 Wróblewska, Hanna, "Not Tadeusz Kantor (…)", in *The Impossible Theatre*, p. 12.

34 Alain Badiou, Bernard Blistène, et al., A Theatre without Theatre, exhibition catalogue, Barcelona: MACBA, 2007, Berardo Museum Lisbon, (a major use of Centre Pompidou collections and documentation).

35 Karmitz, Maria, Joëlle Pijandier-Cabot, Estelle Pietryzk eds., *Silences. Un propos de Marin Karmitz*, Strasbourg: Éditions des Musées de la ville, de Strasbourg; 2009.

36 I use these phrases from Boris Groys's essay "How to do time with art", in Godfrey, Mark, Klaus Biesenbach and Kerryn Greenberg eds, *Frances Alÿs, A Story of Deception*, London: Tate Publishing, 2010, pp. 190–192.

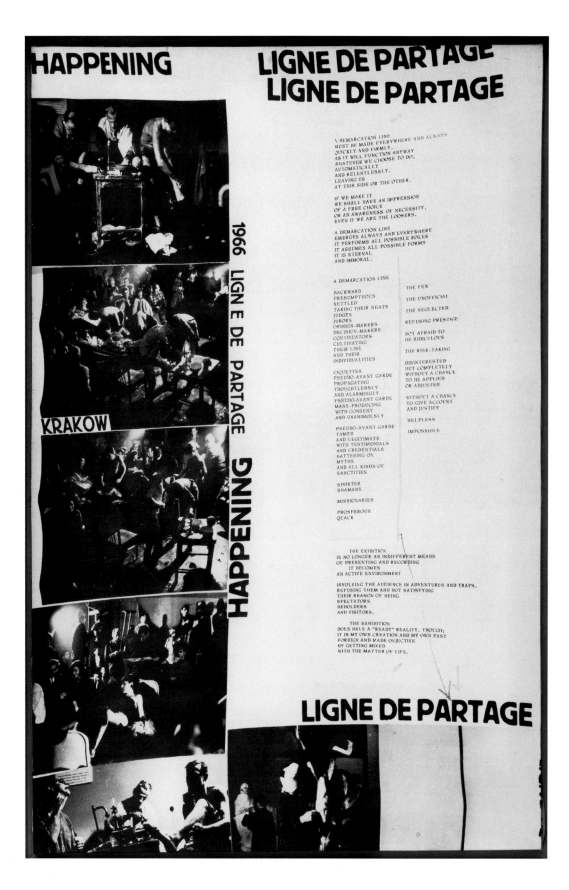

EMANCIPATION AND DAYDREAMS: KANTOR'S HAPPENINGS

KLARA KEMP-WELCH

Kantor's experiments with the happening format in the late 1960s were a continuation of his long-term aim of "regaining the relationship of man to reality".[1] But the happening proved far from straightforward as a strategy of de-alienation. His engagement with what he called "Happening Theatre" (The Theatre of Events) in his manifesto of 1967, was more than an investigation into the possibilities of audience participation as a means to achieve an avant-garde fusion of art with life.[2] It was a systematic attempt to liberate events and situations from everyday convention and to produce another, autonomous space for them. Kantor explained: "Important and unimportant, mundane, boring, conventional events and situations constitute the heart of reality (...) I keep turning them around, recreating them indefinitely until they begin to have a life of their own (…) Then such questions as 'Is this already art?' or 'Is this still life?' become inconsequential to me".[3]

It was not the balance between art and life that interested Kantor, but something else—the production of a space where certain events and situations could have a life of their own, not as art, or as life, but as themselves.

The happening format offered new possibilities for expanding his existing strategy of annexation, incorporating found persons, objects and social conventions into a new, and potentially free, situation. He hoped that the happening could abolish the representational conventions of both art and life in order to "depict reality via reality", directly.[4] His happenings were not what modernists would have called autonomous. Neither were they concerned with what Peter Bürger called the "negation of the autonomy of art by the avant-garde".[5] Kantor's stated position was one of "disinterest".[6]

When asked whether he had ever really believed in painting, Kantor replied: "I believed, but it was not an absolute faith. I was always, in my *Informel* painting too, also concerned with something more than the autonomy of some form or artistic method. I want to apply this method to the whole of reality".[7] The task of art was to confront reality head on and to transform it into something different. He sought to create, *using reality*, a "new sphere of the imaginary (…)".[8] This was, he wrote, both a form of retreat and of attack. The imagination was as "a reply to reality", whose "inner dictate" seemed to him to be grounded in creating a "different" reality, free, autonomous, capable of achieving a moral victory over the other [kind of reality], of triumphing, of restoring spiritual dignity to our time (…).[9] To propose a different reality meant waging war against the existing (binary) order.

The "score" for Kantor's second happening *The Dividing Line* sketched the problem quite clearly.[10] Kantor dryly noted both the expediency and the inevitability of a two-tiered system, proposing, with marked sarcasm, that the dividing line was the only available form for orienting oneself in the chaos of reality: "The dividing line/should be made everywhere and always,/quickly and decisively,/because in any case without our will/it will function of its own accord/automatically/and unforgivingly,/leaving us/on this or that side".[11] By making up our minds to make the dividing line ourselves, he suggested, we "gain the impression/of free choice/ or the consciousness of necessity" (even if we find ourselves on the wrong side of the line).[12] The dividing line, he wrote, "is made always and everywhere,/it fulfils all possible roles,/it takes on all possible forms/is eternal/is amoral."[13] The line is just a line after all—an innocent form, no more. It just is, and it cannot help being, just as people cannot help being on one side or the other of it. The "amoral" line divides the dispossessed and the poor from those in power. Kantor's matter of fact list states the binaries with which his work is most concerned. A thick line runs through the middle of the page. The degree to which divisions are an escapable fact of life was dramatically staged in the Kraków event when participants found themselves walled in at the end of the happening: the exit was bricked up.

Kantor continued to explore the same problem in subsequent happenings, testing out a series of sites where the dividing line, and binary structures could be interrupted or temporarily suspended. He observed with pleasure that making happenings meant that he had "the whole of lived reality at [his] disposition".[14]

Tadeusz Kantor, *Ligne de partage* (*The Dividing Line*), photo on canvas, courtesy Cricoteka, copyright Maria Stangret-Kantor and Dorota Krakowska.

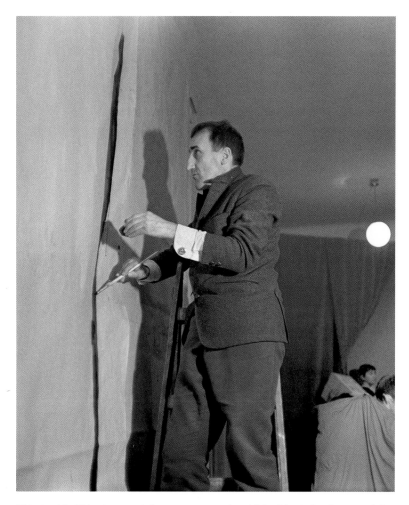

This enabled him to search for a space: one in which objects (and, potentially, subjects?) could acquire a measure of independence from structures of power.

While visiting New York in 1965 it occurred to Kantor that the Post Office was one such space. He wrote a plan for an exhibition at the Post Office. The "exhibits", he wrote, in his brief sketch for this idea, would be "not only paintings, but also ready objects, which are to be found at the Post Office, packages, masses of packets, sacks".[15] They serve as substitutes of sorts (people meanwhile, stand in for objects, in a chaotic whirl of exchanges). The Post Office, he wrote enthusiastically, is a zone in which

> objects—letters (…) /packets, parcels, bags and all their contents/
> exist for a certain time/independently,/without an owner (…) /
> without a function/almost in a void,/between the sender and the
> receiver,/where both one and the other remain powerless (…) This
> is one of the rare moments, in/which the object slips away from
> its fate.[16]

The condition described here is that of limbo. The usual rules are suspended—those persons in control of things in the normal order find themselves powerless. The "poor object", meanwhile, is temporarily free. Kantor's objects aspire to be the masters of their own fate, but, as objects, they are without agency or power—their freedom becomes possible only within a certain sort of space. What if Kantor's experiments with emancipating packages were to be read as a formal testing ground for empowering disempowered subjects? Could there also be a certain sort of space in which people could "slip away from their fate"?

Arguably the simplest proposal for a happening at this time was Maria Stangret's idea to paint thresholds green.[17] The minimal experiment was carried out by Stangret as part of the Winter Assemblage at the Foksal Gallery in 1968. Perhaps thresholds appealed to Kantor because of their connection to what he termed "the reality of the lowest rank": he described them as "completely neutral/ and anonymous".[18] But it cannot be by chance that he determined to draw attention to a form of *limen*—a passageway between places. In the context of the one room Foksal Gallery, the threshold marked the passage from one sphere of conventions to the other: from the outside world to the gallery and back again. This gap, however narrow, clearly offered a set of conceptual possibilities that Kantor thought particularly worthy of attention.

In his work on "liminal entities", such as "neophytes in initiation or puberty rites", religious anthropologist Victor Turner described their condition as that of being "neither here nor there; they are betwixt and between the positions assigned and arrayed by law, custom, convention, and ceremonial".[19] It is not yet known what they will become, they are blank slates on which many possible identities may be inscribed following this crucial moment of suspension. During what he terms the "liminal phase", identity is temporarily voided in preparation for the inscription of a new identity. Kantor reproduced this phase spatially in his happenings. It held the seductive potential for a new model of autonomous subjectivity.

1965, the year of Kantor's first happening, was also the year that Mikhail Bakhtin published in Russian his study of Rabelais' *Gargantua and Pantagruel*. He compared Rabelais' mobilisation of the grotesque to the structure of Medieval and Renaissance carnival, which offered, he wrote, "a completely different, nonofficial, extra ecclesiastical and extra political aspect of the world, of man, and of human relations; [it] built a second world and a second life outside officialdom (…)".[20] Pre-empting Turner's theorisation of the liminal, Bakhtin wrote that the clowns and fools of the carnival-grotesque "stood on the borderline between life and art, in a peculiar mid-zone (…)".[21] For Bakhtin, clowns and fools represented "a certain form of life, which was real and ideal at the same time".[22] I believe that it was this same 'form of life' in a 'mid-zone' that Kantor sought to articulate.

This form of life also accounts for the contradictory condition of his corporeal but ephemeral *Letter* of 1967. Kantor had called the letter a "huge white body"—it was a grotesque body. It was a Bakhtinian take on mail art that could not have been less ephemeral. *The Letter* took place in the space of life, becoming part of the lived reality of the participants for the duration of the happening, just as carnival, according to Bakhtin, "celebrated temporary liberation from the prevailing truth and from the established order; it marked the suspension of all hierarchical rank, privileges, norms, and prohibitions".[23] Kantor shared the ambitions of carnival as defined by Bakhtin:

> To liberate from the prevailing point of view of the world, from conventions and established truths, from clichés, from all that is humdrum and universally accepted. This carnival spirit offers the chance to have a new outlook on the world, to realise the relative nature of all that exists, and to enter a completely new order of things.[24]

But Bakhtin insisted that the transgressive power of carnival was *actual*. Carnival was not "an artistic, theatrical-spectacular form, but rather an as if real (but temporary) form of life itself, which was not simply performed, but lived almost in actual fact (for the duration of carnival)".[25] The paradox of Medieval laughter, Bakhtin observed, was that it was "absolutely unofficial but nevertheless legalised".[26] The invitation of a real police escort (as well as being a legal requirement—thus pointing out that it was one) was a way to bring on board representatives of official life for the purposes of its ridicule: the involvement of the police undermined the authority they represented.

And then there is the *Panoramic Sea Happening* of August 1967. That too took place at an interstice: on a thin strip separating land from sea. The beach at Łazy was home to a strange phenomenon that Kantor called "vacation civilisation". At

Tadeusz Kantor, *Panoramic Sea Happening*, Łazy, August 1967, photograph Eustachy Kossakowski, copyright Anka Ptaszkowska, courtesy Maria Stangret-Kantor and Dorota Krakowska.

certain times of year, Kantor keenly noted, it acquired a completely independent reality, with its own laws, "a particular morality, a way of behaving free of civilization's conventions".[27] Beach culture abandoned workaday conventions. The long stretch of sand was like a fantasy space. He even called it "an impossible space".[28] Reflecting on the happening after the event, he described Łazy, with its vast quantities of air and sea and infinite strip of beach as a "daydream".[29] The daydream, of course, is another liminal site in which the imagination is free to roam—between sleep and wakefulness.

But the beach did not live up to Kantor's expectations. Having abandoned the stage because it was too full of conventions, and used the happening format to explore more emancipatory sites for action, Kantor was dismayed to discover, even here on the beach, *more conventions*! What was worse, these were "as severe as those in everyday life, perhaps even more severe, paradoxically supplanting the natural sand, sea and sun".[30]

Kantor's ambitions were uncompromising: "the creation of a distinct, different, reality, whose freedom is not curtailed by the laws of any system in life".[31] Only a liminal space seemed open to such an ambitious project. The happening had promised to provide such spaces. But Kantor ultimately perceived the experiment to have been a failure. Although he now knew that he had the "whole of lived reality at his disposition", he decided to return to the theatre.

The next episode in his theatrical repertoire was the Theatre of the Impossible. *Lovelies and Dowdies* is set in a cloakroom. And the cloakroom is the *limen* of the theatre, another in-between space, and as such, potentially ripe for appropriation and transformation. It may have been Kantor's most conceptually loaded site. The cloakroom was dedicated to the reality of the lowest rank—a repository for vacated human packaging, anonymous and yet potentially bearing all the traces of its owners most intimate history. But it was also, as Kantor said, "an intensely utilitarian 'system'", that condensed the conventions of social life just as the stage condensed the conventions of art.[32] He described how "The cloakroom functions, sprawls,

The Cloakroom in *Lovelies and Dowdies,* Richard Demarco Gallery's production of Cricot 2 performance in Edinburgh, Forresthill, Poorhouse, August/September 1973, photograph Richard Demarco, courtesy Richard Demarco Archive.

takes up ever wider dimensions of the imagination, becomes indispensable, operates unceasingly, automatically, (…) soullessly, monotonously".[33] To transform this system—as inexorable as reality itself—into a carnival-like zone was the most pressing task of all. The inexorability of this sort of system was the imagination's worst enemy.

Although liminal, the cloakroom was far from free. It was occupied by petty functionaries. Cloakroom attendants, like bureaucrats, had contrived to make themselves indispensable. They pretended to protect the autonomy of the theatre from the intrusion of life outside. They confiscated and hoarded the audience's protective outer garments, according to a bureaucratic system beyond the control of anyone but themselves. Escape from the infernal takeover of the cloakroom attendants seemed impossible.[34] But Kantor always claimed that if a situation was "impossible/and inconceivable/in life,/this 'impossible"/can be achieved successfully/in art/on the condition that/the elements of this/'process'/are bereft of any other aim/(…)/than simply/to be perfectly useless/and disinterested".[35]

Renewing his attack on the conventions of theatre remained his greatest challenge: there were serious obstacles to be overcome. How was one to oust the cloakroom attendants? Could art really hope to liberate reality from the dividing line? What could art hope to achieve from within a vast system that engulfed and appropriated even the daydream? Speaking in the mid-1970s, Kantor said that the aim of his work was to prove that it is somehow "possible in this situation, not to lose hope. It's extremely important not to lose hope. To maintain one's aggressiveness."[36] And, as he moved from the Theatre of the Impossible, to the Theatre of Death, he waged an increasingly savage war on the conventions of the cloakroom and on the stagnation of imagination.

NOTES

1 Quoted after Borowski, Wiesław, *Tadeusz Kantor,* Warsaw: Wydawnictwa Artystyczne i Filmowe, 1982, p. 111 (author's translation from Polish).

2 For a discussion of Kantor's departure from the Kaprow model of the happening, see, Suchan, Jarosław, "Happening as a Readymade", *Tadeusz Kantor: Niemożliwe / Impossible*, Jarosław Suchan ed., Kraków: Bunkier Sztuki, 2000, pp. 67–120.

3 Kantor, Tadeusz, "Teatr Wydarzeń (À propos 'Kurki wodnej')", *Tadeusz Kantor. Metamorfozy. Teksty o latach 1938–1974, Pisma*, vol. 1, Krzysztof Pleśniarowicz ed., Wroctaw: Ossolineum, Kraków: Cricoteka, 2005, pp. 384–385. (author's translation from Polish); Kantor, Tadeusz, "Theatre Happening 1967", Michal Kobialka, trans., in Kobialka, Michal ed., *A Journey Through Other Spaces: Essays and Manifestos, 1944–1990*, Berkeley: University of California Press, 1993, p. 86.

4 Kantor, Tadeusz, "The Impossible Theatre, 1969–73", Michal Kobialka, trans., in Kobialka, *A Journey Through Other Spaces*, p. 90.

5 Bürger, Peter, *Theory of the Avant-Garde*, Michael Shaw, trans., Minneapolis: Minnesota University Press; Manchester: Manchester University Press, 1984, pp. 47–55 (*Theorie der Avantgarde*, Frankfurt: Suhrkamp Verlag, 1974).

6 Kantor, "Theatre Happening 1967", p. 85.

7 Borowski, Tadeusz Kantor, p. 42.

8 Kantor, Tadeusz, "1944 Ulisses", in Zofia Gołubiew ed., *Tadeusz Kantor. Malarstwo i rzeźba*, Kraków: Muzeum Narodowe, 1991, p. 55 (author's translation from Polish).

9 Kantor, Tadeusz, "MANIFESTO. Tadeusz Kantor 1915–1990", Obieg, no. 1(21), 1991, p. 3 (author's translation from Polish).

10 The happening took place on 18 December 1965 at the headquarters of the Association of Fine Artists in Kraków.

11 Kantor, Tadeusz, "Linia Podziału", *Tadeusz Kantor. Metamorfozy*, p. 340 (author's translation from Polish).

12 Kantor, "Linia Podziału", p. 340.

13 Kantor, "Linia Podziału", p. 340.

14 Kantor, Tadeusz, "Idea podróży. Teatr 'i'", *Tadeusz Kantor z Archiwum Galerii Foksal*, Jurkiewicz, Małgorzata, Joanna Mytkowska, Andrzej Przywara ed., Warsaw: Galeria Foksal, 1988, p. 334 (author's translation from Polish).

15 Kantor, Tadeusz, "Idea wystawy na poczcie", *Tadeusz Kantor. Metamorfozy*, p. 311 (author's translation from Polish).

16 Kantor, Tadeusz "Poczta. 1965", *Tadeusz Kantor. Metamorfozy*, p. 312 (author's translation from Polish).

17 The score for the event has been included in anthologies of Kantor's writings, e.g. Kantor, Tadeusz, "Malowanie progów", *Tadeusz Kantor. Metamorfozy*, pp. 445–447 (author's translation from Polish). However, his signature does not appear on known typescripts, so it may be the case that the score, if it was indeed authored by Kantor, post-dated Stangret's happening. Stangret herself also authored a number of brief typescripts with the title *Progi (Thresholds)*, one of which is dated 1969. These are in the Foksal Gallery archive.

18 Kantor, "Malowanie progów", pp. 445–447.

19 See Turner, Victor, *The Ritual Process: Structure and Anti-Structure*, Chicago: Aldine Publishing Company, 1969, p. 95.

20 Turner, *The Ritual Process*, pp. 5–6.

21 Bakhtin, Mikhail, *Rabelais and his World,* trans. Helene Iswolsky, Bloomington and Indianapolis: Indiana University Press, 1984, p. 8.

22 Bakhtin, *Rabelais and his World*, p. 8.

23 Bakhtin, *Rabelais and his World,* p. 10.

24 Bakhtin, *Rabelais and his World,* p. 34.

25 Bakhtin Mikhail, quoted in Renfrew, Alistair, "The Carnival Without Laughter", Adlam, Carol, Rachel Falconer, Vitalii Makhlin & Alistair Renfrew eds., *Face to Face: Bakhtin in Russia and in the West*, Sheffield: Sheffield Academic Press, 1997, p. 188.

26 Bakhtin, Mikhail, quoted in Renfrew, "The Carnival Without Laughter", p. 189.

27 Kantor, Tadeusz, "Rozważania", *Tadeusz Kantor z Archiwum Galerii Foksal*, p. 163 (author's translation from Polish).

28 Kantor, "Rozważania", p. 163 (author's translation from Polish).

29 Kantor, "Rozważania", p. 163 (author's translation from Polish).

30 Kantor, "Rozważania", p. 163 (author's translation from Polish).

31 Kantor, "MANIFESTO", p. 3 (author's translation from Polish).

32 Kantor, Tadeusz, "Szatnia", *Tadeusz Kantor z Archiwum Galerii Foksal*, p. 325 (author's translation from Polish).

33 Kantor, "Szatnia" p. 325 (author's translation from Polish).

34 Krzysztof Miklaszewski wrote a film script titled Tadeusz Kantor's Cloakroom, 1973–1974, based on rehearsals for the play. See Miklaszewski, Krzysztof, *Encounters with Tadeusz Kantor*, George Hyde, trans. and ed., London: Routledge, 2002, pp. 14–29.

35 Kantor, "The Impossible Theatre, 1969–73", pp. 93–94.

36 Tadeusz Kantor speaking at Foksal Gallery, Warsaw, June 1974, in *Tadeusz Kantor z Archiwum Galerii Foksal*, p. 294 (author's translation from Polish).

the living archives

september 1971

galeria foksal psp
warszawa
ul. foksal 1/4
telefon 27 62 43

Artistic activities, when they are under way, remain invulnerable to their showing off; they also set in doubt the reasons to be percepted.

An active thought wishes to exist beyond the manipulations of:
— artists themselves
— display managers
— the greedy audience.

A new work, since it is identical with its message, lasts as long as its process of islolation continues. Its real existence is hooked up in the time span between its broadcasting and its reception.

If the limits are encroached upon from either side, the autonomy of the work is threatened:
— persistent stroking of his thought by the artist contaminates it with the author's lyrical Ego
— when received, a thought is introduced into the circulation of the schematic cultural values

A letter put to a mailbox is no longer subject to any manipultions until it arrives where it is bound to. Its objectless, shapeless, impersonal and necessary authenticity is equivalent to the length of the mail channel.

The time of transmission is the only neutral ground of an artistic work. Even if reduced to a minimum, it determines the occurence of the fact.

Artistic facts call for an establishing of the LIVING ARCHIVES as a possibility to apprehend the transmission.

The LIVING ARCHIVES make it clear that a thought is past when it is accessible.

The LIVING ARCHIVES define a work when it is neutrally present — when the artist has quit it already — when the mill of schematising interpretations has not started yet.

The LIVING ARCHIVES are expected to be a channel in which the works remain in their own state of readiness — already beyond the stimulating thought of their maker, but before the audience distorts them. We step in to give a work its frame, we seize the transmission — we don't care for the broadcasting and the reception.

An exposition, as a place of reception of a work and the last phase of the flow of information, has been the point from which it's been consumed and introduced into the institutional pattern.

A Laboratory of Art used to provid hothouse conditions for the breeding of ideas, it was a local center allowing for exhibitionist advertising of an artist in ways prepared in advance.

By establishing the LIVING ARCHIVES we deny:
— the Laboratory of Art
— the workshop for artstic ideas
as well as WE DENY ANY AND ALL FORMS OF PRESENTATION OF A WORK.

WE ALSO DENY ALL THE ARCHIVES, since any archives present history.

WE DO NOT PRESENT HISTORY BUT WE KEEP THE THOUGHTS ISOLATED.

The LIVING ARCHIVES offer the frames which are not institutional or cultural for any artistic activity.

We do not collect materials in a scientific or methodic way. Our objective are not archives endeavoring to make its files complete. We've got no use for archives as a collection of documents which "are not actual, but are worth to be kept".

A rich collection in the LIVING ARCHIVES is a necessity, but it cannot be used for any purpose.

We are establishing the ARCHIVES THAT ARE FUNCTIONING CURRENTLY.

The LIVING ARCHIVES set worth a model for a w o r k i n g, work maintaining its n e u t r a l i t y.

The LIVING ARCHIVES, by suggesting a changing but always sharp borderline of d e s i s t e n c e, become a new context for creative activity.

The LIVING ARCHIVES are subjugated to creation.

The LIVING ARCHIVES are a current reaction to the
— artistic
— nonartistic
— antiartistic phenomena.

Wiesław Borowski
Andrzej Turowski

THE LIVING ARCHIVE, THE DEATH OF RUBBISH AND THE AESTHETICS OF THE DUSTBIN

JO MELVIN

This essay traces an archival journey through Peter Townsend's editorial papers of the British art magazine *Studio International* in order to demonstrate how the correspondence between Wiesław Borowski, the Director of the Foksal Gallery, led to Townsend's support for Kantor and the Cricot 2 in the 1970s art discussion in the UK. It is important to note that Townsend's commitment to Kantor's practice belongs to the critical framework of the visual arts of the time and that he was sceptical of the British press' designation of Kantor's work as merely theatrically driven and hence positioned only in the newspaper's theatre pages. When Townsend was asked which issues or articles, on any topic, published during his period as Editor, he regarded as the most important ones, his list included those dealing with Kantor and Cricot 2 alongside the writings of Daniel Buren, Hans Haacke, Carl Andre and Roger Hilton.[1]

There are two further finds from the *Studio International* archive which serve to frame this paper: one, an article by Michael Thompson and the other George Brecht's word coinage, "heterospective", a combination made from the prefix hetero and retrospective.

Michael Thompson's article "The death of rubbish" was published in *New Society*.[2] Jonathan Benthall, who wrote a regular column for *Studio International* called "Art and Technology" and who was working at the ICA, sent a photostat copy of Thompson's article to Peter Townsend. Benthall knew Thompson's writing from his contributions to the first two issues of *Art-Language* journal. In the covering letter, Benthall suggested that social anthropological methods could serve art criticism by the way in which they analyse society's structure, and in particular by the way they focus on those aspects classified as marginal and taboo, since the subject matter of some art practices also drew attention to these overlooked areas of detritus. "People have usually seen society on a vertical model, like the digestive tract, with rubbish like excrement at the base. This could be changing." The text referred to a character in William Burroughs' novels who teaches his arse to speak and, indirectly, to Mary Douglas' designation of "dirt" as "matter out of place". It also drew attention to social groups on the margins, as well as those living "alternative" lifestyles.[3]

The artist George Brecht was also a correspondent and contributor to *Studio International* magazine. He coined the term "heterospective" to suggest an alternative to retrospective as a way of approaching exhibition organisation. Heterospective focuses on interchanges, connections and networks. A heterospective exhibition would open spaces between the artist's work and the circumstances surrounding it; it would turn away from the view of art practice as a singular activity, removed from the broad associations of context. The heterospective premise furthermore guides connectivity within archival networks and is an essential tool for the researcher.

Townsend stored his papers from *Studio International* in black rubbish bags in his daughters' attic until they gained 'archive' status. They are now finally housed in Tate's archive. These papers contain stories that lie behind the magazine's publication of articles, they contain correspondence, drafts as well as information on exhibitions and projects which were sent in speculatively in the hope of editorial interest; for instance the Foksal Gallery material. Archive work is often a search for missing pieces in a jigsaw puzzle, one that defies completion. The encounters enable suspensions where one also revisits established moments. New accounts of events shift previous definitions and leads go outwards from the hub. Each item proposes connections, or ones which are seen in a new light, or just seen differently. The papers sent by Borowski opened a radically anti-archival, liberational attitude. They appear complex, yet simple and they follow the modernist paradigm where every encounter can lead to a new beginning. By opening up the role of the performative encounter within the archive they can thereby re-institute the potential for the archive as a radical site.

Wiesław Borowski, the Director of the Foksal Gallery, sent two statements with a covering note to Townsend. This came shortly before Cricot 2 had their second appearance at the Edinburgh Fringe in 1973, with the performance of *Lovelies and Dowdies* at the Forresthill, Poorhouse. Borowski was one of the Cricot 2 company's members. The previous year, Richard Demarco had presented an extensive exhibition

Right and overleaf *Documentation*, 1971, these papers were sent by Wiesław Borowski to Peter Townsend the editor of *Studio International* magazine in 1972, when Kantor and Cricot 2 first performed at the Edinburgh International Festival Fringe. Townsend selected the article on Cricot 2, in January 1974 by Wiesław Borowski as one of the high points from his term as editor of the magazine, courtesy Foksal Gallery in Warsaw.

documentation

september 1971

galeria foksal psp
warszawa
ul. foksal 1/4
telefon 27 62 43

'The Sinking'' — an event from the Panoramic Sea Happening by Tadeusz Kantor, Osieki, 1967

,... a few people are busy around a large trunk. They are wrapping it tight in layers of linen and paper. They are in a hurry. They are looking around with anxiety. They are undoing some strings with much pains... They give orders to each other in a low voice. They act furtively and without anybody's permission. They try to realize their aim taking advantage of the general carelessness. To protect the trunk. ... To make fail any attempts at reaching its contents'. ... They succeed to pack it and stamp it with warnings, instructions, mail symbols: Attention. Fragile. Ostrożnie. Góra. Don't bend. By boat. The Address: GALERIA FOKSAL PSP — Warszawa ... The rumour goes among the public that the trunk contains a collection of the Gallery's important documents : a manuscript of the pedantic chronicle of pseudo-artistic events; applications and responses to applications; longplaying records with speeches; a full file of press items with critical reviews... shorthand reports, protocols, photographs and photocopies... The crowd around the trunk is growing. At a certain moment it is brought to the very shore of the sea. There it is most carfully put aboard of a life boat which quickly sails away sea-bound, with the crowd silently watching. A rocket shot was the sign to throw the trunk into water.

(Tadeusz Kantor — from the Script of the Panoramic Sea Happening, **1967**).

Wiesław Borowski
Andrzej Turowski

documentation

The world of art has entered the epoch of DO-CUMENTATION.

A work freed of its form and function appears as a single or ephemeral actualization of an idea, without any material trace being left.

It is made accessible in the form of a record which is either a document or a project.

It was or it will be.

An unapprehended present state remains an ISOLATED MESSAGE.

A work is not vulnerable to anything which might be a pretext for an information, for it identifies itself with the information about it.

A work of art has lost its permanence. Only formal systems, monuments and institutions endeavor to prolonge its existence.

The museum-archives of DOCUMENTATION try to fix and keep the memories of works in the form of various kinds of records.

Thus we want to have everything documented! In a more thoughtless, pedantic and massive manner than the collectioners or the maniacs of scientific collecting used to collect their collections.

We set up an illusion of survival of artistic ideas, while what we have actually got is a muddled magma of artistically useless and commercially useful „traces".

We are putting the matters together again for unlimited manipulations!

We give ourselves up in the hands of the mass media functionaries.

We are performing a huge-scale exchange of DOCUMENTS and incalculable linked transactions.

DOCUMENTATION is an artificial prolonging of durability of what is essentialy VOLATILE. It keeps in store and reproduces what **used to be** an object of perception, experience and action. It is more difficult to destroy the DOCUMENTATION than to burn down the museums and collections. The self-reproducing documentation including everything and accessible everywhere is more imperative than all the expositions in the world.

Without our notice, the DOCUMENTATION became identical with the museum and collection, assuming their forms and manners.

But the DOCUMENTATION as the final link in the process of transmission becomes a FORM of a work of art.

It cannot be destroyed — it must be denied!

GALLERY FOKSAL PSP

of Polish art and avant-garde film, *Atelier 72*, which also included Kantor. At the same time Kantor and Cricot 2 staged a production of *The Water Hen* but it was not, according to John Barber "even listed amongst the one hundred or so fringe events, and it took trouble to track down to a plumber's workshop in Forest Road [to encounter] an inchoate vision of the world... odd and deeply distressing."[4] In October 1973, Lynn Hershman reviewed Richard Demarco's programme for *Studio International*, which had included the performances of *Lovelies and Dowdies* at the Festival Theatre, Joseph Beuys' 12 hour lecture and Tom Marioni's experimental music productions. Marioni was the Director of the Museum of Conceptual Art in San Francisco.[5] Beuys also played in one of the performances under Kantor's direction. Hershman noted, "Kantor resolutely remains part of the action, tuxedo clad, issuing instructions to all including the audience who become part of the cast as soon as they enter." The article re-printed a poem/statement, of which an extract follows:

> Not the masterpiece—
> product is important,
> nor its 'perceptual'
> and rigid image—
> but the sole
> process of creation,
> which unlocks
> the spiritual and intellectual activities.

The documents which Borowski sent to Townsend were titled "the living archives". The papers stated projective criteria for the ambiguous status of the art object. These were not published in the magazine, yet Townsend was immediately interested in their assertions. Significantly, Borowski supported Demarco's projects. It is important to note the use of the lower case for the title. It reinforces a non-hierarchical relationship with the archive, and the testament to events witnessed.[5] Using ideals and directives to free the archive from history and set it in the present provides the means to explore the testaments encountered in exploration and immersion, where objects are animated through transitive encounter. There is here a symbiotic relationship between the quixotic and the pragmatic. The key point to unpack is that the archive itself represents a threshold for A "new context", then, now; the now-then acts like a concertina time frame.

The second sheet shows a photograph from the *Panoramic Sea Happenings*, an event by Tadeusz Kantor called "The Sinking", at Łazy beach, near Osieki, 1967. It referred to a day of happenings on the beach at Łazy on the Baltic coast, an event which had occurred four years before "the living archives" publication. Below the photograph is an account bearing Kantor's name, "from the Script of the *Panoramic Sea Happenings*". Note the use of the word "script", not description. And it begins in the middle of a sentence, in other words, it is already happening and as its reader I am thrust into its durational span, leapt over, thrown into an ensuing duration, to be neatly in the swim, so to speak.

The critical question to arise from this is whether the reader sinks into the mass of material or swims with it. This is the decision-making processes of negotiation: to include, to exclude, to mesh, weave or desist, and to locate the voices through the inhabitation of the marginalia of the documentation, towards stories that go off the edge, that are off limits. What is apparently sunk in the photograph is the Foksal Gallery archive. It is contained in a trunk straddling the sides of a small life boat. A man at the stern pushes it out to sea, another sits inside and steadies the trunk while a third rows. The action we read concerns some furtive, hurried wrapping of the trunk in linen, in "tight layers" of linen and paper. It refers to "anxious looks, orders given in a low voice without anybody's permission." "They try to realise their aim, taking advantage of the general carelessness... to protect the trunk.... To make fail any attempts at reaching its contents."

The trunk is stamped and addressed with instructions and warnings, "attention", "fragile", "Don't bend. By Boat", The address: GALERIA FOKSAL–PSP Warsaw. We read the

Cover of the catalogue for *Tadeusz Kantor: Emballages 1960–1976* exhibition at Whitechapel Art Gallery, London, September/ October 1976, courtesy Whitechapel Art Gallery and Foksal Gallery in Warsaw.

The catalogue carried an essay by Ryszard Stanisławski. He explained the *emballage* process, to wrap, pack and disclose which was formalised in Kantor's manifesto from 1963 and subject to ongoing development.

Whitechapel Art Gallery, Whitechapel High Street, London E1 7QX

TADEUSZ KANTOR
Emballages 1960-76

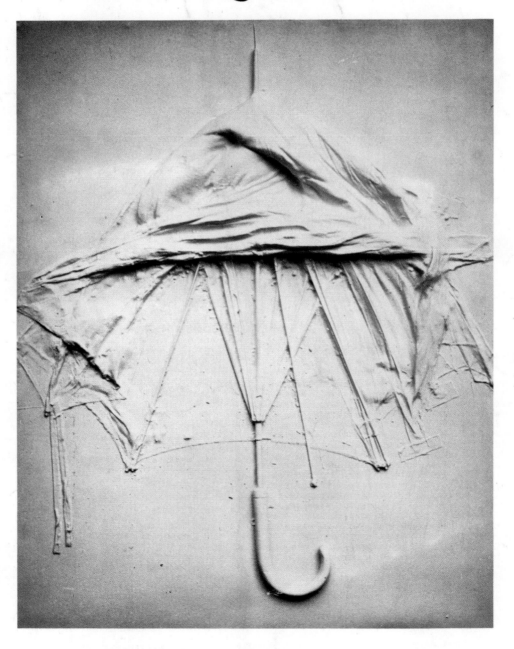

Main & small galleries, 22 September–31 October 1976

UMOWA

między
autor — Tadeusz Kantor
adres — Kraków, ul. Elbląska 6/11
tel. 376-06
Galeria Foksal PSP
adres — Warszawa ul. Foksal 1/4
tel. 27-62-43

a
nabywca ~~Adam MAUERSBERGER~~
adres ~~Sulkiewicza 7 m 13~~

dotyczy
n a b y c i a o b r a z u
wymiary: 110 × 120 cm
tytuł: „parapluie-emballage"
rodzaj: multiple
wykonany w 40 identycznych, numerowa-
nych egzemplarzach
o p i s : do białego płótna przymocowany
autentyczny parasol — całość w kolorze
białym

Warszawa, 1970

podpis autora *podpis nabywcy*

doc pap p-53

rumour. The trunk, it is believed, contains a "collection of important gallery documents: a manuscript of the pedantic chronicle of pseudo-artistic events; applications and responses to applications; long-playing records with speeches; a full file of press items and critical reviews … shorthand reports, protocols, photographs and photocopies…" When the boat went out to sea, "a rocket shot was the sign to throw the trunk into water". Reading this short text, hands dirty with displaced longing, failed projects and grand successes, meant liberation. I began to consider the importance of sabotage; so what strategies were needed to be put in place to destabilise the archive's ideal status and why was the process of sinking a necessity. Metaphorically, literally, or both, I have not liberated the *Studio International* archive from its existence by drowning.

The key points in this documentation sent to Townsend concern the voice and its authenticity directly and whether it is heard. On the far right of the photograph is a loudspeaker, cropped, just in the frame. It contradicts the suggestion of furtive 'low voiced' activities. The loudspeaker heralds volume and authority, it raises visibility and refutes the notion of 'acting' without permission. In the films, the director has it at hand: here we see Kantor holding it up, as in the other photographs from the happenings of that day on the beach at Łazy, found in the exhibition catalogue. This act draws attention to the performative nature of the event.

The presence of the loudspeaker would seem to refute the lack of "permission to speak" and celebrate rebellion as permission being overruled through defiance. Or, the edifice of authority is toppled, as the 'script' clearly refers to 'important' gallery documents. The documents symbolise their significance as the scholarship, research and manuscripts, leading to recognition. Hence the press files are the signs of critical acclaim in the public domain. These trappings and paraphernalia which surround the art object, or the events, reassure all involved. Sink this and the signs of success, of intention and endeavour are lost. It is a propositional loss. The rocket's trajectory went straight to the sky and the trunk sinks to its watery grave. The document announces the rocket's role as the signal to throw the archive over board. And the boat is a lifeboat! Symbolically, it makes for a peculiar symbiosis of principles. The contradictory movements of verticality and horizontality are brought together on the level surface of the sea. Rumours are more often exchanged in conversation than in writing, at least initially, and the rumour, we read, goes around those on the beach. The re-telling of its exchange makes for an interesting situation of the voices' echo, now that they are text-based.

The term "script" implies rehearsal, repetition and/or performative action. There is another layer to arise from the procedural character of this event. The trunk is stamped and marked "fragile". It metaphorically enters the delivery system. It is an object of transaction and in the process of transaction engenders transition between sender and receiver. The truck's contents demonstrates the gallery's reception, the records of achievement and, one speculates, taxes, invoices and all those inevitable disappointments of incomplete business and miscommunication.

"The inevitability and failure of the archives" is a text in the Foksal Gallery publication for an exhibition in the Demarco Gallery in 1979. The exhibition was a visual discussion and presentation of the Foksal Gallery's theoretical and historical position through the display of documents. "[By] referring to the history of the institution we would like to point to the weakness of the institution. This exhibition is a criticism of the Gallery."[6] The exhibition also celebrated a ten year association with Demarco and Polish art.

The central question posed by the exhibition was to address the function of the Foksal Gallery as exhibition space and the direction into which, as an ongoing situation, all this was to lead. In brief, the points are as follows. One, the fact of the exhibition's finitude might limit the work and impact on ideas and possibilities. Two, contingent on this assertion it is the conceptually peripheral which is crucial and which is not to be deleted, or censured from view. *What we most dislike about the Foksal* is the tokenism to the protocol of a conventional gallery with the requisite, private views, exhibition management and programming. Through the presentation of ideological rifts, the viewer is brought into a personal interchange with the Foksal

The Multipart contract refers to the Multipart happening which was an event in two stages. Part one comprised about 40 identical white canvases with a crushed umbrella, painted white, attached to each of them. They were on sale at cost prices and the contract pertained to the acquisition of one of the paintings. The purchaser was invited to contribute to the work by writing/drawing or otherwise marking it. On the May Day celebrations in Warsaw in 1970 architecture students paraded some of the umbrella works through the streets culminating with the burial of one of them. An unanticipated consequence was the rising value of individual pieces. Courtesy Foksal Gallery, Warsaw.

archive, to question memory and the subjective difficulties of retrieval within the institution of the archive as a public exhibition. The archive in this instance is a silent testimonial to events.

Wiesław Borowski's and Andrzej Turowski's statement entitled "documentation" was included in the Demarco Gallery exhibition. It was also one of the papers sent to Townsend. It privileged *the idea* "freed of its form and function", an idea that does not depend on "material trace". The idea in this context is accessed through its record, and is necessarily just a trace. There is ambiguity in connecting the project to its record, for surely the work/project is manifested through its realisation, that is to say, it enters the cultural sphere by being articulated as history. This is a position Lawrence Weiner would accord with, when he said "once the work enters the culture it's history".[7]

Borowski's and Turowski's statement continues: "the work of art has lost its permanence. Only formal systems, monuments and institutions endeavour to prolong its existence." These are "a muddled magma of artistically useless but commercially useful traces". The statement situates the ethos and intention to identify thought processes as artworks in themselves. They underlie art practices and preoccupations of intention in Europe, the UK and the USA. They denote a temporal relation to art as an idea framed by its system. Numerous examples could serve here, I select two, first Ian Wilson's *Chalk Circle* at the Bykert Gallery, New York in 1968 and second, Bill Beckley *Crossing the Delaware* 1969. Both events exist only in documentation. Wilson drew a circle on the gallery floor; he found the telling of it to be more important than looking at it, although photographs document its existence. In Beckley's *Crossing the Delaware* the documentation consists of reporting the event, as the camera was lost in the river. Beckley planned to paint a line across the river, but as the current was very strong, he fell into the water, and lost the paint and the camera. The story enters history. It's a position in which culture is institutionally preserved. It must have been hard to objectify the dematerialised art practices at the end of the 1960s. Accessing history is the doubting historian's dilemma. Seth Siegelaub, New York's most innovative gallery dealer in the 1960s speaks about the problem of history as epitomised by the event's context. In his view it is only fully understandable at the time when past codes become inaccessible.[8]

The Kantor exhibition at the Whitechapel Art Gallery in 1976 was accompanied by two publications: one was in-house and the other, *Emballage*, was the Foksal Gallery's. The Whitechapel catalogue had a 'multipart' umbrella illustrated on the cover. The word's coinage "multipart", from multiplication and participation, draws attention to collaboration as a system. And the context of the work's systematic process is similar to Sol Le Witt's performative instructions for the presentation of his wall drawings. The multipart involved a contract between individual collectors acquiring a work, "the purchase of a picture", for $60. Letters were sent to the network of people connected to the gallery. Jasia Reichardt who was at that time exhibition organiser at the ICA, London, received one of them. The process mapped connectivity between people and location, idea, place and time. The subsequent action happening in Warsaw, on 1 May 1970, Labour Day, is part of a chain of events before staging the exhibition in the gallery. Reichardt's letter refers to the work "Multipart" as an action.

The agreement authorises purchase of the painting in the series, a free action on the painting and participation in the exhibition at the Foksal Gallery; upon receipt of payment the picture will be sent immediately. The multipart action demanded behaviour from the collectors. Conditions of the contract are, "please do, write, sign, scribble, rub, immortalise, write insults, praises…", an admonition to read the list of directions in order to change the object. The besmirched status of marginalia meant focusing away from the periphery. It is like seeing the pages with the reader's signs turned back, with the words underlined. These confrontational actions spotlight the authorial decision-making processes as well as the value, or virtue, of authenticity and the uniqueness of the created object.

The umbrella is a motif for the processes of procedural connectivity. Its function is redundant, as it has turned into an *emballage*. This process of transformation includes

abject signs of detritus and marginalia which surround the object in order to inform its tactile and metaphysical qualities. Like the fluff and shreds found in the pockets of the *Anatomy Lesson*, Kantor's happening "after Rembrandt", 1968, when the dissection strips character to bareness, through the exposure of transportable baggage, in order to show a physiological anatomy instead of the body itself. To demonstrate the intrinsic means showing signs of exchange; those hands grabbing an object leave their traces. Kantor exposed ambiguous relationships in the archive and used it as a method to identify a phenomenological encounter so as to find a way to render the system transparent without explication.

The umbrella's spokes connect at the hub on the shaft. The shaft is what the umbrella material furls round when closed. The release clasp is the key to its function. Kantor's umbrella spaces are flattened spaces. Stuck to the canvas, painted white, they are redundant, just objects. Metaphorically, the umbrella alludes to interior spaces where imaginative reconnection through the use of spokes to the hub is possible. Like memory compressed to two dimensions the question is how to access the secrets they contain. The hub is the syllogism for the event recorded, namely flattened time and flattened space.

One of Kantor's manifestos states that every audience is the first audience. Through experiencing the work a transaction and exchange occurs and both are intermingled to make the event. The possibility of a pure, authentic experience unfolding through the encounter's duration is a central tenet of modernism's hegemony. In other words, the duration frames the experience as well as the event. It's a dual frame. Idealism, freedom towards the possibility of pure experience, combined with a necessary disinterest for the audiences participating in the act of transaction. All this is located outside the so called "normal" relations with the world. It's a return to Kantian aesthetics in action. And it is a surprising formation, because Kant is not associated with those marginal preoccupations of the forgotten or bereft. Kantor refers to his yardstick for beginning at base level, "reality of the lowest rank…".

Kantor described himself as "total artist"; by this he envisaged a fluid space where the visual practices of painting, sculpture and happenings extend to create an intermingling where everything present is in a state of becoming. Kantor's presence on the inside of production, on the stage, destabilised 'normal' relations with spectatorship and participation for audience and players alike. "The reality on the stage should become a reality as definite as the audience. The drama is not presented, it comes into being and grows before the eyes of the spectator." The action moves between temporalities of remembrance, where memory is brought to presentness in a fusion of intimacy and a culturally acquired historical understanding of events. Realisation of form echoes the constructivist engagement with space. "A happening is once and only once—like a street accident you can't repeat it… I have tried to make use of the same method.…"[9]

NOTES

1 This is not the place for discussion of *Studio International*'s policy on critical attention to artists' practices "beyond the iron curtain", suffice to note the contributions from Prague, Belgrade, Bucharest, "New Russian Art", and Polish artists exceeded the other "mainstream" art magazines in the UK and the USA during the 1960s and 1970s.

2 Thompson, Michael, "The death of rubbish", *New Society,* vol. 30, May 1970, pp. 916–917.

3 Peter Townsend, *Studio International* Magazine Archive, Tate Gallery Archive, TGA 20028, Art & Technology File.

4 Barber, John, "An Inchoate Vision of the World", *The Daily Telegraph,* 25 August 1972.

5 Hershman, Lynn, "Review: Visual arts at the Edinburgh Festival", *Studio International*, vol. 186, October 1973, no. 959, pp. 158–159.

6 *Galeria Foksal PSP,* exh. cat., The Richard Demarco Gallery, August 1979.

7 Lawrence Weiner in conversation with author, unpublished transcript 30 March 2005, New York.

8 Seth Siegelaub in conversation with author, 28 January 2006, Amsterdam.

9 Kantor interview with Cordelia Oliver, "Kantor at full gallop", *The Guardian,* 18 August 1972.

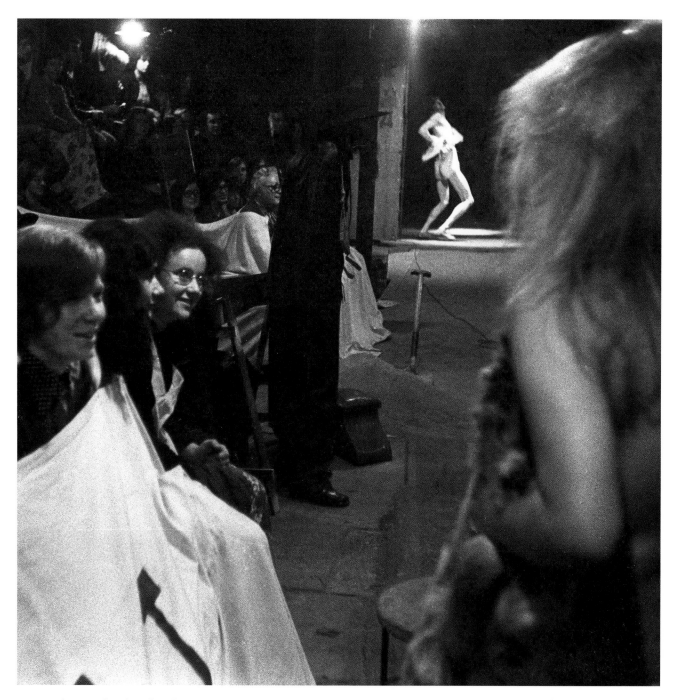

Cricot 2 performance of *Lovelies and Dowdies,* Richard Demarco
Gallery's production for Edinburgh Fringe Festival, Forresthill,
Poorhouse, August/September 1973, photograph Richard
Demarco, courtesy Demarco Archive.

KANTOR IN THE UK

NOEL WITTS

I attempt here to give a chronological account of the reception of Kantor's work in the UK, to show how the impact has only slowly grown over a period of 40 years. It may seem strange to Polish readers that it took so long for the UK to recognise this figure, but we are still slow to recognise European genius in theatre, in spite of the efforts of Peter Daubeny's World Theatre Series in the 1960s, the London International Festival of Theatre, and the current programming at the Barbican, London.

It was, however, Richard Demarco, with his unique flair, who introduced the work of Tadeusz Kantor, the great Polish theatre-maker, to UK audiences, at the Edinburgh Festival Fringe in 1972, 1973 and 1976. The two productions Kantor brought were of texts by the Polish Surrealist Witkiewicz—practically unknown in the UK at that time—*The Water Hen* and *Lovelies and Dowdies*. But Kantor had turned these texts into something that today would be seen as a cross between installation and event, where, according to Michal Kobialka "there was no separation between the audience and the actors". In 1973 *Lovelies and Dowdies* won a *Scotsman* Fringe First Award, when UK critics, led by Michael Billington of *The Guardian*, were waking up to the fact that in far-off Poland there were modes of theatre-making that completely ignored the naturalist tradition of Stanislavsky, that "played with" texts, and which produced a form of theatre that was, at least in the UK, almost unclassifiable. If it were classified it would be part of the 'fringe', which is where UK critics place anything which they can't quite profile. You will see from these remarks that I accuse most UK critics of theatre of having a history of being blinkered and out of sympathy with most performances which do not foreground the triumvirate of writer/actor/director.

Were Kantor's works 'plays' or some other sort of visual theatre art? Billington's enthusiasm was so in spite of there being no translation, no surtitles, no real aid to understanding the Polish context. Audiences were watching performances that transcended categorisation, and as Kantor himself later explained: "Whether it is theatre, or painting, or drawing, or a book—it all comes into being in a strange way, and I can do anything. You cannot say 'theatre ends here and painting begins here'. To me it's all the same."[1]

For audiences in the UK, brought up on the 'well-made' play, this work was a revelation, in that it spoke across boundaries and made connections with other theatre-makers for whom the visual had been essential—Meyerhold, Schlemmer, Edward Gordon Craig.

Kantor brought *The Dead Class* to Riverside Studios (which was then directed by David Gothard) in 1976 and in 1982, where I saw his work for the first time, still with no translation or surtitles. The impact then was extraordinary, as by that time Kantor was clearly beginning to be seen internationally as one of the key performance makers of the twentieth century, alongside Stanislavsky, Brecht, Grotowski, Robert Wilson, and Pina Bausch (whose work had also been seen in London for the first time around the same period).

For me this was one of the key experiences of my career—directing a Performing Arts department in a Polytechnic in Leicester which made one of its aims the acknowledgement of the links between the visual arts and performance. For us Kantor and Meyerhold were the key theatre figures, as they created work that was light years away from the naturalistic tradition

The Dead Class at Riverside Studios, London, September 1976, photograph Richard Demarco, courtesy Demarco Archive.

of UK theatre. At this time also Kantor's work was seen by a generation of future theatre-makers such as Theatre de Complicite and Improbable Theatre.

In educational terms it was therefore important to bring this Polish work to the attention of students who themselves were beginning to create work away from

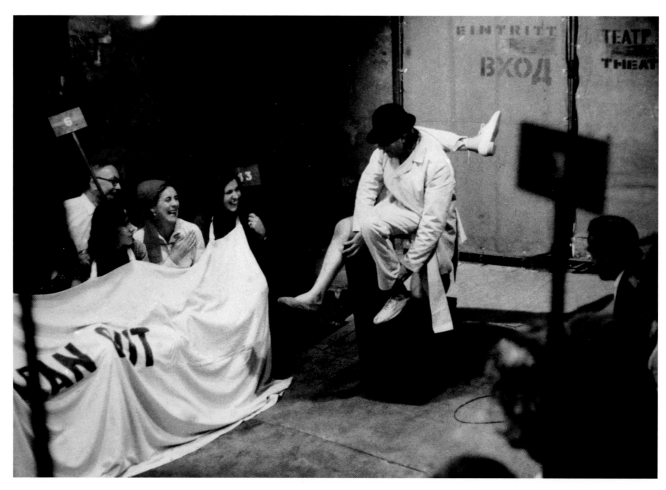

the naturalistic tradition. Sometime in the 80s I met Krzysztof Miklaszewski, who had been a member of Cricot 2, having had a major role in *The Dead Class* for many years. He gave me a video of Kantor's work recorded by Polish TV, which included *The Dead Class* and *Wielopole, Wielopole*, and which I proceeded to show to many students over many years. Even today's students remember the first gesture of the old people in *The Dead Class*, where they raise their hands as if to either answer a question or request something—an eternal gesture from all schools everywhere.

By this time *Wielopole, Wielopole*, Kantor's excursion into his memory of his family, had been shown in the UK to great acclaim, so that there was an acknowledgement that meant that progressive higher education—as often so much more advanced than the mainstream theatre in the UK—was beginning to explore alternative modes of theatre-making that owed little to that writer/actor/director axis that had become enshrined in so much theatre in most theatre departments and drama schools. Around this time companies like Forced Entertainment, Station House Opera, and Complicite were showing audiences that 'theatre' has indeed many manifestations, and that the playwright might not, after all, be the most prominent of theatre's collaborators. Were Kantor's pieces 'plays' or events? Was Pina Bausch's work 'dance' or 'theatre' or something else. She called them "pieces".

Although mainstream UK theatre still regarded (and maybe still does?) Kantor's work as outside its remit, there was a steady drip of Kantor being fed into UK universities by those dedicated theatre academics and practitioners who saw that here was a way of proving that theatre-making and visual art had links, even roots, which needed to be explored if we were to continue to encourage the next generation of theatre-makers.

Above Demarco Gallery presentation of *Lovelies and Dowdies*, Edinburgh International Festival Fringe, Forresthill, Poorhouse, August/September 1973, photograph Richard Demarco, courtesy Demarco Archive.

Opposite Leaflet for *The Dead Class* at Riverside Studios, London, September 1976, courtesy Demarco Archive.

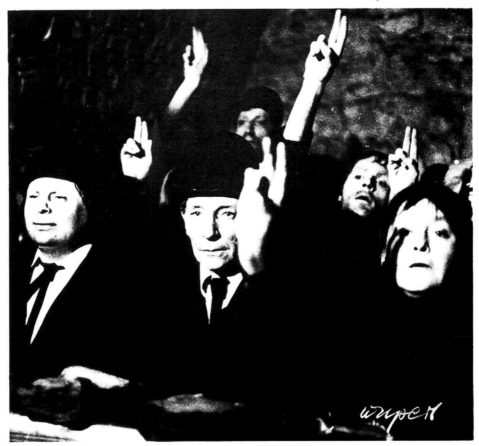

For years I had been showing the Miklaszewski video to students as part of a series of lectures that included Kantor as a major twentieth century artist, and it was therefore a real pleasure to be commissioned by the UK publisher Routledge, together with my colleague Michael Huxley, to prepare the *Twentieth Century Performance Reader,* which was to include writings by major performance practitioners in an "expanded performance" field, including theatre, dance, music, and their major theoretical exponents. The book was finally published in 1986 with Kantor's "Theatre of Death" manifesto preceded by a conversation with the American choreographer Bill T Jones, and followed by Allan Kaprow on happenings. So for the first time, as far as I know, Tadeusz Kantor became anthologised along with Stanislavsky, Meyerhold, John Cage, Merce Cunningham, and Pina Bausch, company where he deserved to be. We had found Kantor's text "Theatre of Death" in a book called *Twentieth Century Polish Theatre*, published as long ago as 1979 by John Calder, the major UK publisher of non-UK theatre texts. (His list in those days consisted of work by Raymond Radiguet, Frank Wedekind, Tristan Tzara, and Goethe!) It's difficult to be precise about the impact of our new book, but it has, over the years become one of Routledge's best sellers, so one must assume that the mix of writings and diverse artists is answering some incipient demand for readers to know what exactly has happened in performance in the twentieth century; as well as for students who are now seeing the connections between the various art forms.

Kantor died in 1990, just before the first performances of *Today Is My Birthday* which he had been rehearsing. The show then went to the Edinburgh Festival where it was included in the official programme. Here there was a show about Kantor's past and his obsessions, but without Kantor, and with an empty chair on stage where he might have sat. It ended with a freeze frame of the moment in rehearsal where Kantor had left—one of the most moving and evocative images of twentieth century theatre.

In 1990, at the Polytechnic in Leicester, I directed some Kantor workshops which explored the potential of Kantor's late *Milano lessons*, which he had taught with a select group of students in Milan in 1986 and which resulted in a performance entitled *The Wedding Ceremony*. It was clear from this experiment that following Kantor's instructions could expand the imagination of performers in a unique way and led to a demand for some knowledge of what Kantor's methods might have been, a demand which so far has not been answered, perhaps because there never was a "Kantor Method"! However, in 1990 also there was a major UK publication, by Marion Boyars, of Kantor's score for *Wielopole, Wielopole*, translated and edited by Mariusz Tchorek and George Hyde of the University of East Anglia in Norwich, which had always had an interest in Polish theatre. This gave UK readers a sense of how Kantor had constructed his work and became a major resource for 'Kantorians' in the English-speaking world.

So far Kantor had been taken on board by progressive theatre-makers in the UK, and by university students in progressive departments. Finally in 1991 the BBC, too, began to take an interest in who they had largely regarded as a fringe character. I was finally commissioned by BBC Radio 3 to make a 45 minute documentary about Kantor, produced by Martin Jenkins. This meant travelling to Warsaw and Kraków to interview those who had worked with Kantor, and resulted in a Radio 3 Sunday evening slot, which, in those days, was a prime time event, though after one broadcast there is really no idea of the possible impact. However, much to my regret, Kantor never became the subject of a *South Bank Show*, Melvyn Bragg's key arts TV series which ended in 2009.

In 1993 Michal Kobialka's major book on Kantor, *A Journey Through Other Spaces*, was published by the University of California Press. Kobialka was then Professor of Theatre at the University of Minnesota, and his book for the first time allowed readers access to the life history, photographs of the work, and in particular English translations of some of the key manifestos that Kantor had, throughout his career, always written. They were tough, uncompromising, anti-establishment rants—

sometimes entirely in capital letters—from an artist who felt that his history and experience was undervalued in a Poland where much cultural policy had been dictated from Moscow, and with this publication Kobialka joined the ranks of those key writers and academics who have successfully managed to profile the work of this major theatre artist.

In 1999 the UK-based CONCEPTS network (The Consortium for the Co-ordination of European Performance and Theatre Studies), which had been established to make links across the new Europe that had come into being as a result of the collapse of Communism, held a major conference devoted to Kantor in Kraków. This was sponsored in part by Maria Stangret, Kantor's wife, Kantor's actress and a painter, who allowed us to hold the proceedings at Kantor's house in Hucisko, 20 kilometres from Kraków, and by Krzysztof Pleśniarowicz, at that time Director of the Cricoteka. Here were gathered many of the European supporters of Kantor—Richard Demarco, Michal Kobialka, Pleśniarowicz, David Hughes, and others, who met to celebrate and reflect on the achievements of this great artist. The conference included papers by Kobialka, Pleśniarowicz, Faynia Williams (who had performed in Kantor's *Lovelies and Dowdies* at Edinburgh), Richard Demarco, Eleonor Margolies, Eric Prince, John Bennett, as well as Zuzana Hlavenkova from Slovakia, Krzysztof Pacek from Łódź, and many others. The conference ended with a session on "The Future of Kantor Studies", which was optimistic, in that at that time Kantor was only just being accepted into the pantheon of major European theatre-makers. In retrospect this conference made a significant contribution towards the study of Kantor in the UK, bringing together as it did, other European thinkers and teachers out there whose work could now be accessed.

In 2001 The Centre for Performance Research at the University of Aberystwyth, UK, hosted a major conference on Kantor, thereby adding him to its list of "Past Masters" which had previously included figures of the stature of Meyerhold, Stanislavsky, Grotowski, and Lecoq. This was a major event which brought together Kantor's circle of friends, which included Wiesław Borowski, and a series of UK academics, to find a way of placing Kantor in the pantheon. On this occasion the English version of Krzysztof Pleśniarowicz's book *The Dead Memory Machine* was launched by the Black Mountain Press. Pleśniarowicz had a first-hand experience of both of the artist and his company from the inside. His book is, with that of Kobialka, the key source for any study of Kantor, allowing a unique insight into the Polishness of Kantor and his performance history from the very beginning as well as incorporating information about Kantor's visual art.

In 2002 the UK publisher Routledge brought out Krzysztof Miklaszewski's *Encounters with Tadeusz Kantor*, once again translated and edited by George Hyde. This is another invaluable collection of interviews and conversations over a number of years, in which we can catch the authentic voice of Kantor, less hectoring and more humorous than in his manifestos.

In 2003/2004 came another major Kantor breakthrough, when the Cricoteka in Kraków, now under the direction of Natalia Zarzecka, began publishing the DVDs of Kantor's performances, and documentary films realised by Andrzej Sapija; more importantly with subtitles, so that non-Polish speakers could at last see the texts that Kantor had used, and the ways in which he had expropriated and used them to re-create a sense of Polish identity that had been lost. These videos and tapes were bought up hurriedly by some UK Kantor enthusiasts, but are still not easily available without application to the Cricoteka. They do, however, constitute an invaluable resource as records of live performances of most of the later work from *The Dead Class* onwards.

In 2006 and 2007, Central Saint Martins College of Art and Design in London, in cooperation with Cricoteka, commissioned a series of Kantor projects from Andrea Cusumano, an Italian artist who had always been interested in Kantor's work and methodology. This formed part of the programme for students of the MA Scenography course at Central Saint Martins which was, and still is, directed by Pete Brooks, the director of both Impact Theatre and lately Imitating the Dog.

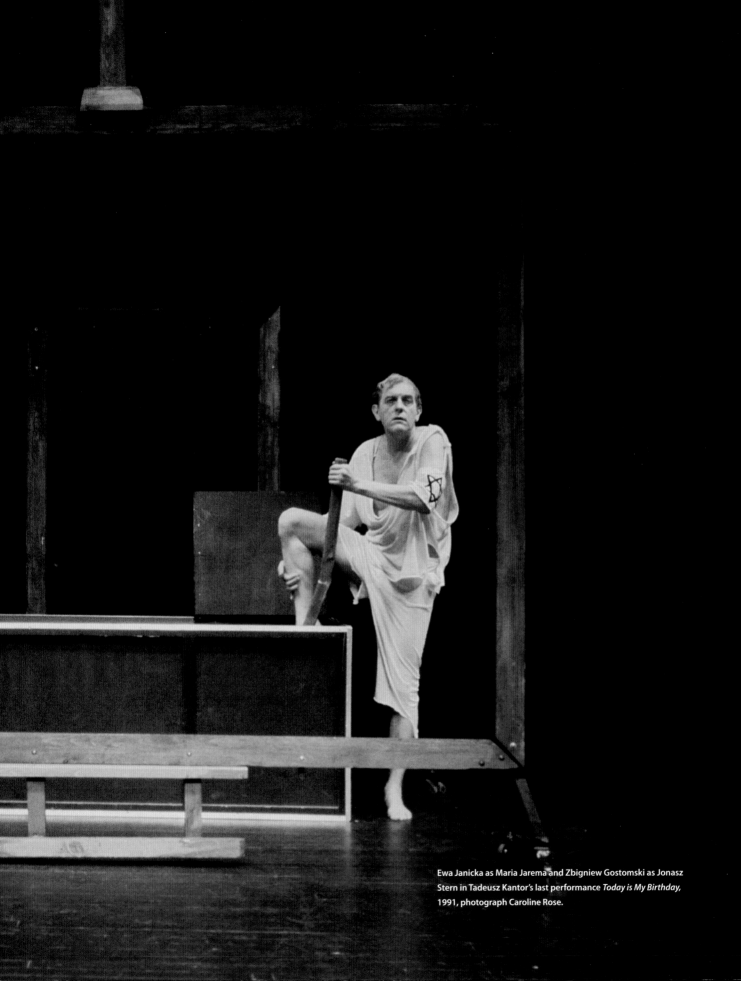

Ewa Janicka as Maria Jarema and Zbigniew Gostomski as Jonasz Stern in Tadeusz Kantor's last performance *Today is My Birthday,* 1991, photograph Caroline Rose.

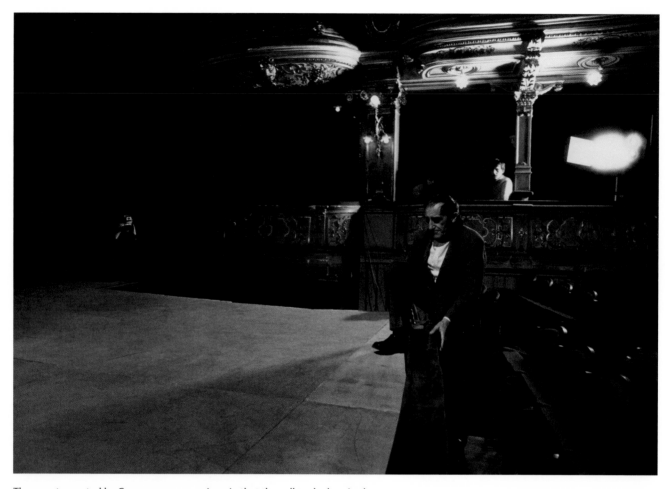

The events created by Cusumano were unique in that they all took place in the Krzysztofory Gallery where *The Dead Class* had originally been performed. In each case they took their inspiration from Kantor's work and even from one of his performers. Mira Rychlicka had been a member of Cricot 2 from the beginning. After these performances I had the privilege of showing the DVD of *The Dead Class* at the Cochrane Theatre in London, in the presence of Mira, who typically accused the film-maker, Andrzej Wajda, of leaving out her best moments! These events, sponsored by a major London University solidified Kantor's importance for the UK, in that he has now finally become a force to be recognised within the ways in which he created his theatre pieces. In many ways his importance in terms of his process, how he created this series of masterpieces, has yet to be recognised, in spite of a few practical workshops run by Andrzej Welminski, one of the long standing Cricot 2 actors.

In 2007 Routledge, under the editorship of the indominatible Franc Chamberlain, commissioned from me a book about Tadeusz Kantor, as part of the Routledge series of Performance Practitioners. These included Barba, Bausch, Boal, Brecht, Copeau, Grotowski, Laban, Lepage, Lecoq, Meyerhold, Stanislavsky, and Wilson. It is entirely appropriate that Kantor should be included in this group of key twentieth century masters and to enable this to happen has been my main pleasure in writing the book. Although my Polish is limited, my historical and theatrical knowledge is not, and I had the advantage of access to both the Pleśniarowicz and Kobialka books, without which I would have floundered. I was also lucky in that Kobialka's second book on Kantor *Further On, Nothing* was published in 2009 so that there was some up-to-date thinking to be addressed.

Kantor climbing the stage of Słowacki Theatre in Kraków, before the performance of *Let The Artist Die*, January 1986, photograph Leszek Dziedzic, courtesy Cricoteka and Galeria Dyląg in Kraków.

However the great pleasure for me has been in writing an accessible introduction for English speakers to a great twentieth century theatre-maker, and though it comes 20 years after his death it does enable readers to locate Kantor within his Polish times and those of his contemporaries. The fact that these two books were published near each other meant that the *Times Literary Supplement* for 19 February 2010, was able to commission a substantial review from the playwright Samantha Ellis who acknowledges that "it is impossible to understand Kantor's work without knowing his life".[2] Her only mistake is to speak about Kantor's pieces as "plays", a word that would never have passed the great man's lips. Plays no, perhaps séances, installations, scenarios, experiments, collages, *cricotages*, any term that would indicate the distance away from mainstream theatre that Kantor always maintained. Plays take place in theatres; Kantor's work was in gymnasiums, churches, underground spaces. It was only at the end of his life that one work was shown in the Słowacki Theatre in Kraków (and there is a wry photo of Kantor climbing on the stage of this august space), and as part of the Edinburgh Festival, one of the most prestigious in Europe, the Cricot 2 company filled the stage of the King's Theatre; without Kantor, only the memorial empty chair.[3]

Looking back, although Kantor came to the UK as early as 1972, in many ways the work was ahead of its time for a country that was still unmistakably heir to the literary tradition of making theatre. Over the years the alternative theatre movement has grown to the extent that there are now small companies emerging every year who proudly state that they are part of a non-text-based theatre tradition. Over the years the publications and events that I have outlined above have shown these younger theatre artists that there is indeed an avant-garde tradition where texts are thrown around, played with, ignored, and that the high priest of this tradition is Tadeusz Kantor. The empty chair at the Edinburgh performances of *Today Is My Birthday* symbolised the end of a Polish theatre which produced a major European artist who we now at last celebrate; along with Stanislavsky, who he tolerated, Grotowski, who he despised, and the Russian Meyerhold, who he adored. Kantor's grave at the Rakowicki Cemetry in Kraków presents us with a sculpture of a boy sitting at a school desk—a clear memory of *The Dead Class*. However behind this figure looms a large Catholic cross, leaving an ambiguous message for such a complex and controversial figure. I sometimes think Kantor is here laughing at us with his ironic face, daring us to believe in simple solutions and beliefs, when his entire career was built out of complexity and fear.

NOTES

1 Pleśniarowicz, Krzysztof, *The Dead Memory Machine: Tadeusz Kantor's Theatre of Death*, Aberystwyth: Black Mountain Press, 2000, p. 87.

2 Ellis, Samantha, "Ghetto geometry", *The Times Literary Supplement*, 19 February 2010, pp. 23–23.

3 *Let the Artists Die*, 25–31 January 1986; *Wielopole, Wielopole* was also part of the Edinburgh Festival, shown at Moray House Gymnasium, 26–30 August 1980.

BIBLIOGRAPHY

Adamson, Nathalie, *Painting, Politics and the Struggle for the École de Paris,1944–1964*, Farnham and Burlington, Vermont: Ashgate, 2009.

Atelier 72: Edinburgh Festival: Aug–Sep, exh. cat., Edinburgh: The Richard Demarco Gallery, 1972.

AG, "Polish play beats language barrier", *The Glasgow Herald*, 7 September 1973.

AW, "A painting comes alive", *The Glasgow Herald*, 23 August 1976.

Bakhtin, Mikhail, *Rabelais and his World,* Helene Iswolsky trans., Bloomington and Indianapolis: Indiana University Press, 1984.

Badiou, Alain, Bernard Blistène Yann Chateigné, Marc Dachy, Elie During, Patricia Falguières, Pedro G Romero, Jean-Jacques Lebel, Anne Stenne eds., *A Theater Without Theater*, exh.cat., Barcelona: MACBA, Lisbon: Colecçao Berardo, 2007.

Bałka, Miroslaw, *The Unilever Series: How It Is*, Helen Sainsbury ed., London: Tate Publishing, 2009.

Barber, John, "An inchoate vision of the world", *The Daily Telegraph*, 25 August 1972.

Barber, John, "Digging up our buried years", *The Daily Telegraph*, 6 September 1976.

Biennale de Paris Archives, online http://www.archives.biennaledeparis.org/fr/1959/index.htm

Bois, Yve-Alain, Rosalind Krauss, *Formless: A User's Guide*, New York: Zone Books, 1997.

Bois, Yve-Alain, "The Falling Trapeze", *Jean Fautrier: 1898–1964*, Curtis L Carter, Karen K Butler eds., New Haven and London: Yale University Press, 2002, pp. 57–61.

Borowski, Wiesław, "Tadeusz Kantor and his 'Cricot 2' Theatre", *Studio International*, vol. 187, January 1974, pp. 22–23.

Borowski, Wiesław, *Tadeusz Kantor*, Warsaw: Wydawnictwa Artystyczne i Filmowe, 1982.

Borowski, Wiesław, "To Paint Anew: Thought from Warsaw", *Studio International*, vol. 196, January/February 1983.

Borowski, Wiesław, "The Paintings from Chłopy of Andrzej Szewczyk" [Review: Warsaw], *Studio International*, vol. 196, April/May 1983.

Borowski, Wiesław, "Tadeusz Kantor's 'Où sont les neiges d'antan'", *Studio International*, vol. 196, April/May 1983.

Borowski, Wiesław, Hanna Ptaszkowska, Mariusz Tchorek and Andrzej Turowski, "Foksal Gallery Documents", *October*, vol. 38, Autumn 1986, pp. 52–62.

Bürger, Peter, *Theory of the Avant-Garde*, Michael Shaw trans., Minneapolis: Minnesota University Press; Manchester: Manchester University Press, 1984.

Calvocoressi, Richard, "Edinburgh Festival: Tadeusz Kantor: Cricot 2 Theatre", *Studio International*, vol. 193, January 1977, pp. 45–46.

Caplan, Leslie, "Ambiguity in the grotesque", *The Times Higher Education Supplement*, 24 September 1976.

Carrick, Jill, *Nouveau Réalisme, 1960s France, and the Neo-avant-garde: Topographies of Chance and Return*, Farnham: Ashgate, 2010.

Chambers, Colin, "Experiments in the Polish experience", *Morning Star*, 20 September 1976.

Chmielewska, Ella, Agnieszka Chmielewska, Mariusz Tchorek, Paul Carter, "A Warsaw Address: a dossier on 36, Smolna Street", *The Journal of Architecture*, vol. 15, issue 1, February 2010, pp. 7–38.

Cieszkowski, Krzysztof, "Illusion and repetition: Tadeusz Kantor interviewed", *Art Monthly*, no. 42, Dec.1980/Jan.1981, pp.6–8.

Chrobak, Józef and Marek Świca eds., *I Wystawa Sztuki Nowoczesnej: Pięćdziesiąt lat później*, exh. cat., Kraków: Starmach Gallery, 1998.

Critics' Forum broadcast on Saturday 30 August, 1980, BBC, transcript, manuscript in the collections of Cricoteka.

Davies, Norman, *God's Playground,* Oxford: Oxford University Press, 1981.

Darwent, Charles, "George Brecht: Composer and artist with the Fluxus movement

who pioneered conceptual art", *The Independent*, 17 March 2009.

Ellis, Samantha, "Ghetto geometry", *The Times Literary Supplement,* 19 February 2010.

Elsom, John, "Décor by Babel", *The Listener*, 2 September 1976.

Elwell, Julia, "Puppets on the string of life", *Echo*, 9 September 1976.

Eyre, Richard, "Inside the Human Corral", *The Scotsman*, 21 August 1972.

Feaver, William, "Painting prose", *The Observer Review*, 17 October 1976.

Folie, Sabine ed., *Das unmögliche Theater: Performativität im Werk von Pawel Althamer, Tadeusz Kantor, Katarzyna Kozyra, Robert Kusmirowski und Artur Zmijewski/ The Impossible Theater: Performativity in the Works of Pawel Althamer, Tadeusz Kantor, Katarzyna Kozyra, Robert Kusmirowski and Artur Zmijewski,* exh. cat., Wien: Kunsthalle Wien, Warsaw: Zachęta Narodowa Galeria Sztuki, Nuremberg: Verlag für Moderne Kunst, 2005.

Gerould, Daniel ed. and trans., *The Wikiewicz Reader*, Evanston: Northwestern University Press, 1992.

Gołubiew, Zofia ed., *Tadeusz Kantor. Malarstwo i rzeźba*, Kraków: Muzeum Narodowe, 1991.

Gombrowicz, Witold, *Ferdydurke*, Danuta Borchardt trans., Susan Sontag foreword, New Haven and London: Yale University Press, 2000.

Groys, Boris, "How to do time with art", *Frances Alÿs: A Story of Deception*, exh. cat., Mark Godfrey, Klaus Peter Biesenbach and Kerryn Greenberg eds, London: Tate Publishing, 2010.

Halczak, Anna, *Cricoteka,* Warsaw: Biblioteka Narodowa/Cricoteka, 2005.

Havel, Vaclav, *The Memorandum*, London: Eyre Methuen, 1981.

Hershman, Lynn, "Review: Visual arts at the Edinburgh Festival", *Studio International*, vol. 186, October 1973, pp.158–160.

Holbrook, David, *English for Maturity,* Cambridge: Cambridge University Press, 1967.

Huxley, Michael, Noel Witts eds., *The Twentieth Century Performance Reader*, London: Routledge, 2002.

Janiccy, Wacław and Lesław, *Dziennik podróży z Kantorem,* Kraków: Wydawnictwo Znak, 2000.

Jurkiewicz, Małgorzata, Joanna Mytkowska, Andrzej Przywara eds., *Tadeusz Kantor z Archiwum Galerii Foksal,* Warsaw: Galeria Foksal, 1998.

Jurkiewicz, Małgorzata, Jolanta Pieńkos eds, *Teatr niemożliwy: Performatywność w sztuce Pawła Althamera, Tadeusza Kantora, Katarzyny Kozyry, Roberta Kuśmirowskiego i Artura Żmijewskiego / The Impossible Theatre: Performativity in the Works of Paweł Althamer, Tadeusz Kantor, Katarzyna Kozyra, Robert Kuśmirowski and Artur Żmijewski,* ex. cat., Wien: Kunsthalle Wien, Warszawa: Zachęta Narodowa Galeria Sztuki, 2006.

Kantor, Tadeusz, "1944 Ulisses", Gołubiew, Zofia ed., *Tadeusz Kantor. Malarstwo i rzeźba*, exh. cat., Kraków: Muzeum Narodowe, 1991, p. 54–55.

Kantor, Tadeusz, "Repères", Le Rocher, Chexbres, February 1964, *Kantor*, Lausanne: Galerie Alice Pauli, 1964.

Kantor, Tadeusz, "Idea podróży. Teatr 'i'", *Tadeusz Kantor z Archiwum Galerii Foksal,* Małgorzata Jurkiewicz, Joanna Mytkowska, Andrzej Przywara eds., Warsaw: Galeria Foksal, 1998, pp. 333–336.

Kantor, Tadeusz, "Rozważania", *Tadeusz Kantor z Archiwum Galerii Foksal ,* Małgorzata Jurkiewicz, Joanna Mytkowska, Andrzej Przywara eds, Warsaw: Galeria Foksal, 1998, pp. 163–164.

Kantor, Tadeusz, "Szatnia", *Tadeusz Kantor z Archiwum Galerii Foksal,* Małgorzata Jurkiewicz, Joanna Mytkowska, Andrzej Przywara eds, Warsaw: Galeria Foksal, 1998, pp. 325–326.

Kantor, Tadeusz, "Demarcation line", *Atelier 72: Edinburgh Festival: Aug–Sep,* exh. cat., Edinburgh: Richard Demarco Gallery, 1972.

Kantor, Tadeusz, *Emballages 1960–1976*, Ryszard Stanisławski ed., exh. cat., London: Whitechapel Art Gallery, 1976.

Kantor, Tadeusz, *Emballages*, Wiesław Borowski ed., Piotr Graff trans., Warsaw: Galeria Foksal PSP Books, 1976.

Kantor, Tadeusz, *Wielopole, Wielopole,* Mariusz Tchorek and George Hyde trans., London: Marion Boyars, 1990.

Kantor, Tadeusz, "MANIFESTO. Tadeusz Kantor 1915–1990", *Obieg,* no. 1 (21), 1991.

Kantor, Tadeusz, *Pisma,* 3 vols, Krzysztof Pleśniarowicz ed., Wrocław: Ossolineum, Kraków: Cricoteka, 2004–2005.

Kantor, Tadeusz, *Metamorfozy: Teksty o latach 1938–1974/Pisma,* vol.1, Krzysztof Pleśniarowicz ed., Wrocław: Ossolineum, Kraków: Cricoteka, 2005.

Kantor, Tadeusz, *Teatr Śmierci: Teksty z lat 1975–1984/ Pisma,* vol. 2, Krzysztof Pleśniarowicz ed., Wrocław: Ossolineum, Kraków: Cricoteka, 2004.

Karmitz, Marin, Joëlle Pijaudier-Cabot, Estelle Pietrzyk, Laure Lane eds., *Silences: Un propos de Marin Karmitz,* exh. cat., Strasbourg: Éditions des Musées de la Ville de Strasbourg, 2009.

Kitowska-Łysiak, Małgorzata, "Visual Arts", *Tadeusz Kantor* (2002) http://www. culture.pl/en/culture/artykuly/os_kantor_tadeusz.

Kobialka, Michal, ed. and trans., *A Journey Through Other* Spaces: *Essays and Manifestos, 1944–1990, Tadeusz Kantor,* with a critical study of Tadeusz Kantor's theatre by Michal Kobialka, Berkeley: University of California Press, 1993.

Kobialka, Michal, *Further On, Nothing: Tadeusz Kantor's Theatre,* Minneapolis: University of Minnesota Press, 2009.

Kristeva, Julia, *Powers of Horror: An Essay on Abjection,* Léon S Roudiez trans., New York: Columbia University Press, 1982.

Lacan, Jacques, *Ecrits: A Selection,* Alan Sheridan trans., London: Routledge, 2001.

Leeman, Richard ed., *Le Demi-Siècle de Pierre Restany,* Paris: INHA-Les Éditions des Cendres, 2009.

Lupasco, Stéphane, *L'énergie et la matière vivante,* Paris: Julliard, 1962.

Lupasco, Stéphane, *Science et art abstrait,* Paris: Julliard, 1963.

Macuga, Goshka, *The Nature of the Beast,* Bloomberg Commission, London: Whitechapel Gallery, April 2009–April 2010.

Mahlow, Dietrich (director), *Kantor ist da: Der Künstler und seine Welt,* Saarländischer Rundfunk, 1968, 46 min.

Mathieu, Georges, *De la Révolte à la Renaissance, au delà du Tachisme,* Paris: Gallimard, 1973.

Meyric-Hughes, Henry, Hélène Lassalle, Ramón Tío-Bellido, *AICA in the Age of Globalisation,* Paris: AICA Press, 2010.

Michalczuk, Dominika, "Przeciwko tym mitom", *'Zostawiam światło, bo zaraz wrócę'—Tadeusz Kantor we wspomnieniach swoich aktorów,* Jolanta Kunowska ed., Kraków: Cricoteka, 2005, pp. 176–182.

Mickiewicz, Adam, *Forefathers' Eve* (1823–1832), Dorothea Prall Radin trans., George Rapall Noyes ed., London, 1928.

Miklaszewski, Krzysztof, *Encounters with Tadeusz Kantor,* George Hyde ed. and trans., London and New York: Routledge, 2002.

Miklaszewski, Krzysztof ed., *Tadeusz Kantor: Między śmietnikiem a wiecznością,* Warsaw: Państwowy Instytut Wydawniczy, 2007.

Murawska-Muthesius, Katarzyna, *An Impossible Journey: The Art and Theatre of Tadeusz Kantor,* exh. leaflet, Norwich: Sainsbury Centre for Visual Arts, University of East Anglia, 2009.

O'Brien, Flann, *The Third Policeman,* London: MacGibbon & Kee, 1967.

Oliver, Cordelia, "Kantor at full gallop", *The Guardian,* 18 August 1972 .

Paulhan, Jean, *Lettre aux Directeurs de la Résistance* (1951), Paris: Jean Jacques Pauvert, 1968.

Piaget, Jean, *The Language and Thought of the Child,* Marjorie and Ruth Gabain trans., London: Routledge 2001.

Pleśniarowicz, Krzysztof, *The Dead Memory Machine: Tadeusz Kantor's Theatre of Death,* Aberystwyth: Black Mountain Press, 2000.

Polit, Paweł, "Warsaw's Foksal Gallery 1966–1972: Between PLACE and Archive", *Artmargins,* January 2009, http://www.artmargins.com/index.php/featured-articles/179-foksal-gallery-1966-72-between-place-and-archive.

Presences polonaises: L'art vivant autour du musée de Łódź, exh. cat., Paris: Musée National d'Art Moderne, Centre Georges Pompidou, 1983.

Prière de toucher, Exposition Internationale du Surréalisme, exh. cat., Paris: Galerie Maeght, 1947.

Renfrew, Alistair, "The Carnival Without Laughter", *Face to Face: Bakhtin in Russia and in the West*, Adlam, Carol, Rachel Falconer, Vitalii Makhlin & Alistair Renfrew eds., Sheffield: Sheffield Academic Press, 1997.

"Riverside Studios", *The Times,* 9 June 1982.

Schorlemmer, Uta ed.,*"Kunst is ein Verbrechen": Tadeusz Kantor, Deutschland und die Schweiz: Errinerungen—Dokumente—Essays—Filme auf DVD*, Nuremberg: Verlag für moderne Kunst, Kraków: Cricoteka, 2007.

Schorlemmer, Uta ed., *"Sztuka jest przestępstwem: Tadeusz Kantor a Niemcy i Szwajcaria: Wspomnienia—dokumenty—eseje—filmy na DVD*, Kraków: Cricoteka, Nuremberg: Verlag für moderne Kunst, 2007.

Schulz, Bruno, *The Fictions of Bruno Schulz*, Celina Wieniewska trans., London: Picador, 1988.

Selz, Peter ed., *15 Polish Painters*, exh. cat., New York: Museum of Modern Art, 1961.

Serota, Nicholas, "Tadeusz Kantor at Whitechapel", *Tadeusz Kantor: Interior of Imagination*, Jarosław Suchan and Marek Świca eds, exh. cat., Warsaw: Zachęta Narodowa Galeria Sztuki, Kraków: Cricoteka, 2005, pp. 122–125.

Stanisławski, Ryszard ed., *Emballages: Kantor*, exh. cat., Łódź: Muzeum Sztuki, 1975.

Stanisławski, Ryszard, Christoph Brockhaus, *Europa, Europa: Das Jahrhundert der Avantgarde in Mittel- und Osteuropa*, exh. cat., Bonn: Kunst- und Austellungshalle, Bonn: Stiftung Kunst und Kultur des Landes Nordrhein-Westfalen, 1994.

Suchan, Jarosław ed., *Tadeusz Kantor: Niemożliwe/Impossible*, exh. cat., Kraków: Bunkier Sztuki Galeria Sztuki Współczesnej, 2000.

Suchan, Jarosław, "Happening as a Readymade", *Tadeusz Kantor: Niemożliwe / Impossible*, Jarosław Suchan ed., Kraków: Bunkier Sztuki, 2000, pp. 67–120

Suchan, Jarosław and Marek Świca eds., *Tadeusz Kantor: Interior of Imagination*, exh. cat., Warsaw: Zachęta Narodowa Galeria Sztuki, Kraków: Cricoteka, 2005.

Tabakova, Nia Nikolaeva, *Utopia and Memory: Christo before Jeanne-Claude 1935–1963,* MA dissertation, The Courtauld Institute of Art, University of London, 2006.

Thompson, Michael, "The death of rubbish", *New Society*, vol. 30, May 1970, pp. 916–917.

Turner, Victor, *The Ritual Process: Structure and Anti-Structure,* Chicago: Aldine Publishing Company, 1969.

Ward, Duncan and Gabriella Cardazzo (directors), *Kantor,* London: Filmmakers, 1987, 35 min.

Warszawa—Moskwa/Moskva—Varšava 1900–2000, Anda Rottenberg, Maria Poprzęcka, Lidia Jowlewa eds, Małgorzata Buchalik, Beniamin Cope et al. trans., exh. cat., Warsaw: Zachęta Narodowa Galeria Sztuki, 2004, Moscow: State Tretiakov Gallery, 2005.

Wilson, Sarah, *Paris 1945–1975—The Sainsbury Family Collection*, Norwich: Sainsbury Centre for Visual Arts, University of East Anglia, 1989.

Wilson, Sarah, "Paris Post War: In Search of the Absolute", *Paris Post War: Art and Existentialism: 1945–1955,* exh. cat., London: Tate Gallery, London: Tate Publishing, 1993, pp. 25–52.

Wilson, Sarah, "'Fêting the Wound': Georges Bataille and Jean Fautrier in the 1940s", Carolyn Gill ed., *Writing the Sacred: Georges Bataille*, London: Routledge, 1995, pp. 172–192.

Wilson, Sarah , "Saint-Germain-des-Prés: from Occupation to Reconstruction", *Paris: Capital of the Arts: 1900–1968 ,* exh. cat., London: Royal Academy of Arts, 2002, pp. 236–249.

Wilson, Sarah, "Voids, palimpsests, kitsch: Paris before Klein", *Voids*, Paris: Éditions du Centre Georges Pompidou, 2009, pp. 192–198.

Witts, Noel, *Tadeusz Kantor*, London and New York: Routledge, 2010.

Zarzecka, Natalia and Michal Kobialka, *Tadeusz Kantor: Twenty Years Later*, a special issue of *Polish Theatre Perspectives,* vol. 2, no. 1, Spring/Summer 2011 (forthcoming).

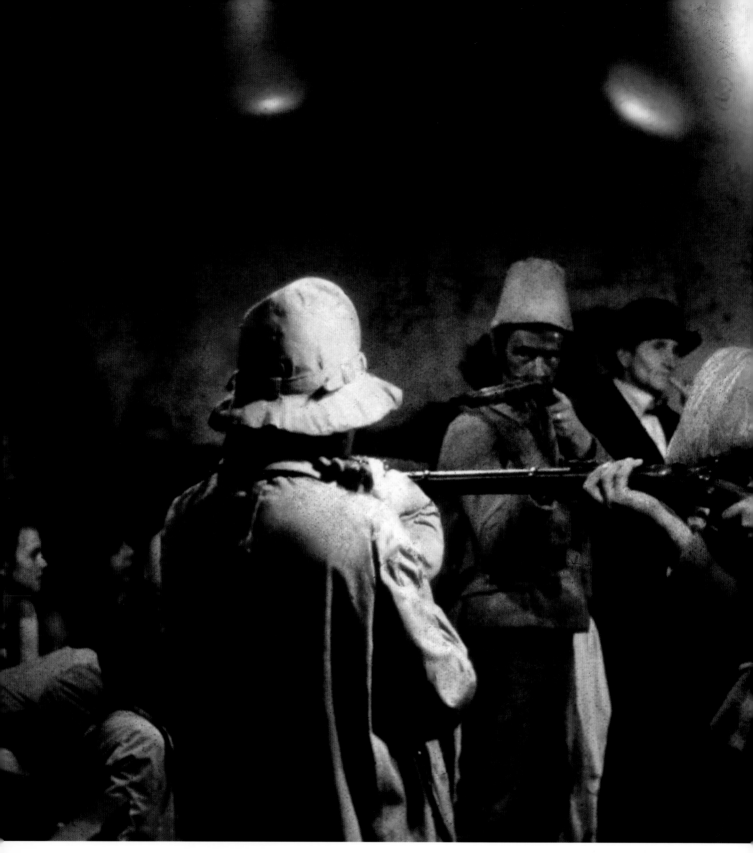

Jacek Maria Stokłosa (centre) and Wiesław Borowski (right)
performing with rifles in *The Water Hen*, Richard Demarco
Gallery's production for Edinburgh Fringe Festival, Forresthill,
Poorhouse, August 1972, photograph Richard Demarco, courtesy
Richard Demarco Archive.

REVIEWS OF KANTOR'S PERFORMANCES IN THE UK: A SELECTION

THE WATER HEN
EDINBURGH, FORRESTHILL, POORHOUSE
THE EDINBURGH INTERNATIONAL FESTIVAL, THE FRINGE
20.08–27.08.1972

—, "Towards a new theatre", *Oxford Strumpet*, no. 41, 1972.
—, "Around the Fringe", *The Scotsman*, 26 August 1972.
Barber, John, "An inchoate vision of the world", *The Daily Telegraph,* 25 August 1972.
Barber, John, "Riches from the poorhouse", *The Daily Telegraph,* 11 September 1972.
Billington, Michael, "Edinburgh Festival: Polish play", *The Guardian*, 23 August 1972.
Costello, Kevin, "*Water Hen*: Cricot Theatre", *Cracker*, no. 18, 3 September 1972.
Eyre, Richard, "Inside the human corral", *The Scotsman*, 21 August 1972.
Hobson, Harold, "The funniest farce of the Festival", *The Sunday Times*, 3 September 1972.
Lewsen, Charles, "Actors' series of living sculptures", *The Times*, 29 August 1972.
Oliver, Cordelia, "Kantor at full gallop", *The Guardian*, 18 August 1972.
Oliver, Cordelia, "Edinburgh Festival", *The Guardian*, 21 August 1972.
Oliver, Cordelia, "Edinburgh–2", *Plays and Players,* vol. 20, no. 229, October 1972.
Say, Rosemary, "Operatic flaws—but theatre starts well", *The Sunday Telegraph*,
 27 August 1972.
Shepherd, Michael, "Scottish International", *The Sunday Telegraph*, 20 August 1972.
Vaizey, Marina, "From Poland with love", *Financial Times*, 2 September 1972.
Young, B A, "*The Water Hen*", *Financial Times*, 25 August 1972.
Ziarski, Tadeusz, "Penderecki i 'Kurka wodna'", *Dziennik Polski i Dziennik Żołnierza*,
 [London], 7 September 1972.

Reviews in non-British press
[Teatr], *Trybuna Ludu*, no. 253, 10 September 1972.
"Cricot 2" w Edynburgu", *Literatura*, 14 September 1972.
"Polish News from Abroad: Tadeusz Kantor's Theatre Cricot–2 in Great Britain",
 Le Théâtre en Pologne/The Theatre in Poland, no. 2, 2 February 1973.
Antecka, Jolanta, "Polska sztuka w Edynburgu", *Dziennik Polski*, 16 September 1972.
Borowski, Wiesław, "Zdyscyplinowane szaleństwo Kantora", *Kierunki*, 12 November 1972.
Taborski, Bolesław, "Rzecz o podboju", *Życie Literackie*, no. 40, 1 October 1972.

LOVELIES AND DOWDIES
EDINBURGH, FORRESTHILL, POORHOUSE
THE EDINBURGH INTERNATIONAL FESTIVAL,
THE FRINGE
19.08.1973–8.09.1973

—, *The Scotsman*, 1 September 1973.

—, *The Scotsman*, 7 September 1973.

—, "All the World Stooge", *Cracker*, no. 36, 19–26 August 1973.

A.G., "Edinburgh Festival: Polish play beats language barrier", *The Glasgow Herald*,
 7 September 1973.

Barber, John, "Strange happenings in Poles' experiment", *The Daily Telegraph*,
 23 August 1973.

Billington, Michael, "*Lovelies and Dowdies* at the Forresthill", *The Guardian*,
 23 August 1973.

Coveney, Michael, "Cricot 2", *Financial Times*, 24 August 1973.

Done, Kevin, "Around the Festival Fringe", *The Scotsman*, 27 August 1973.

Hershman, Lynn, "Visual arts at the Edinburgh Festival", *Studio International*, vol. 186,
 no. 959, October 1973.

Hignett, Sean, "*Lovelies & Dowdies*", *Cracker*, no. 37, 26.08- 2 September 1973.

Oliver, Cordelia, "Edinburgh 1", *Plays and Players*, vol. 21, no. 241, October 1973.

Overy, Paul, [n.t.], *The Times*, 28 August 1973.

Riddell, Alan, [n.t.], *The Sunday Telegraph*, 26 August 1973.

Shepherd, Michael, "Demarco plus", *The Sunday Telegraph*, 26 August 1973.

Reviews in non-British press

—, "Die Prinzessin im Hüherkäfig", *Frankfurter Allgemeine Zeitung*, 10 September 1973.

—, "Il teatro polacco con gli occhi aperti sul mondo", *L'Unità*, 27 September 1973.

Calandra, Denis, "Experimental Performance at the Edinburgh Festival", *The Drama
 Review*, vol. 17, no. 4, December 1973, pp. 60–68.

"Polish News from Abroad: Kantor in Edinburgh for the Second Time", *Le Théâtre en
 Pologne/The Theatre in Poland* [Warsaw] , no. 2, February 1974.

Siro, C., "Teatro "off' e "out" a Edimburgo", *Tribuna Letteraria*, 1973.

LOVELIES AND DOWDIES
GLASGOW, SCOTLAND'S FRUIT MARKET
12.09–14.09.1973

PHF, "Brash gimmickry in Polish play", *The Glasgow Herald*, 14 September 1973.

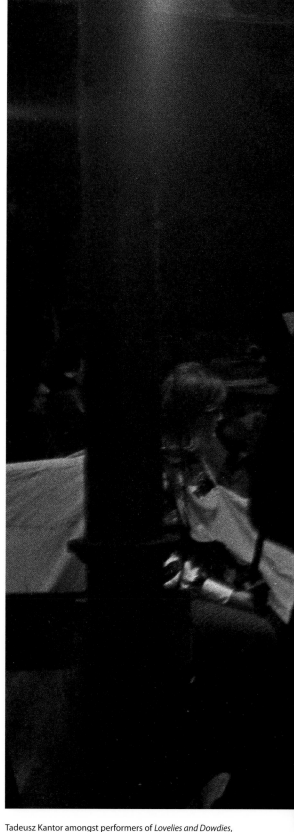

Tadeusz Kantor amongst performers of *Lovelies and Dowdies*, Cricot 2 performance presented by Richard Demarco Gallery for the Edinburgh International Festival Fringe, Forresthill, Poorhouse, August/September 1973, photograph Richard Demarco, courtesy Demarco Archive.

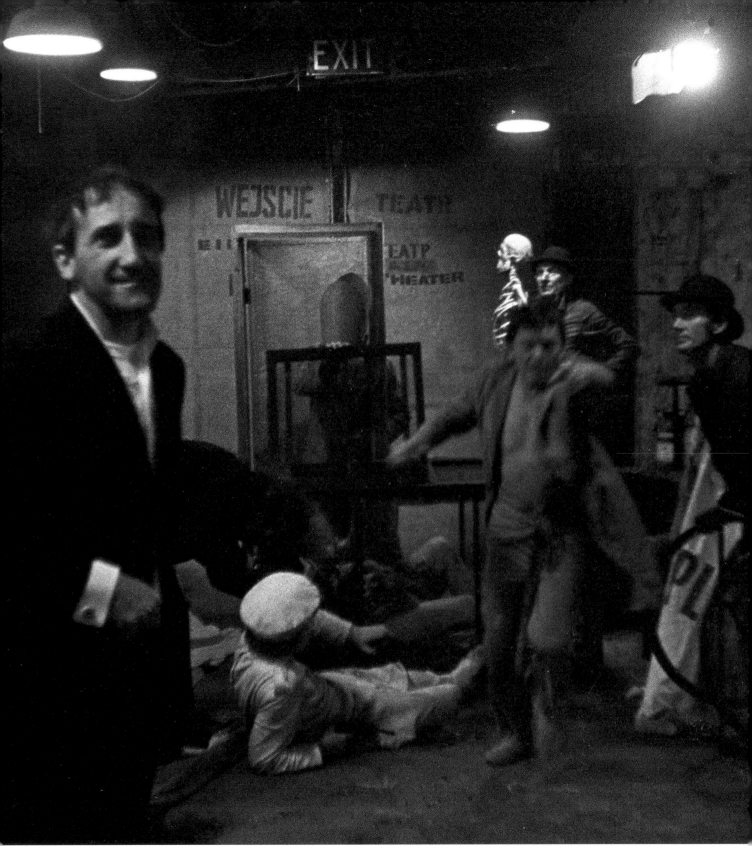

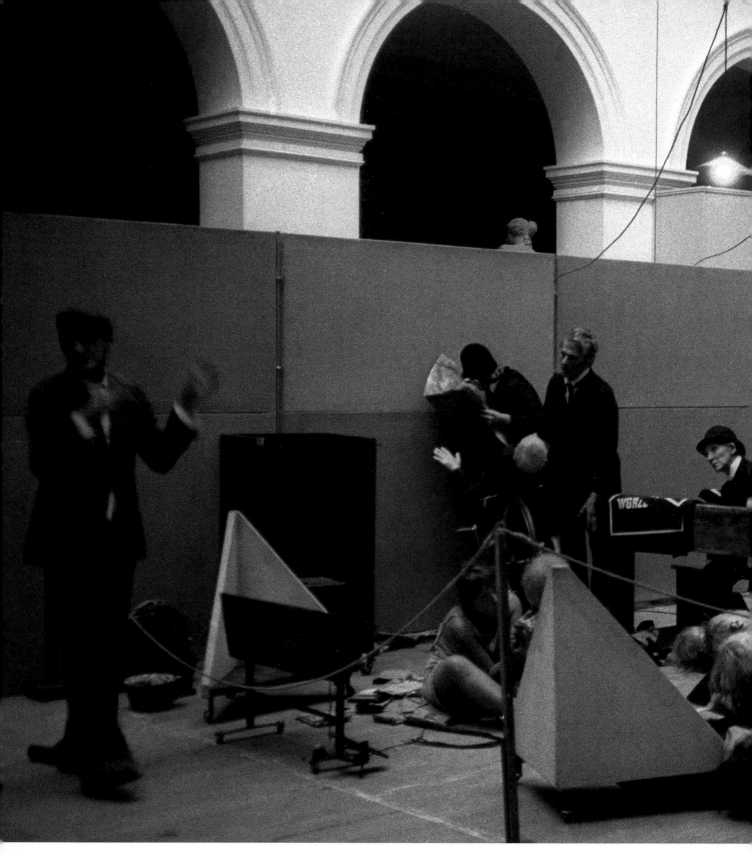

Rehearsals of the Demarco Gallery presentation of *The Dead Class* at the Sculpture Court of Edinburgh College of Art, Edinburgh International Festival Fringe, August/September 1976, photograph Richard Demarco, courtesy Demarco Archive.

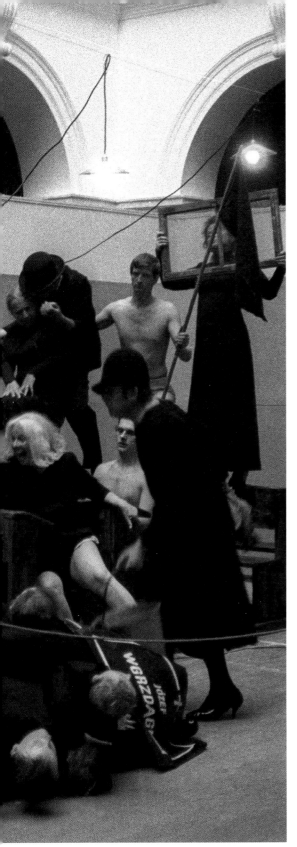

THE DEAD CLASS EDINBURGH,
EDINBURGH COLLEGE OF ARTS,
THE EDINBURGH INTERNATIONAL FESTIVAL,
THE FRINGE
18.08.1976–04.09.1976

Ascherson, Neal, "The Artist as Traitor", *The Scotsman*, 28 August 1976.
AW, "A painting comes alive", *The Glasgow Herald,* 23 August 1976.
BDB., "Cricot", *Festival Times,* 18 August 1976.
Barber, John, "Digging up our buried years", *The Daily Telegraph,* 6 September 1976.
Barron, Brian D, "Atelier '76 at 61 High St '*The Dead Class*'", *Festival Times,* 25 August 1976.
Billington, Michael, "Fringe on top", *The Guardian,* 30 August 1976.
Calvocoressi, Richard, "Edinburgh Festival—Tadeusz Kantor: Cricot 2 Theatre", *Studio International,* vol. 193, no. 985, January/ February 1977, pp. 45–46.
Critics' Forum, BBC Radio 3, 16 October 1976, manuscript in the collections of Cricoteka.
Elsom, John, "Décor by Babel", *The Listener*, 2 September 1976.
McFerran, Ann, "*The Dead Class*", *Time Out* [Edinburgh],10-16 September 1976, p. 16.
Massie, Allan, "Theatre of Death", *The Scotsman*, 20 August 1976.
Nightingale, Benedict, "Proper Stuff", *New Statesman,* 3 September 1976.
Oliver, Cordelia, "Cricot Theatre", *The Guardian*, 23 August 1976.
Overy, Paul, "Surrealism without surfeit", *The Times,* 31 August 1976.
Parsons, Gordon, "Fringe Benefits", *Morning Star*, 11 September 1976.
Riddell, Allan, "Troy still falls", *The Sunday Telegraph*, 29 August 1976.
Walker, John, "Revival of Ben Johnson Masterpiece at Edinburgh Festival", *International Herald Tribune*, 7 September 1976.
Wardle, Irving, "Edinburgh Festival", *The Times*, 30 August 1976.
Young, BA, "Picking at the Fringe", *Financial Times,* 31 August 1976.

Reviews in non-British press
Bodnar, Izabela, "Edynburg—arena najlepszych", *Przekrój*, no. 1644, 10 October 1976.
Bodnar, Izabela, "O festiwalach edynburskich", *Pismo*, August 1983.
WB, "Tournée du théâtre Cricot–2 en Grande–Bretagne/Cricot-2 in Great Britain", *Le Thèàtre en Pologne/The Theatre in Poland,* March 1977.
Gieraczyński, Bogdan, "Na przykład Cricot 2", *Tygodnik Demokratyczny,* no.38, September 1976.
Goossens, Xavier, "Au Festival d'Edimbourg", *La Libre Belgique,* September 1976.
Henkel, Barbara, "Teatr: Niezależna rzeczywistość", *Sztandar młodych*, 9.12.1976.
[k], "Udane tournee Teatru 'Cricot 2", *Dziennik Polski*, no. 219, 25–26 September 1976.
Miklaszewski, Krzysztof, "Edynburg-odmłodzony trzydziestolatek", *Teatr*, no. 2, 23.01.1977.
Miklaszewski, Krzysztof, "Teatr: W XX-lecie istnienia Cricot-2. /Kantor is coming, Kantor extended", *Kultura*, 7 November 1976.
Taborski, Bolesław, "Wielka Brytania i reszta świata", *Życie Literackie*, 17 October 1976.

THE DEAD CLASS CARDIFF, WALES SHERMAN THEATRE ARENA 8.09–9.09.1976

Elwell, Julia, "Puppets on the string of life", *Echo*, 9 September 1976.

THE DEAD CLASS LONDON, RIVERSIDE STUDIOS 11.09–18.09.1976

—, "Invitation only", *Evening Standard*, 13 September 1976.
—, "Cricot 2 at Riverside Studios", *Financial Times*, 8 September 1976.
Barber, John, "1976 awards", *The Daily Telegraph*, 6 September 1976.
Barber, John, "1976 awards", *Plays and Players,* November 1976.
Billington, Michael, "Riverside Studios: *The Dead Class*", Arts Guardian, 13 September 1976.
Caplan, Leslie, "Ambiguity in the grotesque", *Times Higher Education Supplement*, 24 September 1976.
Chambers, Colin, "Experiments in the Polish experience", *Morning Star*, 20 September 1976.
Cork, Richard, "Enter the hollow men", *Evening Standard,* 23 September 1976.
Elsom, John, "1976 awards", *Plays and Players*, November 1976.
Esslin, Martin, "*The Dead Class*", *Plays and Players,* November 1976.
Feaver, William, "Painting prose", *The Observer Review,* 17 October 1976.
Hoffmann, Anna, "Witkiewicz i teatr Tadeusza Kantora", *Dziennik Polski i Dziennik Żołnierza* [London] 6 October 1976.
Karren, Tamara, "Umarła Klasa Kantora", *Tydzień Polski* [London], 9 October1976.
MAM, "*The Dead Class*", *The Stage,* 23 September 1976.
Marcus, Frank, "Foreign bodies", *The Sunday Telegraph*, 19 September 1976.
Marcus, Frank, "Tadeusz Kantor for *The Dead Class*, 1976 Awards", *Plays and Players*, November 1976.
Mullaly, Terence, "Capturing today for ever", *The Daily Telegraph,* 20 September 1976.
Reichardt, Jasia, "Kantor's tragic theatre", *Architectural Design,* vol. 46, November 1976.

Reviews in non-British press
Bajorek, Andrzej, "Sukces teatru Cricot 2 nad Tamizą", *Życie Warszawy*, 7 September 1976.
Bianchi, Ruggero, "Chi ha paura del marxista cattivo?", *Arte e Società*, nos. 9–10, October 1976–January 1977.

Opening of *Tadeusz Kantor: Emballages 1960–1976* at the Whitechapel Art Gallery, London, September/October 1976, from the left: Maria Stangret-Kantor, Wiesław Borowski, photograph Richard Demarco, courtesy Demarco Archives.

TADEUSZ KANTOR: EMBALLAGES 1960–1976
WHITECHAPEL ART GALLERY
CURATED BY NICHOLAS SEROTA
22.08.1976–31.10.1976

Chambers, Colin, "Experiments in the Polish experience", *Morning Star,* 20 September 1976

Cork, Richard, "Enter the hollow men", *Evening Standard*, 23 September 1976.

Critics Forum, BBC Radio 3, 16 October 1976, manuscript in the collections of Cricoteka.

Feaver, William, "Painting prose", *The Observer Review,* 17 October 1976.

Overy, Paul, "The bandaged nude", *The Times,* 28 September 1976.

Reichardt, Jasia, "Kantor's tragic theatre", *Architectural Design*, vol. 46, November 1976.

Roberts, Keith, "London, Oxford, Hull, Newcastle, New York, etc.", *The Burlington Magazine,* vol. 118, November 1976, p. 788.

Tisdall, Caroline, "Kantor at the Whitechapel", *The Guardian*, 29 September 1976.

Vaizey, Marina, "Kantor's Package Tour of Life", *The Sunday Times,* 17 October 1976.

WIELOPOLE, WIELOPOLE
EDINBURGH,
MORAY HOUSE GYMNASIUM
THE EDINBURGH INTERNATIONAL
FESTIVAL OF ART
26.08–30.08.1980

—, "Polish Theatre", *Festival Times,* 20 August 1980.
—, "Edinburgh: The Festival Theatre", *Harpers & Queen*, August 1980.
—, "Kantor is coming.", *Festival 80*, 17 August–6 September 1980.

Bachmann, Gideon, "The Kantor Circus dons a death mask", *Now!*, 15 August 1980.
Bachmann, Gideon, "Pageant of death", *The Guardian*, 2 September 1980.
Barber, John, "Phantoms of memory", *The Daily Telegraph,* 28 August 1980.
Barber, John, "Timely view of dour Polish life", *The Daily Telegraph*, 28 August 1980.
Billington, Michael, "A Festival on a shoe–string", *The Guardian,* 23 August 1980.
Billington, Michael, "Torment of a child", *The Guardian,* 27 August 1980.
Billington, Michael, *"Wielopole, Wielopole"*, *The Guardian,* 28 August 1980.
Brennan, Mary, "Disturbing childhood memories", *The Glasgow Herald,* 28 August 1980.
Chaillet, Ned, "Edinburgh: a slide into the past and a glance into the future",
 The Times, 1 September 1980.
Critics Forum broadcast on Saturday, 30 August 1980, BBC; manuscript in the
 collections of Cricoteka.
Cushman, Robert, "Panache from Poland", *The Observer*, 31 August 1980.
Elsom, John, "Fringe feast", *The Listener,* 4 September 1980.
Fenton, James, "Kantor's Last Supper", *The Sunday Times,* 31 August 1980.
Levin, Bernard, "The Edinburgh Festival", *The Listener*, 4 September 1980.
Nightingale, Benedict, "Skid-Row Toscanini", *New Statesman*, 5 September 1980.
Parsons, Gordon, "Kantor's vision is a world without hope", *Morning Star*, 28 August 1980.
Radin, Victoria, "Going from dog to God", *The Observer,* 31 August 1980.
Vaizey, Marina, "The theatrical genius of Tadeusz Kantor", *The Sunday Times
 Magazine*, 24 August 1980.
Wright, Allen, "Kantor's great achievement", *The Scotsman*, 27 August 1980.
Young, BA, "Wielopole-Wielopole", *Financial Times*, 28 August 1980.

Reviews in non-British Press
—,"*Wielopole, Wielopole* in tournée all'estero", *La Nazione*, 26 August 1980.
Bodnar, Izabella, "Edynburg '80", *Student*, no. 19, 25 September–8 October 1980.
Bodnar, Izabella, "O festiwalach edynburskich", *Pismo*, April 1983.
Caplan, Leslie, Krystyna Bobińska, "Metoda klisz. Rozmowa z Tadeuszem Kantorem",
 Dialog, no. 12, December 1980.
Holmberg, Artur, "Theater to Make Intellectuals Cry", *International Herald Tribune*
 [Paris], 11–12 October 1980.
Sujczyńska, Monika, "Cricot 2 w Edynburgu", *Przekrój*, 28 September 1980.
—; "Reactions of the British Press to "*Wielopole, Wielopole*" after the Performances
 at the Edinburgh Festival/Opinions de la presse britannique sur „*Wielopole,
 Wielopole*" après les représentations données au festival d'Edimbourg", *Le
 Théâtre en Pologne/The Theatre in Poland*, 1981, no. 1, pp. 29–30.

WIELOPOLE, WIELOPOLE
LONDON, RIVERSIDE STUDIOS
3.09–14.09.1980

—, "*Wielopole, Wielopole*", *Fulham Chronicle,* 12 September 1980.

—, "Poles return", *West London Observer*, 3 September 1980.

—, "Return to Riverside", *Fulham Chronicle*, 5 September 1980.

—, "Meet Kantor at Riverside", *The Stage*, 11 September 1980.

—, "What's on", *Evening News*, 11 September 1980.

—, "Footsbarn off on world tour", *The Stage and Television Today*, 18 September 1980.

BM, "Theatre", *The Guardian*, 30 August 1980.

CM, "Stark view from East", *West London Observer,* 10 September 1980.

Chaillet, Ned, "One More Masterpiece", *Time Out*, 5–11 September 1980.

Cieszkowski, Krzysztof, "Illusion and repetition: Tadeusz Kantor interview", *Art Monthly,* issue no. 42, December 1980/January 1981.

Colvin, Clare, "Intense eye on truth", *Evening News*, 5 September 1980.

Corbett, Susan, "*Wielopole, Wielopole*", *The Stage and Television Today*, 11 September 1980.

Coveney, Michael, "*Wielopole, Wielopole*", *Financial Times*, 8 September 1980.

DM, [n.t.], *What's on in London*, 12-18 September 1980.

Elsom, John, "Me, myself and I", *The Listener*, 11 September 1980.

Feaver, William, "Art: Categorical breakthrough", *Vogue*, no 11, 1 September 1980.

Grant, Steve, "Theatre", *Time Out*, 12–18 September 1980.

Jenkins, Peter, "Shakespearian tragedy", *Spectator,* 13 September 1980.

Kent, Sarah, "Visual Arts", *Time Out,* 12–18 September 1980.

King, Francis, [n.t.], *The Sunday Telegraph*, 7 September 1980.

Ostrowski, Wojciech, "Tadeusz Kantor i jego Cricot 2", *Dziennik Polski i Dziennik Żołnierza* [London], 3 September 1980.

Shelton, Pete, "*Wielopole, Wielopole*: The souls of the dead rise up and march once more", *The Performance Magazine*, no. 7, 08 September 1980.

Stewart, Michael, "Macabre pageant", *Tribune*, 12 September 1980.

JT, "Puzzle of a Polish childhood", *The Times*, 5 September 1980.

Walker, John, "Magic of a priestly ritual with the imagery of death", *Now!*, 5 September 1980.

Wardle, Irving, "*Wielopole, Wielopole*", *The Times*, 5 September 1980.

Reviews in non-British press

—, "Reactions of the British Press to "*Wielopole, Wielopole*" after the Performances at the Edinburgh Festival/Opinions de la presse britannique sur "*Wielopole, Wielopole*" après les représentations données au festival d'Edimbourg", *Le Théâtre en Pologne/The Theatre in Poland*, 1981.

Kantor, Tadeusz, "Texts by Tadeusz Kantor About His Production of '*Wielopole, Wielopole*', Quelques textes de Tadeusz Kantor sur la réalisation du spectacle '*Wielopole, Wielopole*', *Le Théâtre en Pologne/The Theatre in Poland,* 1981.

Petrajtis-O'Neill, Elżbieta, "Kantorowska Ostatnia Wieczerza", *Tygodnik Powszechny,* 2 November 1980.

THE DEAD CLASS
LONDON, RIVERSIDE STUDIOS
17.11–28.11.1982

—, "*The Dead Class* reviews", *West London Observer*, 24 November 1982.

Asquith, Rose, [n.t.], *City Limits*, 12-18 November 1982.

Ascherson, Neal, "Class of Kantor", *The Observer,* 14 November 1982.

Carne, Rosalind, "*The Dead Class*/Riverside Studios", *Financial Times*, 18 November 1982.

Fenton, James, "The real life of plays and players", *The Sunday Times*, 21 November 1982.

Grant, Steve, "Dada's boy", *Time Out,* 19-25 November 1982.

Grant, Steve, [n.t.], *Time Out,* 26 November–2 December 1982.

Hudson, Christopher, "How death is brought to life…", *The Standard,* 18 November 1982.

de Jongh, Nicolas, "London arts center forced into liquidation owing £120,000 as
 staff start sit-in", *The Guardian*, 27 November 1982.

de Jongh, Nicolas, "*The Dead Class*", *The Guardian,* 18 November 1982.

Radin, Victoria, "Quite dead", *The Observer,* 21 November 1982.

Vaughan, Tom, "Unique theatre from Poland", *Morning Star,* 25 November 1982.

Wardle, Irving, "Haunted vision from museum of memory", *The Times,* 18 November 1982.

Reviews in non-British press

—, "Kolejne wojaże teatru Kantora", *Dziennik Polski,* 12 December 1982.

—, "Notatki", *Tygodnik Powszechny*, no. 51, 19 December 1982.

—, "Spektakle Teatru Cricot 2 cieszą się powodzeniem", *Dziennik Polski*, 22 November 1982.

—, "Teatr", *Życie Literackie*, 02 January 1983.

Ostaś, Marek, „Polskie barwy nad Tamizą", *Trybuna Robotnicza,* 05 December 1982.

OÙ SONT LES NEIGES D'ANTAN (WHERE
ARE THE SNOWS OF YESTERYEAR)
LONDON, RIVERSIDE STUDIOS
30.11–5.12.1982.

—, [n.t.], *Art Monthly*, no. 62, December 1982/January 1983, p. 75.

—, "Worst value in town", *The Standard*, 1 December 1982.

Borowski, Wiesław, "Kantor's theatre of emotion", *Studio International,* vol. 195, April
 1982, pp. 49–55.

Borowski, Wiesław, "Tadeusz Kantor's 'Où sont les neiges d'antan'", Warsaw/ London
 Feb 1981, *Studio International,* vol. 196, April/May 1983, p. 51.

Carne, Rosalind, "Cricotage/Riverside Studios", *Financial Times*, 2 December 1982.

Chaillet, Ned, "Brief encounters in Kantor's rare snow", *The Times,* 27 November 1982.

Grant, Steve, "The second work…", *Time Out*, 3-10 December 1982.

Januszczak, Waldemar, "Cricot 2", *The Guardian*, 1 December 1982.

Kantor, Tadeusz, "Kantor's drawings for 'Wielopole Wielopole', 1979/80", *Studio
 International*, vol. 195, no. 4, 1982, pp. 94–95.

Thaxter. John, "If you care for the theatre, look in", *Richmond and Twickenham Times*,
 3 December 1982.

TODAY IS MY BIRTHDAY
EDINBURGH, EMPIRE THEATRE
THE EDINBURGH FESTIVAL OF ART
23.08–27.08.1991

Billington, Michael, "Birthday Present", *The Guardian*, 26 August 1991.
Billington, Michael, [n.t.], *London Theatre Record*, vol. 11, 1991.
Boyes, Roger, "Down with the red flag and up with the curtain", *The Times,* 7 August 1991.
Cambell, David, "Dead and Kicking", *Festival Times*, 24–30 August 1991.
Coveney, Michael, "Blue Angel delight", *The Observer,* 1 September 1991.
Fowler, John, "Unseen presence at the birthday party", *The Glasgow Herald,* 23 September 1991.
France, Peter, "Kantor's Final Poem", *The Times Literary Supplement,* 6 September 1991.
Kingston, Jeremy, "Portrait in three dimensions", *The Times*, 27 August 1991.
Kingston, Jeremy, [n.t.], *London Theatre Record,* vol. 11, 1991.
Linklater, John, "*Today Is My Birthday*", *The Glasgow Herald*, 24 August 1991.
Linklater, John, "Why they Kantor, why we cant", *The Glasgow Herald*, 26 August 1991.
Morrice, Julie, "Who dares wins the plaudits", *Scotland on Sunday*, 25 August 1991.
Oliver, Cordelia, "Recalls meeting...", *The Scotsman*, 5 August 1991.
Peter, John, "Brilliant darkness", *The Sunday Times,* 1 September 1991.
Peter, John, *London Theatre Record*, vol. 11,1991.
Pulver, Andrew, "Death Manifesto", *The List*, 23-29 September 1991.
Ross, Raymond, "*Today Is My Birthday*—Empire Theatre", *Evening News*, 27 August 1991.
Spencer, Charles, [n.t.], "Ghostly dreams", *The Daily Telegraph*, 26 August 1991.
Spencer, Charles, *London Theatre Record*, vol. 11, 1991.
Taylor, Paul, "Picture this", *The Independent,* 28 August 1991.
Taylor, Paul, *London Theatre Record*, vol. 11, 1991.
Wright, Allen, "Kantor's stunning final statement", *The Scotsman*, 24 August 1991.
Wright, Allen, [n.t.], *London Theatre Record*, vol. 11, 1991.

Reviews in non-British press
—, "Polacy w Edynburgu", *Trybuna*, 28 August 1991.
(pa), "Cricot-2 wystąpi w Wenecji i Edynburgu", *Życie Warszawy,* 17 August 1991.

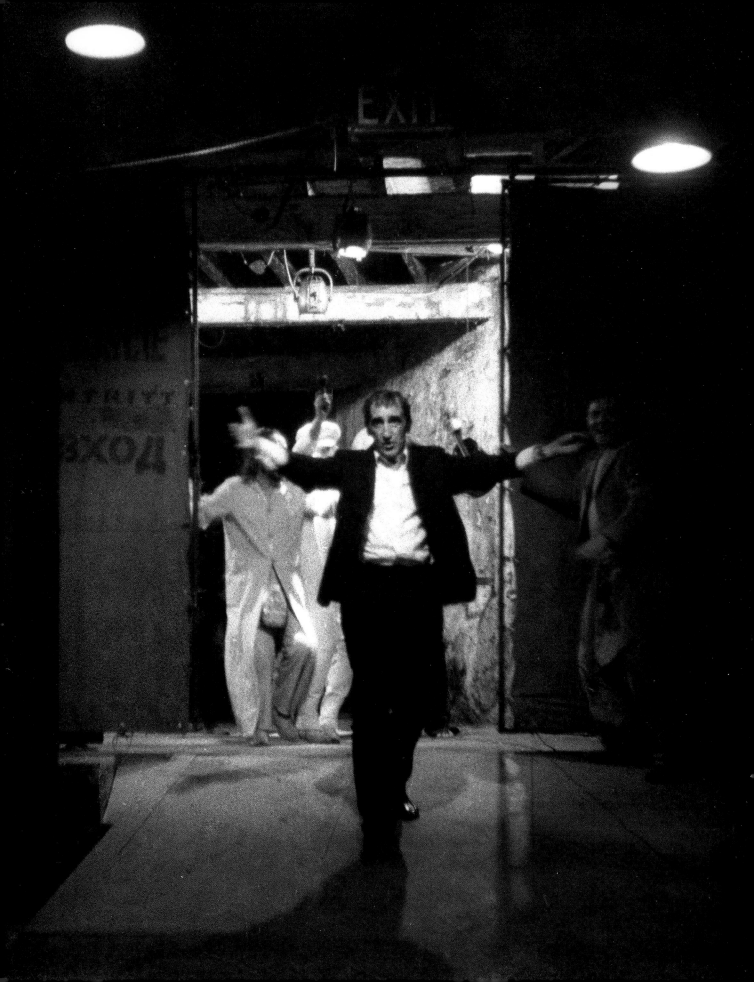

CONTRIBUTORS

WIESŁAW BOROWSKI
Wiesław Borowski was born in 1931 and is an art critic, art historian and curator. In 1966, with Anka Ptaszkowska and Mariusz Tchorek, he founded the Foksal Gallery in Warsaw, which he ran until 2006. Under his leadership the Gallery hosted a plethora of exhibitions of major avant-garde artists from Europe and the US, including Christian Boltanski, Joseph Beuys, Lawrence Weiner and Michael Craig-Martin. Borowski actively promoted Polish art in the UK, supporting activities of the Polish avant-garde, including Kantor's. He is the author of the first major monograph on Kantor, 1982, and was involved in setting up Cricoteka.

KRZYSZTOF CIESZKOWSKI
Krzysztof Cieszkowski was born in London in 1948 and works as Acquisitions Librarian at the Tate Library, London. His numerous articles and reviews were published in *The Literary Review, Art Monthly, Times Literary Supplement, Burlington Magazine* and *History Today*.

RICHARD DEMARCO
Richard Demarco wears many hats. He is the Kingston University Emeritus Professor of European Cultural Studies; he is essentially a watercolourist, teacher and promoter of both the visual and performing arts. He was born in Edinburgh in 1930, inheriting an Italo-Scottish cultural heritage. During the Cold War, he crossed the Iron Curtain over 90 times, fostering cultural links between East and West Europe with a particular focus on Poland.

AMANDA GEITNER
Amanda Geitner is Head of Collections and Exhibitions at the Sainsbury Centre for Visual Arts, UEA, Norwich. Recent exhibitions include *AfterShock: Conflict, Violence and Resolution in Contemporary Art,* 2007, *Constructed: The UEA Collection of Abstract and Constructivist Art 1968–2008* and *Take a Look at Me Now: Contemporary Art from Poland,* 2009.

DAVID GOTHARD
David Gothard was Artistic Director of the Riverside Studios, London. He is Associate of the Abbey Theatre, Dublin and Artistic Director of the Anna Mahler Association for new work in all the arts, based in Spoleto, Italy. He regularly teaches creative writing at the Writers' Workshop, Iowa, the National Film School, the Slade and Chelsea Art Colleges.

RICHARD GOUGH
Richard Gough is Artistic Director of the Centre for Performance Research, Professor of Theatre & Performance in the Department of Theatre, Film and Television Studies at the University of Wales, Aberystwyth and General Editor of *Performance Research (The Journal of Performance Arts)*. He was founding President (1997–2001) of *Performance Studies international* (PSi) and he has curated and organised numerous conferences and workshops over the last 30 years as well as directing and lecturing internationally.

JONATHAN HOLLOWAY
Jonathan Holloway is currently Artistic Director of the Perth International Arts Festival in Australia. Between 2004 and 2010 he was Artistic Director/Chief Executive of the Norfolk & Norwich Festival which he turned into the fourth biggest city arts festival in the UK. Prior to this he established and ran the National Theatre's Events Department, and was Resident Theatre Director of the Wilde Theatre, Bracknell.

GEORGE HYDE
Born in Scotland in 1941, George Hyde read English at Cambridge under F R Leavis. He taught at the University of East Anglia, where he helped Max Sebald set up the British Centre for Literary Translation. He was also Professor at Kyoto Women's University, and taught at Polish universities during and after the Communist period, developing an interest in Polish theatre. Publications include a study of Vladimir Nabokov, books on D H Lawrence, and literary translation from Russian and Polish, including Tadeusz Kantor's *Wielopole, Wielopole*.

Kantor in Demarco Gallery presentation of *Lovelies and Dowdies*, Forresthill, Poorhouse, Edinburgh International Festival Fringe, August/September 1973, photograph Richard Demarco, courtesy Demarco Archive.

KLARA KEMP-WELCH

Dr Klara Kemp-Welch is Leverhulme Early Career Fellow at the Courtauld Institute of Art, where she is coordinating a research project called "Networking the Bloc: Rethinking International Relations in European Art". Her PhD at University College London, 2008, concerned East Central European art and its relation to theories of dissidence.

JO MELVIN

Jo Melvin is an art historian and theory coordinator at Chelsea College of Art and Design. Recent projects include *Shall I stay or shall I go?*, Chelsea Space, 2010; *Kantor is Here,* SCVA, Norwich, 2009; *Tales from Studio International*, Tate Britain, 2008; *Barry Flanagan*, Waddington Galleries, 2010; *Bob Law,* Riding House, 2009; *Spinofferie Barbara Reise, Art Critic, Writer, Landlady, Art Historian & Collector,* in *Hunting & Gathering, The Happy Hypocrite,* 2008.

KATARZYNA MURAWSKA-MUTHESIUS

Katarzyna Murawska-Muthesius is currently Deputy Director of The National Museum in Warsaw and tutor at Birkbeck College, University of London. Her research centres on art of the Cold War, cartography and caricature, and on the relations between Polish and British art. Edited books include*: The National Museum Warsaw Guide,* 1996, 2001, *Borders in Art: Revisiting Kunstgeographie*, 2000, *Jan Matejko's Battle of Grunwald: New Approaches,* 2010. She co-curated *An Impossible Journey: The Art and Theatre of Tadeusz Kantor,* 2009.

SANDY NAIRNE

Sandy Nairne is currently Director of the National Portrait Gallery. He was Director of Programmes at Tate, working alongside Nicholas Serota in the building of Tate Modern and the Centenary Development at Tate Britain. He has worked previously as Assistant Director, Museum of Modern Art, Oxford, Director of Exhibitions at the ICA and Director of Visual Arts for the Arts Council of Great Britain. He is well known for his innovative television series and book *State of the Art*, 1987, and co-edited anthology *Thinking about Exhibitions*, 1996. His most recent book is *The Portrait Now*, with Sarah Howgate, 2006.

NICHOLAS SEROTA

Nicholas Serota has been Director of Tate since 1988. Since then Tate has opened Tate St Ives, 1993 and Tate Modern, 2000, redefining the Millbank building as Tate Britain, 2000. Tate has also broadened its field of interest to include twentieth century photography, film, performance and occasionally architecture, as well as collecting from Latin America, Asia and the Middle East. As a curator, his most recent exhibitions have been Donald Judd and Cy Twombly at Tate Modern and Howard Hodgkin at Tate Britain.

VERONICA SEKULES

Dr Veronica Sekules is Head of Education and Research at the Sainsbury Centre for Visual Arts. She is a Fellow of the Society of Antiquaries and of the Royal Society of Arts, formerly vice-chair of the Board of Engage, the association for gallery education in the UK, now on its steering group for the 'Extend' education leadership network. She is an active researcher and writer and has run projects and workshops in many different countries. From 2005–2006 she was on secondment to Tate Britain as project manager for 'Visual Dialogues', working with young people in a regional partnership of museums in Manchester, Birmingham, Sheffield and Newcastle.

TOMASZ TOMASZEWSKI

Tomasz Tomaszewski is Assistant of the Director of Cricoteka since 2004. He supervises Cricoteka's publications, including a series of records of Kantor's spectacles on DVD. He was Coordinator of many international projects promoting Kantor's oeuvre in Spain, Great Britain, France, Belgium, Romania, Russia and South Korea.

SARAH WILSON

Sarah Wilson teaches at the Courtauld Institute of Art, University of London and was a full-time Visiting Professor at Paris-IV Sorbonne in 2002–2004. She curated *Paris, Capital of the Arts,* 1900–1968, 2001, 2002 and *Pierre Klossowski*, 2006. Her recent publications include *The Visual World of French Theory: Figurations*, 2010. Following her first visit to Poland in the 1990s with Richard Demarco she has travelled to Warsaw many times, and is particularly interested in the links between Poland and Paris.

NOEL WITTS

Noel Witts teaches at the University of the Arts, London, and is Visiting Professor in Performing Arts at Leeds Metropolitan University. He was founder/director of Performing Arts at De Montfort University, UK , is co-editor of *The Twentieth Century Performance Reader,* and is now working on a revised edition as well as the *Twenty-First Century Performance Reader.*

NATALIA ZARZECKA

Natalia Zarzecka is Director of the Centre for the Documentation of the Art of Tadeusz Kantor Cricoteka since 2004. She moved there from the Krzysztofory Gallery. In 2006, she began setting up the Museum of Tadeusz Kantor and a new venue of Cricoteka in an old power station on the Vistula river in Kraków, to be completed by 2012. Her research is focused on the reception of Kantor in Italy. She co-curated *An Impossible Journey: The Art and Theatre of Tadeusz Kantor*, 2009.

INDEX

Edited by Katarzyna Murawska-Muthesius,
Natalia Zarzecka and in co-operation with Tomasz Tomaszewski (Cricoteka).
Designed by Alex Prior at Black Dog Publishing Limited.

Black Dog Publishing Limited
10A Acton Street
London WC1X 9NG
info@blackdogonline.com

All opinions expressed within this publication are those of
the authors and not necessarily of the publisher.

British Library Cataloguing-in-Publication Data.
A CIP record for this book is available from the British Library.

ISBN: 978 1 907317 32 3

Black Dog Publishing Limited, London, UK,
is an environmentally responsible company.
Printed in China by Everbest Printing Co. Ltd.

The book is published in association with the exhibition
An Impossible Journey: the Art and Theatre of Tadeusz Kantor
and the symposium *Kantor Was Here*
both at the Sainsbury Centre for Visual Arts, University of East Anglia, Norwich, 2009.

The exhibition, the conference and this book are part of POLSKA! YEAR,
a cultural programme coordinated by the Adam Mickiewicz Institute in Warsaw
to promote Polish Culture in Great Britain.
www.POLSKAYEAR.pl

The exhibition, the conference and this book were organised in partnership with
Cricoteka: The Centre for the Documentation of the Art of Tadeusz Kantor, Kraków

Cover Image: Sandy Nairne in the Demarco Gallery presentation of *Lovelies and Dowdies*, Glasgow,
Fruit Market, September 1973, photograph Richard Demarco, courtesy Demarco Archive.

This book is part of POLSKA! YEAR, a
cultural programme coordinated by the
Adam Mickiewicz Institute in Warsaw to
promote Polish culture in the UK.

POLSKA! YEAR

Adam Mickiewicz Institute
CULTURE.PL

cricoteka

Cultural Institution of the Małopolskie Voivodeship

architecture art design
fashion history photography
theory and things

black dog
publishing

london uk

www.blackdogonline.com